Practical Photography

HOW TO SHOOT LIKE A PRO

CARLTON
BOOKS

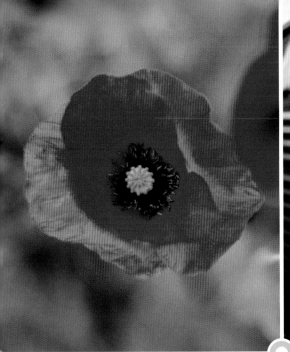

THIS IS A CARLTON BOOK

This edition published in 2018 by Carlton Books Limited
First published in 2016 by Carlton Books Limited
20 Mortimer Street
London W1T 3JW

Text © Carlton Books Limited and Bauer Consumer
Media Limited 2016
Pictures © Bauer Consumer Media Limited 2016
Design © Carlton Books 2016

A CIP catalogue for this book is available from
the British Library.

ISBN: 978 1 78739 067 6

Printed in Dubai

CONTENTS

Introduction

Have you just bought a camera and now you are wondering what all those buttons and dials do? You're not alone. We all scratch our heads in bewilderment when we pick up a proper camera for the first time. AF, Drive, ISO, WB, Lock, Menu … it's probably how Egyptologists felt before discovering the Rosetta Stone. User guides offer some reassurance, but they'll only get you so far, and they certainly won't help you be more creative and take better pictures – which is where this book comes in.

Practical Photography's How to Shoot Like a Pro has been designed to unlock not only your camera's full creative potential, but also yours. Taking a bite-sized modular approach to every core skill and technique, you'll learn how to take total control of your camera, what all those buttons and dials do, and master the skills you need to get started. Then, once you're handling your camera with confidence, we'll introduce you to a wide range of fascinating subjects, and will even show you how to organize and edit your images in a logical way. More importantly, you'll learn how to think like a photographer and see potential images where others wouldn't.

When *Practical Photography* first launched its Camera School course in 2008, we were pleasantly surprised by how many readers signed up. We'd anticipated a few hundred students, but ended the course with over 3000. The positive feedback we received from these readers told us we were onto something special. Technology continues to evolve at a rapid pace, but the fundamental skills of photography remain the same. This book charts the journey we think everyone with a passion for image making should take.

Starting with the absolute basics, *Practical Photography*'s team of experts guide you through a series of increasingly challenging techniques and projects, from landscapes and portraits to macro and wildlife, via more creative subjects such as artistic light painting and graphic black and white. Every chapter includes jargon-free advice, simple step-by-step instruction, and inspirational images. Oh, and the motivation to get out there and put your new skills into practice. Think of *How to Shoot Like a Pro* as your photographic Rosetta Stone. Ready? Let's get started …

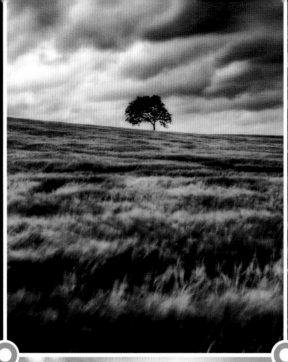

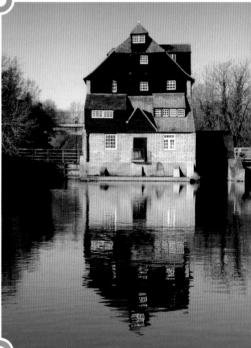

PART 1
THE BASIC SKILLS

Getting to know your DSLR

DSLRs can be daunting, so get to know what all the buttons
do and you'll instantly feel more confident about how to use it.

Your camera controls explained

Getting to know your way around a DSLR
is a bit like learning the controls in a car.
It may seem impossibly complicated at
first, but with a little practice it will become
second nature. Of course, cameras are
slightly different, but a little background
knowledge is always a good thing. It's
important to remember that the set-up
varies between DSLRs, so the controls we
touch upon here may be found in different
places on your camera. If this is the case,
simply check the instruction manual.

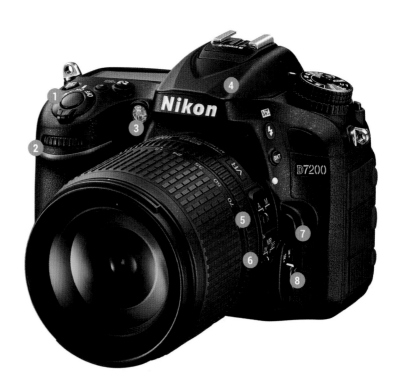

1 SHUTTER BUTTON The camera's most
used button of all is the one that
releases the shutter when fully pressed
down. It also autofocuses and meters
when depressed halfway.

2 APERTURE DIAL The dial in front of
the shutter button is mostly used
to change aperture when shooting in
aperture-priority mode and manual mode.

3 FOCUS-ASSIST LIGHT This comes on
automatically in low-light situations
to help the camera focus. It doesn't work
miracles, but it can be a great help.

4 POP-UP FLASH Press to open the
built-in flash. On some cameras,
when the flash is up, this button can be
used in conjunction with the shutter dial
to control flash exposure compensation.

5 MANUAL/AUTOFOCUS Use this switch
on the lens to change between manual
focus and autofocus.

6 IMAGE STABILIZATION This reduces the
risk of camera shake when shooting
hand held at slower shutter speeds.

7 LENS-RELEASE BUTTON Pushing
this allows the lens to be rotated
and removed from the camera body.
If it gets knocked accidently, your lens
shouldn't just fall off.

8 FOCUS POINT MODE BUTTON
Focus points allow you to choose
which part of the frame (what you see
through the lens) will be focused. This
button allows you to change the focus
mode and decide whether focus is set

for static or moving subjects when used
with the shutter and aperture dials.

9 METERING MODE You can change the
way the camera reads light in a scene
when this is pressed and the aperture
dial is rotated.

10 EXPOSURE COMPENSATION Use
exposure compensation with
aperture-priority and shutter-priority
modes to adjust camera exposure.

11 PLAY AND DELETE The play button
opens up the image viewer on the
LCD screen, while the delete button allows
you to remove unwanted photos.

12 MENU This button is the door to all
your camera's settings. Menus can

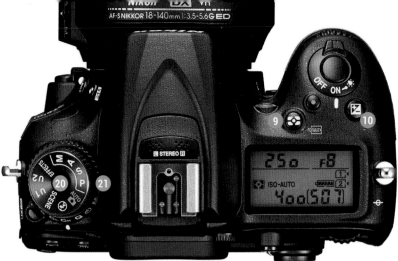

20 **MODE DIAL** The mode dial offers a number of shooting modes that cater for all photographers, regardless of ability. From full auto to manual, you can have as much or as little control as you're comfortable with. See below for the different shooting modes.

21 **RELEASE MODE DIAL** Not all DSLRs feature this dial. On this camera it allows you to change frame rate – single shot, continuous bursts, self-timer, quiet shutter, remote and mirror lock-up. To turn this dial you have to press down the button to the left to unlock it.

be vast but are great for customizing features and settings.

13 **WB/ISO/QUAL** These dedicated buttons give you fast access to commonly changed settings. The more a control is likely to be changed, the greater the likelihood it will have a direct access button like this.

14 **D-PAD** The D-pad can be used for a range of navigation tasks, including selecting an AF point, changing settings and looking through images when viewing.

15 **VIEWFINDER** This small window on the back of the camera provides you with a view through the lens. The light meter, current shutter speed and aperture settings are all displayed at the bottom of the window.

16 **LIVE VIEW** This is a feature that all new DSLRs have. It allows you to compose shots and focus using the LCD screen rather than the viewfinder.

17 **THUMB DIAL** The dial at the back of the camera on the right is mainly used to change shutter speed when shooting in shutter-priority and manual mode. Not all DSLRs have this dial.

18 **INFO** This button brings up most of the camera settings on the LCD screen so they can be seen at a glance.

19 **AE-L/AF-L** This button will lock exposure when the shutter button is depressed halfway. This means that if you recompose the shot, exposure won't change. It can also be used to lock focus.

MODE DIAL SHOOTING MODES

PSAM Program, shutter-priority, aperture-priority and manual are different shooting modes that provide varying levels of exposure control.

AUTO This is a point-and-shoot mode in which the camera takes care of pretty much everything for you. All you have to do is depress the shutter button halfway to focus, and then fully press it to take a shot.

AUTO FLASH OFF This mode is exactly the same as auto, except that the flash will not automatically pop up, even in low-light conditions.

SCENE Scene modes are pre-programmed to use the settings best suited to a specific subject. Some cameras have as many as 30 scene modes. The most common are portrait, sport, landscape, night portrait and close-up.

U1 & U2 These two modes allow you to save commonly used settings presets. Not all cameras have these modes.

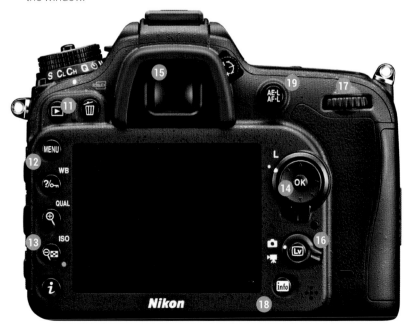
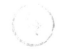

Setting up your DSLR

Whether changing settings is old hat or you've never dared to leave auto, the guide below will tell you everything you need to know about setting up your DSLR.

SHOOTING JPEGs

JPEG is a popular file format used by digital cameras. In a nutshell, JPEGs are compressed image files that take up very little space on memory cards and are processed in-camera. They're ready for printing as soon as they're downloaded from the camera, or they can be processed further in software like Photoshop. Despite this almost complete package, it's important to remember that if you shoot JPEGs, there are still several choices you can make regarding their size, quality and style.

The first thing you need to consider is whether to choose large, medium or small. There's no definitive answer, but our advice is to shoot large JPEGs all the time, unless you'll only be using the images online. The reason is that it's easier to make an image file smaller than it is to make it larger. Blowing it up loses quality, but making it smaller won't be an issue.

JPEG quality

With JPEG size chosen, it's time to think about quality. This refers to the amount of compression applied to make a small file size. Fine-quality JPEGs use less compression than low-quality JPEGs. The higher the

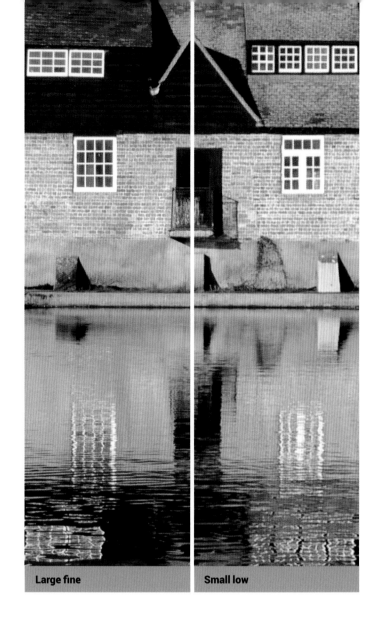

Large fine **Small low**

quality, the more detail will be retained, and the image will suffer from fewer compression artefacts (image degradation). As with JPEG size, we recommend setting quality to Fine for the highest-quality JPEGs possible. Quality can be lowered easily in Photoshop, but increasing it is near-impossible. If you're concerned about large image files quickly filling memory cards, don't worry. Large, high-quality JPEGs take up very little space, so it pays to shoot at these settings to avoid disappointment later.

JPEG style

Your camera gives you a standard default JPEG, but in your menu is the option to change styles to suit the subject. For example, on the Nikon D7200 this function is called Set Picture Control. Here you can switch between six different picture styles. Some are only slightly different, whereas others, such as Black and White or Vivid, offer a more obvious change. It's definitely worth exploring

Large JPEG

Medium JPEG

Small JPEG

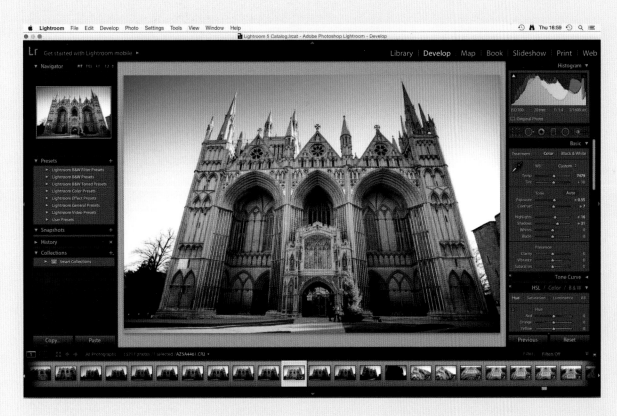

Left RAW files can be pushed harder in post processing software like Lightroom.

Below Standard, Vivid, Neutral, B&W.

pictures styles and how they suit the type of images you like to shoot. All the processing is done in-camera, so remember to reset the style so you don't accidently shoot Black and White when you actually want Neutral!

RAW

Another type of image file is RAW. Dubbed "digital negatives", these unprocessed and uncompressed images provide the most flexibility in terms of exposure latitude (the extent to which a photo can be over- or underexposed but still produce acceptable results). JPEGs can't be pushed as far if they are poorly exposed.

Whether you shoot with JPEGs or RAW files, the way you use the camera doesn't change. Switching between file types is done via the camera's menu, and in many cases there is a direct access button for a speedy change between the two. The downside to RAW files for beginners is that they have to be processed manually using special software like Photoshop. Although this isn't difficult, learning how to do it can take time, so shooting JPEGs may be easier to begin with. Alternatively, you could shoot RAW and JPEGs at the same time so you have the easy JPEGs to hand, but when you're ready in the future, you can process the RAW files. RAWs also have considerably larger file sizes.

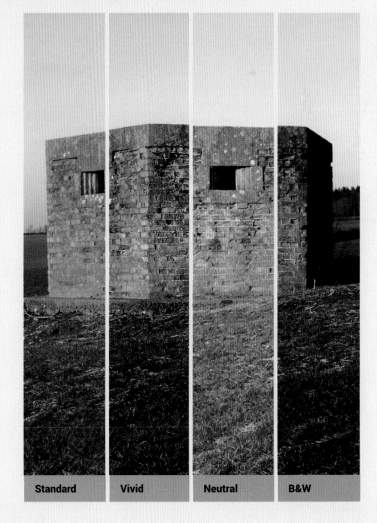

| Standard | Vivid | Neutral | B&W |

WHITE BALANCE (WB)

White balance is a way of telling the camera what type of light source is illuminating a scene and how pure white should appear under those conditions. The eye can do this extremely effectively, but cameras aren't quite as sophisticated. WB settings include auto, flash, fluorescent, incandescent, cloudy, daylight and custom. If shooting JPEG, it's extremely important that you use the correct settings. Auto isn't too bad, but it's far from perfect. It is, however, good for situations where there's mixed lighting or more than one type of light source. With RAW, WB can be changed when processing, so sticking to auto is fine.

FORMATTING

Once you've downloaded all the images from the memory card to a computer, it's time to delete them from the card. There is an option when reviewing shots on the LCD to delete all photos, but this isn't the best way to do it. Formatting cards not only deletes all photos, it also helps avoid card corruption that can lead to data loss. The option to format your card is often in the menu, but some DSLRs have direct-access button combinations for this.

ISO

This sets the sensitivity of the sensor to light, so exposures can be made in different lighting conditions. Scrolling through ISO, you'll find settings as low as 100 going all the way up to 12,800 or higher. There's also an auto setting, where the camera will choose the ISO according to the light conditions, but this doesn't always do the best job. As a rule of thumb, set ISO to 100 on a bright or normal day, 400 if it's cloudy and 1600 in low light. The lower the ISO, the better the image quality and the less noise is visible.

COLOUR SPACE

Colour space may sound like a dark art, but in reality it's a really simple concept. There are two options to choose from – sRGB and Adobe 1998 – and these can display a limited number of colours. sRGB is a smaller space with fewer colours and is used for web-based images, while Adobe 1998 can display more colours and is better for printing. You can print from an sRGB photo, but putting an Adobe 1998 image on the web will result in washed-out colours. As a result, it's best to stick to sRGB for general shooting.

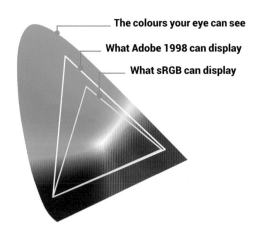

The colours your eye can see

What Adobe 1998 can display

What sRGB can display

How to hold your camera

Holding a DSLR correctly is important because it means you're standing steady, can move freely and, above all, you'll be comfortable. Once you know how to hold a camera properly, it will become second nature. In a way, you and your body will become the human equivalent of a tripod for the camera, so you need a solid stance.

ARMS

Keep your elbows tucked in toward your body. This will keep the camera steady when it's held up to the eye. As a result, you can get sharper photos because there will be less movement between autofocusing and taking a shot. This technique also helps in other situations, such as low-light photography.

GRIP

This is the one that's always wrong in movies, so don't copy what you see! The design of DSLRs requires you to hold them with your right hand so the shutter button can be depressed. Place your left hand under the camera and the base of the lens to keep it steady. With your elbows tucked in your grip will be solid.

FEET

Feet should be facing forward and positioned shoulder-width apart. This will give you a firm stance but will also allow you to pivot at the hips – movement that is essential in many photographic situations. If you need to get a lower viewpoint, kneel down on one leg and use the other to keep you steady. You can even rest an elbow on the supporting leg for greater stability.

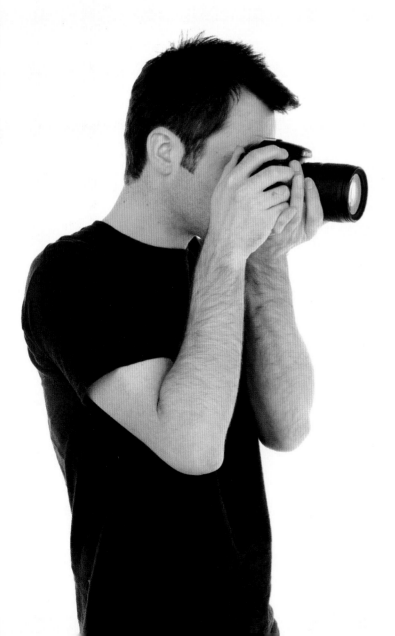

Basic exposure

If photography has a holy trinity, it has to be shutter speed, aperture and ISO. These exposure controls form the basis of all photos taken with a DSLR and, together, control how light or dark photos will be.

Exposure control

ISO, aperture and shutter speed work together to create exposures. Between them, they control the light sensitivity of the sensor, how much can reach it and for how long. They also provide a lot of in-camera creative control over the way shots look, so it's vital to understand how to use them. A term you'll hear time and time again is "stops". This refers to an increment of exposure. A 1-stop increase doubles the amount of light you let in.

ISO

This sets the light sensitivity of the sensor. The shutter speed and aperture are then set according to this. The lower the setting, the less sensitive the sensor will be to light, so ISO 100 is less light sensitive than ISO 400. ISO 100 is usually a good option in bright conditions, ISO 400 when it's very cloudy, and ISO 800 and above when it's getting dark. It's best to shoot at the lowest ISO settings you can for the conditions you're shooting in to ensure the best quality.

ISO stops

To increase ISO settings by a stop, you simply double the value, so it goes 100, 200, 400, 800, 1600, 3200, 6400 and so on. Generally speaking, increasing ISO by a stop means you can use a shutter speed 1 stop faster, or aperture 1 stop

narrower. The same goes for dropping a stop – you can use a slower shutter speed or a wider aperture.

Noise

The main problem with high ISO settings is noise. The higher you go, the grainier the images become, green and magenta flecks and patches appear, colour saturation drops and sharpness decreases. Sometimes it is unavoidable to hike up ISO, though, if it's the only way to achieve the desired exposure for a given subject. In the examples below you'll see ISO 100 is the sharpest with no noise. At ISO 6400 the detail is breaking up, with more noise visible. At ISO 12,800 it has heavy noise and green and magenta flecks and is very grainy.

SHUTTER SPEED

Shutter speed controls how long the sensor is exposed to light. Shutter speeds or exposure times extend from as much as 30 seconds to as fast as 1/8000sec. But if you need an exposure time longer than 30 seconds, you can use Bulb or B mode. This mode, when used with a lockable cable release, allows the shutter to be held open indefinitely. If you ever use this mode, make sure you have a stopwatch to time your exposure.

Shutter stops

Shutter speed allows you to be creative in terms of sharpness and movement blur, as well as to push aperture to its extremes. Shutter-speed stops are equal to ISO and aperture stops and cover the range of 1/1000sec, 1/500sec, 1/250sec, 1/125sec, 1/60sec, 1/30sec, 1/15sec, 1/8sec, 1/4sec, 1/2sec, and 1 second. There are more shutter-speed settings, but these are the most commonly used.

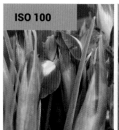
ISO 100

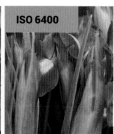
ISO 6400

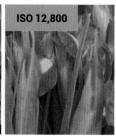
ISO 12,800

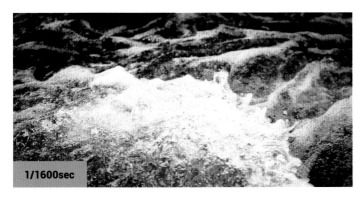

1/1600sec

Fast shutter speeds These allow fast-moving subjects to be frozen, which is ideal for wildlife and sports photography. When shooting with a fast shutter speed, it's not uncommon to set a wide aperture like f/4 and a medium to high ISO. In this example, we shot at ISO 1600, f/4 at 1/1600sec.

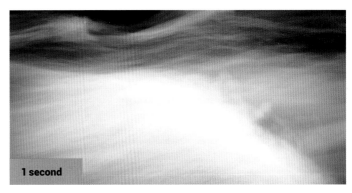

1 second

Slow shutter speeds These are often used to capture movement with varying amounts of blur. They're also common in landscape photography where low ISOs and narrow apertures are needed. This is why most landscapers use tripods which keep the camera still and eliminate blur. In this example, we shot at ISO 100, f/22 at 1 second.

Camera shake

Camera shake describes blur that's caused when photos are taken at slow shutter speeds, when even the tiniest camera movements are captured. This happens most often when you're shooting handheld, at a shutter speed too slow for the focal length of the lens you're using. It can also occur if you're shooting on a tripod without a cable release, as simply pressing the shutter button can create enough vibration to blur the shot. When shooting handheld, as a rule of thumb, your shutter speed should be at least reciprocal to the focal length of the lens you're using. For example, if you're shooting with a 200mm lens you'll need a shutter speed of 1/200sec or faster. You can use image stabilization to break this rule.

produce a large depth of field. Wide apertures are great for portraits and shots where you want to focus attention on a specific part of the photo. A larger depth of field is better for subjects like landscapes, where having everything sharp and in focus provides the most aesthetically pleasing results.

Aperture stops

Aperture stops can sound confusing to beginners. This is because a large or wide aperture is represented by a small number like f/4. A small or narrow aperture refers to a large number like f/16. Get your head around this, and you'll have no more problems. The main aperture stops are f/22, f/16, f/11, f/8, f/5.6, f/4, f/2.8, f/2 and f/1.4.

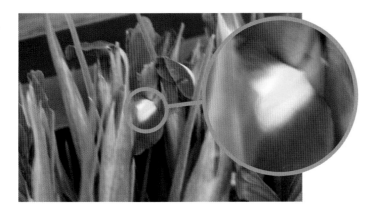

APERTURE

Aperture controls the amount of light that passes through the lens during exposure. At a creative level, the aperture allows you to control the depth of field, or front-to-back sharpness in the photo. Wide apertures like f/2.8 provide a shallow depth of field, and narrow apertures like f/16

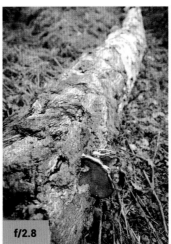

f/2.8

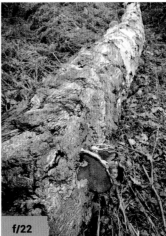

f/22

Shallow depth of field
Here, the back of the tree is out of focus. There's a narrow band of sharpness in line with the fungus on the right. We shot this example at ISO 100, f/2.8 at 1/125sec.

Large depth of field
This photo has front-to-back sharpness. Here we shot at ISO 100, f/22 at 1/10sec. We used a tripod and the camera's self-timer to avoid camera shake.

Understanding the histogram

It's easy to check if your images are properly exposed by reviewing them on your LCD. For extra accuracy, use your camera's histogram. Knowing what they show and how this can be used to your advantage could really help your photography. A histogram is a graphical representation of an image's tonal distribution, from solid black to pure white via midtones. Imagine a picture-postcard landscape – the bright blue sky and fluffy white clouds are light tones, the lush green grasses are midtones, and the long, raking shadows are darker tones. Histograms are an intrinsic part of digital photography and can be useful when reviewing images, checking exposures and making sure you don't blow your highlights or "clip" shadows (see opposite).

The skill is in knowing how to read histograms and understanding their limitations. You'll never see a histogram where the tones are evenly distributed across the graph. An image with a wide tonal range, with deep shadows, even midtones and bright highlights, will have a smooth "mountain", with the highest point near the middle and the sides gently falling off. And for many shots this is exactly what we want to see. But if you're shooting at dusk or in bright conditions, your histogram will look very different. A dark or low-key image will peak to the left, while a bright or high-key image will peak to the right.

What a histogram can't read is intent – it doesn't know whether you're trying to create a high-key effect or have simply overexposed your shot – and this is where you come in.

Shadows Histograms can be roughly divided into three areas: shadows, midtones and highlights. The left-hand third shows the spread of darker tones in an image, from dark grey through to solid black, and also shows how much of the image will be dominated by these tones. The higher the histogram "mountain" or peak in this area, the darker the image will be.

Midtones The middle third of a histogram represents the midtones – the range of tones from dark grey to light grey via mid-grey (often referred to as 18 per cent grey as used for grey cards) in the centre. In the real world, grass, foliage, water and tarmac are all typical midtones despite being different colours.

Highlights The right-hand third of the histogram represents the highlights – the range of tones from light grey through to pure white. High-key images (those with mostly light tones) will show a bias or peak toward the right of the histogram. Take a look at our example on the opposite page.

READING A HISTOGRAM

When reviewing images on the LCD screen, it's possible to scroll through settings to display a histogram alongside the shots you've taken. This retrospective histogram can be a great aid to improving exposures. Switching to this mode shows you how tones are distributed across the image and, more importantly, whether any clipping of the shadows or highlights has occurred. However, the advent of Live View – the ability to see a real-time view of your image through your camera's LCD – has been an absolute revelation. One of the major advantages of using Live View is the ability to see a real-time histogram. If you're still unsure what a histogram actually represents, this is a great way to see it in action: simply point your camera at a dark object or scene and then switch to a light subject or scene, and watch as the histogram peaks move from left to right.

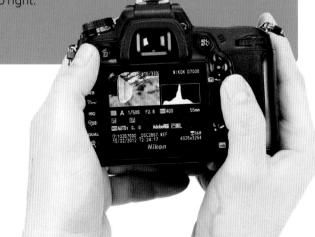

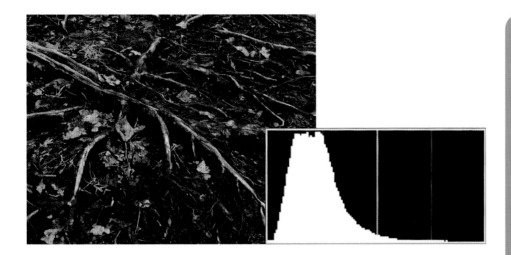

Clipping refers to an exposure that has lost detail in the shadows or the highlights. By this, we mean shadows have become pure black and highlights pure white, so no image is recorded. In some shots this isn't a problem and, if it only occurs in small areas, is easily dismissible. But if detail in either of these areas is important, you have to adjust exposure accordingly to allow the information to be captured, and this is where the histogram can be useful. There's also a clipping warning feature on DSLRs where blown highlights and clipped shadows flash on the LCD screen. In the histogram below, you can also see how the graph has been chopped off at the top.

Dark-tone histogram

When you read a histogram, you have to consider the tones that are present in the photo. But what happens if the scene contains mostly light or dark tones? The answer is simply a histogram where the graph is bunched up to the left or right. This photo contains only dark tones, so the histogram is bunched to the left with some coverage over the midtones. With no highlights, the information becomes almost non-existent to the right. The histogram is correct, but it can only show a representation of the tones actually present in the scene.

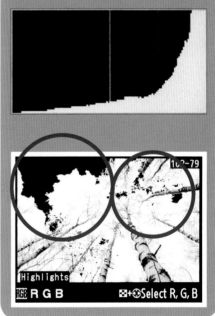

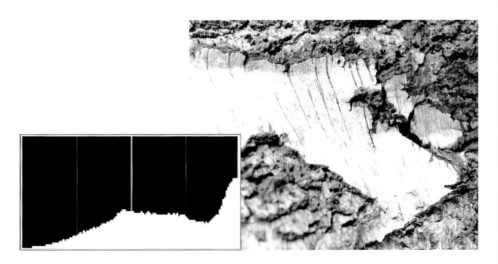

Light-tone histogram

This photo of silver birch bark contains mostly light and even pure white tones. This creates a histogram that's bunched up to the right. With more dark tones present than there were light tones in the example at the top of the page, the graph is also higher on the left. One important thing to consider is that while a bunched histogram can be perfectly acceptable, it can also imply a problem with exposure. For instance, if you've clipped shadows or highlights, the histogram will be pushed up against the far left or right edge and/or chopped at the top.

Using scene modes

We all like to take full manual control of our camera settings because this is when we can really unlock our creativity and put our photography skills to work. But no one wants to be frantically trying out different apertures and ISOs while that perfect shot comes and goes, and we all know that using full auto may not give appropriate settings to capture your subject.

This is where scene modes come in really handy. All you have to do is flick your mode dial into the preset that matches your subject, and you're ready to shoot. Your camera will take care of all the important settings, including ISO, aperture, shutter speed and focusing mode. For example, if you're shooting a fast action subject, simply switch to sports mode, which will raise the ISO and set a large aperture to give the fastest shutter speed available. Among other things, it will also set focusing to continuous so your camera will track the subject and keep it in focus as it moves in the frame.

On most DSLRs there are around four scene modes available. These are usually Sports, Portrait, Landscape and Macro. Your camera may have others such as Child or Night Portrait. Let's take a closer look at the four most common scene-mode presets to find out exactly why they can be so useful.

Portrait mode

When shooting portraits, it's usually desirable to have a shallow depth of field so that the background is nicely blurred to help the subject stand out. The Portrait scene mode does exactly this, setting the lens to a wide aperture. It leaves ISO and white balance set to auto, and uses a shutter speed that enables you to shoot handheld. Metering is usually set to evaluative (matrix), which is fine for most portraits, and AF mode is set to single shot. Adjustments to contrast and saturation make the skin tones and hair look softer and more natural than in full auto mode. The flash will fire automatically in low light, and you can shoot continuously by holding down the shutter button.

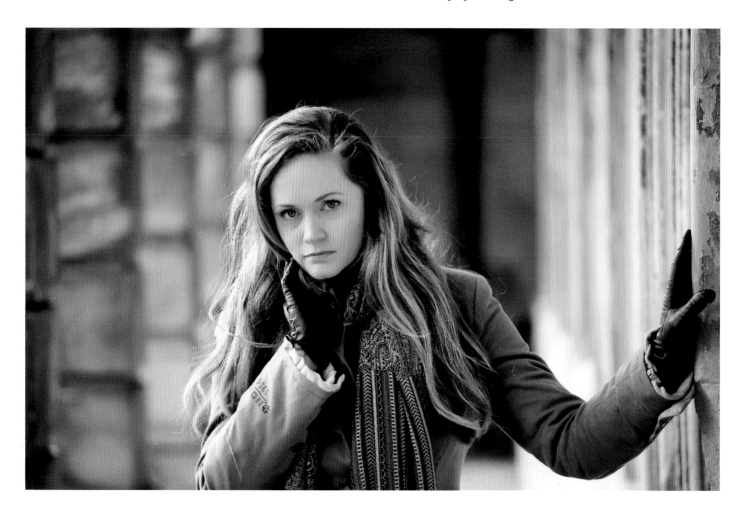

Landscape mode

For most landscapes you will want everything in focus, so in this mode the camera sets a small aperture for a wide depth of field. The ISO is set to auto, though because of the small aperture a tripod may be needed in darker conditions (like night scenes) because the shutter speed will be slow and you may not be able to hold it perfectly still. The camera automatically boosts the saturation of greens and blues in the scene to make landscapes a little more vivid. Metering is set to evaluative (matrix), and the AF is set to single shot. The built-in flash won't fire, even if it's raised. The drive-mode options available are single shot or self-timer.

Macro mode

Macro mode won't transform your lens into a macro lens or reduce the minimum focusing distance. For this you'd have to invest in a lens with a macro function. However, the Macro scene mode will give you the best possible camera settings for close-up work. Most importantly, it will set a small lens aperture to create a wide depth of field, so that as much of your subject is in focus as possible. This is important because depth of field is typically very shallow when shooting close-ups. Macro scene mode will also keep colours more natural than full auto mode, and uses evaluative (matrix) metering, auto flash, auto ISO and white balance, single-shot shot AF, and single or self-timer drive mode.

Sports mode

When shooting fast action subjects, it's important to have the fastest possible shutter speed to eliminate any motion blur. In Sports scene mode, your camera may increase the ISO (even if it means noisy shots) and may use a wide aperture (even if it means a shallow depth of field) to achieve that. For this reason, getting the focus right is even more critical. To aid with this, the camera will automatically have continuous shooting and continuous focusing active to help you more easily track your subject around the frame. The flash may not be useful in this mode, since its recycle time may be too slow to keep up with the maximum shooting speed.

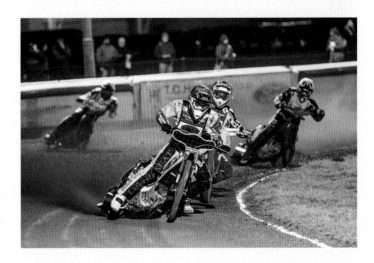

Semi-auto modes

Your camera's scene-mode presets are a quick and easy way to set up your camera for a specific subject and can be really useful. However, because these modes are completely automatic, they don't allow you any control at all over your key settings. So if you're in Portrait mode, for example, and feel the camera has made the background too blurry, there's not much you can do about it. For this reason, it's best to learn how to work in the semi-automatic modes. These will allow you to be more creative with the look of your shots, but unlike in full manual, the camera will automatically adjust one of two exposure variables (aperture or shutter speed) to keep the exposure balanced. You'll be in charge of choosing the other one, as well as the ISO.

Don't consider this a cop-out though. Many professional photographers use semi-automatic modes, and you'll find using them not too dissimilar to full manual. Each semi-automatic mode is suited to a certain situation, and once you become familiar with what settings work for you, both the potential to be creative and the speed at which you work will increase.

The important thing to remember when using these modes is that altering one setting will have an influence on the other. If you opt for a fast shutter speed, the camera will have to select a wider aperture to allow more light to pass through the lens. Manual mode allows you to override such calculations, but semi-automatic modes have the added advantage of helping you get a balanced exposure very quickly.

APERTURE PRIORITY

In this mode, you set the aperture, and the camera determines the shutter speed to balance the exposure.

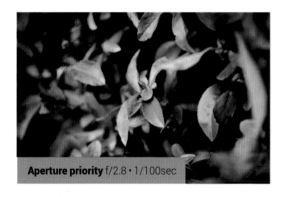

Aperture priority f/2.8 · 1/100sec

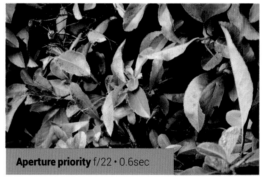

Aperture priority f/22 · 0.6sec

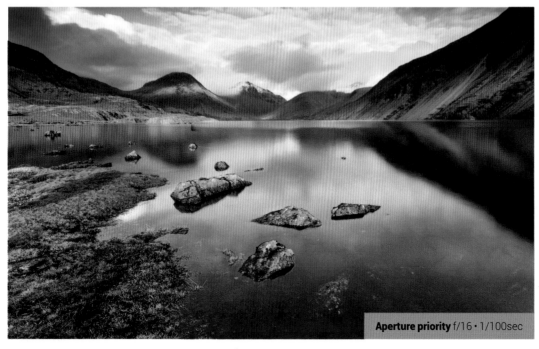

Aperture priority f/16 · 1/100sec

Aperture priority is the "go to" mode for controlling depth of field, since it gives you the option of having everything or just one part of your subject in focus. It is used extensively in portrait photography, because is perfect for isolating the subject against an out-of-focus background.

An aperture of f/4 is popular for portraits, but opening this up even wider, or as wide as your lens will allow, can produce stunning artistic-looking shots.

SHUTTER PRIORITY

By selecting shutter priority, you will be setting the shutter speed that you require, and the camera will pick a suitable aperture to give an accurate exposure for the conditions.

Shutter priority is the mode of choice when you want to capture a moving subject, and it will give you two options: it will freeze the subject (a shutter speed of 1/1000sec will certainly do this) or create motion blur. Motion blur is when a slower shutter speed is selected to show a blurred subject. This is often used for effect and can generate a different kind of picture to emphasize speed. Shutter priority is an ideal mode for sports and wildlife photography.

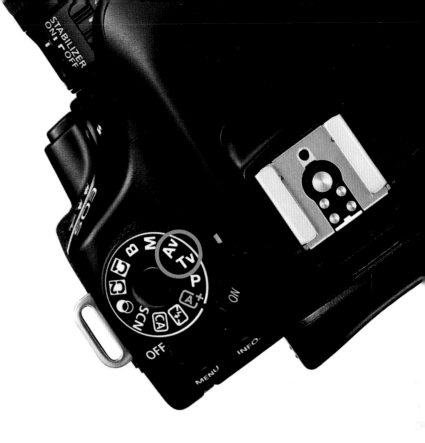

You'll find aperture priority and shutter priority on your camera's main mode dial. On Nikon DSLRs, they are listed as A for aperture priority and S for shutter priority. Canon use Av for aperture priority and Tv for shutter priority.

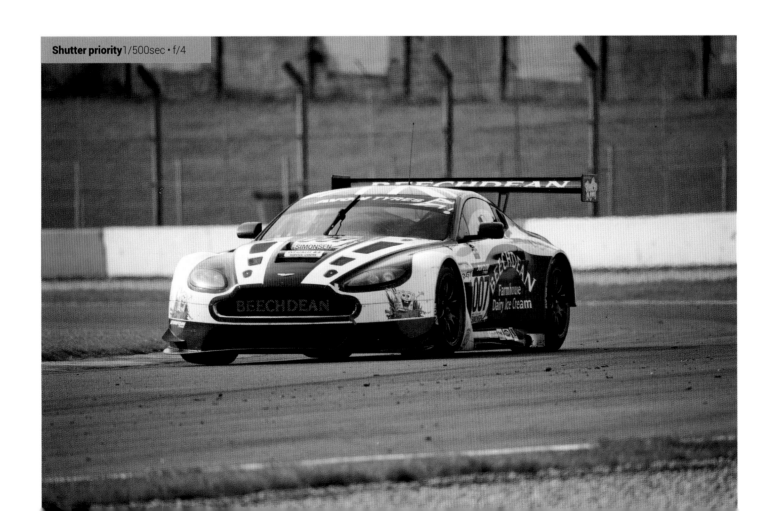

Shutter priority 1/500sec • f/4

Focus

Understanding the importance of achieving sharp shots every time is really just a case of getting to grips with using one focus point. Simple!

Getting sharp shots is vital when it comes to taking images you're happy with. With modern DSLRs featuring numerous focus points spread across the frame, it's important to understand the simplicity of using just one. Don't be fooled into thinking that one focus point means you're limited to only having the centre of the image in focus though – this is merely the default focus point. It's only when you start experimenting and moving the points around that you can see the benefits of being able to choose and move your focus points.

SETTING A SINGLE FOCUS POINT

The method for selecting just one focus point varies between different camera brands, so for detailed instructions, check your user manual. On all DSLRs, once you have activated single-point AF, you can use the D-pad to choose a point that covers the object you want to focus on. Some entry-level DSLRs have nine AF points, whereas other pro-level models have I50 or more. When you're getting used to using your DSLR though it's easy to work with the camera's default settings. In focusing terms, this means the predictive focusing option is activated. Choosing where you want the focus point puts you in total creative control.

CHOOSING YOUR FOCUS POINT

Now you know how to set your focus point, you must choose where you want it to go. The focus point you select is going to zone in on the area of the scene you want to be pin-sharp. This is known as the focal point in a scene. As you can see from the image opposite, using a wide aperture such as f/2 and focusing on the fingers has created plenty of depth. The focus point was moved from its default setting of the centre to the bottom right of the frame.

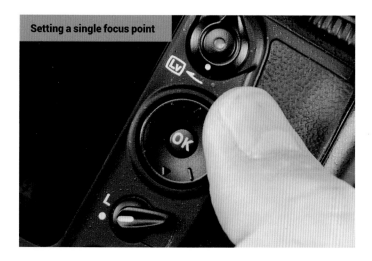

Setting a single focus point

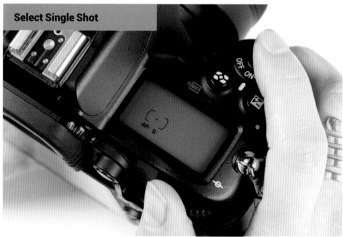

Select Single Shot

SELECT SINGLE SHOT

When shooting in a controlled situation (such as the portrait on the right), it can help to select the single-shot option. This means that when you focus on your scene, the focus will lock on to where your focus point is positioned and stay sharp until you press the shutter down. As you attempt to take another image, the focus will search and lock on once again.

FOCUS AND RECOMPOSE

So, what are the advantages of the single-shot mode? It's great for shooting portraits or detailed images, allowing you to focus on your subject by pressing the shutter halfway down, then recomposing. You're now able to frame the scene exactly how you want it, before finally taking the shot. Many photographers work in single-shot mode with only the central AF point active. The subject can be focused in the centre of the frame then, with the shutter button half-pressed to lock focus, the image recomposed. This is often a faster way of working than changing the AF point selection, especially if you're only taking one or two shots.

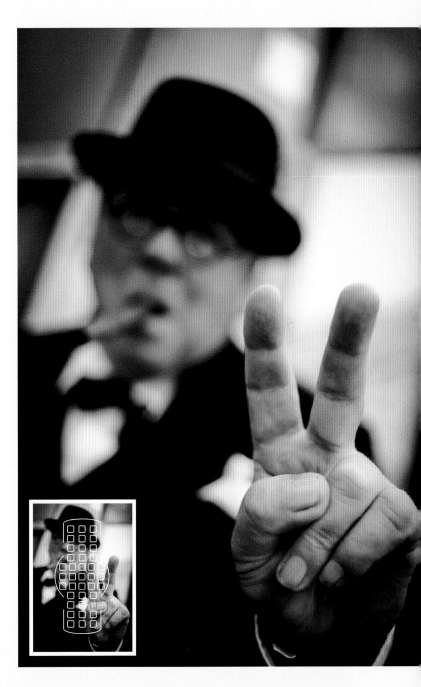

FIND YOUR FOCUS

Experiment with single focus points by snapping a member of your family. By doing this you will soon develop a focusing method that works best for you.

Sharpness

Sharpness in photography is a critical thing to get right, though this doesn't mean your whole image always has to be sharp throughout. In fact, you may wish to limit sharpness for artistic effect, but even then the important thing is getting the right point in your picture pin-sharp so that it anchors your composition.

Let's take a closer look at some of the more advanced techniques. It doesn't matter which type of subject you prefer to shoot, all the techniques we'll look at here will come in useful at some point.

Focusing and sharpness are as much about creativity as they are about technique, so don't think of this section as purely technical. It's much more than that, and some of the techniques you'll learn will give your photography a stylish edge.

WHEN YOU NEED MANUAL FOCUS

Manual focus is exactly what it says on the box – the photographer turns the focus ring until the image in the viewfinder becomes sharp. The shutter button is then pressed to take a shot. Autofocus is so good these days, it may be hard to imagine when you'd need to turn it off. But situations such as shooting into bright sunlight, photographing the stars, and taking extreme close-ups of tiny objects are easier to get right without AF.

USING CONTINUOUS AF

Continuous autofocus is the essential mode to use for moving subjects, whether they're moving toward the camera, away from it or past it. When the shutter button is pressed halfway this mode tracks travelling subjects, continually changing focus, so when the shutter is pressed fully, the subject is sharp and in focus. Having more than one active focus point increases the chance of getting the subject in focus. However, it's best not to use this mode for shooting static subjects, because results might not be as sharp as when using single-shot AF.

LOCATE THE SWITCH
The vast majority of lenses have an autofocus/manual switch, but setting the actual focus mode is usually achieved with a direct access button, a switch or a menu option. It all depends on your DSLR, so it's best to check the user manual.

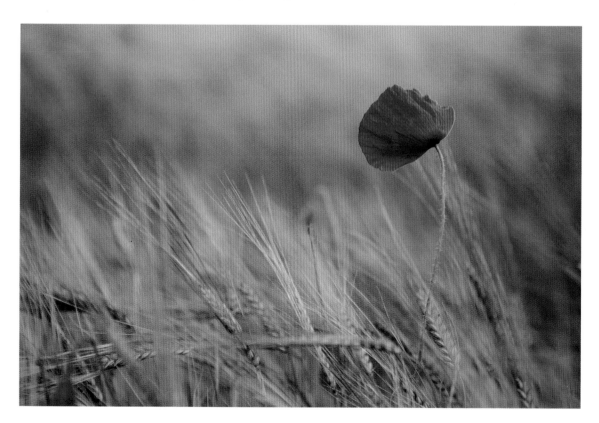

Focus point position
To ensure the poppy is sharp and not the background, the focus point covering this part of the frame was activated. This was especially important as the image has a shallow depth of field.

Precise focusing
Shooting this macro subject at f/2.8 meant focus was absolutely critical, and the best way to make sure exactly the right part of the subject was sharp was to focus manually.

Focusing on moving subjects
Continuous AF is the best option for fast-moving subjects. Here the shutter button was pressed halfway as the car was tracked and only pressed fully to take the shot.

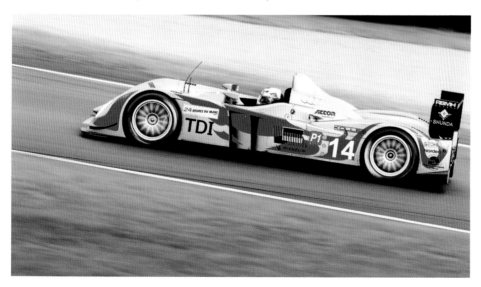

FOCUS-POINT ACTIVATION

For most situations it is best to have a single focus point active, because this ensures that only the right part of the subject is pin-sharp. But there are times when using a different AF point area mode is advantageous, because doing so increases the chance of getting a sharp shot every time. Some people like to use more than one active point all the time, but it really depends on what you prefer. The best thing to do is try the different AF area modes on your DSLR to see what works best for your shooting style. All DSLRs are different, so you'll need to consult the user manual to find out which modes your camera offers. Here are a few common modes.

Single-point AF
This is when just a single point is made active. This point can be any one of the points the camera possesses, and is often selected using the D-pad.

Dynamic-area AF
This mode allows the user to select a single focus point, and depending on the exact mode, a number of the surrounding focus points will serve as backup.

Auto-area AF
In this mode, all focus points are activated, and the camera uses things like colour-detection technology to determine what the main subject is and if it should be in focus.

ENSURING YOUR SHOTS ARE SHARP

You can maximize your depth of field to ensure sharp shots every time by understanding aperture settings and finding your lens's sweet spot – the aperture at which your lens produces the sharpest results. Most good-quality lenses will give great sharpness at the centre but fall off and blur slightly as you get closer to the edges. In order to achieve edge-to-edge sharpness, you need to know the abilities of each of your lenses. Most lenses perform best at around f/8; however, this doesn't mean that to get the best shots all the time you must only shoot at f/8, since that would leave all your images looking the same.

Having the edges of your frame slightly soft isn't a big problem if you've intentionally shot a portrait with the background out of focus, but if you've cropped in tight for a frame-filling image this isn't going to look good. Our example below helps illustrate exactly what we mean. The "Point" image shows the whole frame, and the three images below are zoomed in on the area at the top-right corner of the sign. The quality shouldn't change too much on the screw, because it's in the centre, but we'd expected to see noticeable changes on the edges. All three shots are taken at different apertures on a 50mm f/1.8 lens, ranging from the smallest to the largest, and it is clear to see that the sweet spot is definitely at f/8.

 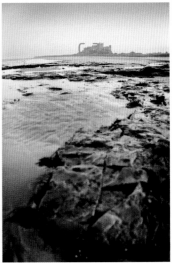

Focusing on the rock that sits in the foreground has thrown the background out of focus, from about halfway up. This is due to the great distance between them.

Focusing on the castle sitting on the horizon means the rocks at the front are now out of focus. The distance between the two subjects is still obvious, though.

MAXIMIZE DEPTH OF FIELD

Aperture isn't just a tool that allows you to let more light on to your sensor. The aperture you select, coupled with choice of focal length and where within a scene you decide to focus, is a key factor in defining how much depth of sharpness your image has. Opening your aperture wide is great for isolating subjects and throwing the background out of focus, while closing your aperture down is perfect for landscapes, where you want to capture the whole scene pin-sharp from front to back, exactly how you saw it with your own eyes.

So where do you focus?

As we've shown (left), the smallest aperture isn't necessarily the sharpest option, so to overcome this you can combine a focusing technique with a mid-range aperture, such as the sweet-spot aperture of f/8, to get an image that has great sharpness throughout the whole scene. Take the image on the right, for instance. With large foreground interest from the rocks and a prominent subject on the horizon, it would be easy just to choose one or the other to focus on. But shooting at an aperture such as f/8 means there's still the chance that whichever element doesn't fall on the focal plane will be too out of focus. To get around this problem, focus on an area between these two subjects – in this case, the sand in the centre of the scene. This has created an image that has front-to-back sharpness at f/8.

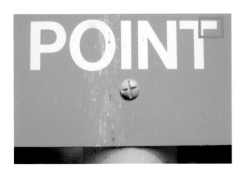

f/1.8 Shot at the lens's widest aperture, the definition of the lettering on the edge of the sign is very poor. It's not a crisp line at all.

f/8 It's a different story when shot at f/8, resulting in a very pin-sharp image and with very defined edges.

f/22 By closing the aperture even more and taking it to its smallest possible aperture of f/22, the quality is slightly lost again.

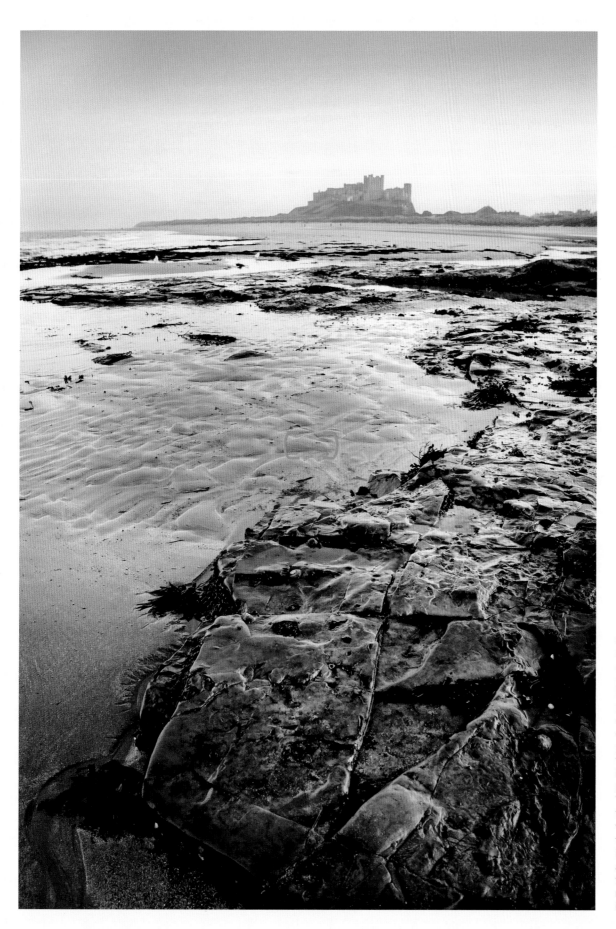

Striking a balance
Combining an aperture that produces pin-sharp images with a focal point that ensures every subject sits on the same focal plane is a common technique with keen landscape photographers. To capture front-to-back sharpness, we've focused nearer the centre of the image, on the sandy area. Shooting at f/8 has ensured that no area of the scene is out of focus.

Creative focus techniques

What's out of focus in your image is just as important as what's in focus. Here we explain how to throw attention on the right point within the frame using thoughtful focusing and aperture.

Read any textbook on the practical aspects of photography, and there'll be a few pages dedicated to differential focus. It's a fancy term for what is quite a simple concept – the art of drawing attention to your main subject. Through lens choice, focusing and aperture control, you are effectively pointing the viewer to the place you want them to look. In a sense, you are designing your photograph with creative control over the technical aspects of your DSLR.

The main point to remember when using differential focus is that it can make a huge difference to the composition of your image. In fact, sometimes it can make or break a shot by totally changing the way you look at a scene.

Although you may be confused by the idea of differential focus, you've probably used the technique at its most basic without even realizing it. If you take a portrait at a typical focal length of 70mm, set a wide aperture of f/4, and then focus on your subject's eyes, whatever is in the background will blur sufficiently to throw all attention on to the face. It's that simple.

But step beyond the basics and start experimenting with the power of differential focus, and you'll quickly add a new dimension to all your images. It works with absolutely any subject you choose to try as well.

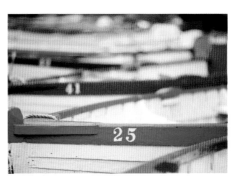

Sharp foreground
Using a short telephoto lens, we've focused on the number 25 and chosen an aperture that throws the rest of the boats in the background right out of focus, so that our eye locks on to the sharp point in the foreground.

Muddled image
Switch the point of focus to the boats in the background, and the eye now really has to search for its reference point – something that's sharp and easily recognizable. In this case, the differential focus just muddles the composition.

LOSING A DISTRACTING FENCE

You may not need to photograph through a fence too often, but it is a situation that occurs when at a zoo. You're on one side of the fence and on the other side is a beautiful animal that you'd like to make appear a little more "natural".

If you have a medium to long telephoto lens, you can perform an easy trick to make the fence disappear. If your lens is a zoom, take it to its longest setting then have the end of the lens as close to the fence as possible without risking damage to the front element. Position the lens so any gap in the wire mesh is as close to the centre of the lens as possible, then focus on your subject. The wire mesh of the fence will pretty much disappear, although some may still show if you shoot using an aperture that gives you a lot of depth of field (see below).

Combining focal length with aperture
Using a 200mm lens, we first focused on the fence so the cheetah can be seen out of focus in the background. Obviously this isn't the shot we want. Focusing on the cheetah with an aperture of f/8 we can get a much better image of the animal but the out-of-focus wire is still rather intrusive Changing the aperture to f/4 means the combination of focal length, focal point and aperture finally renders the fence almost invisible.

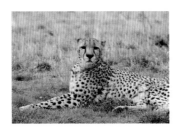

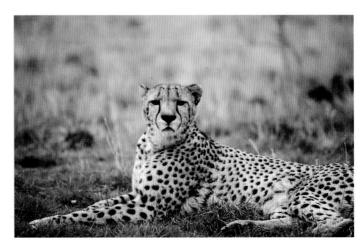

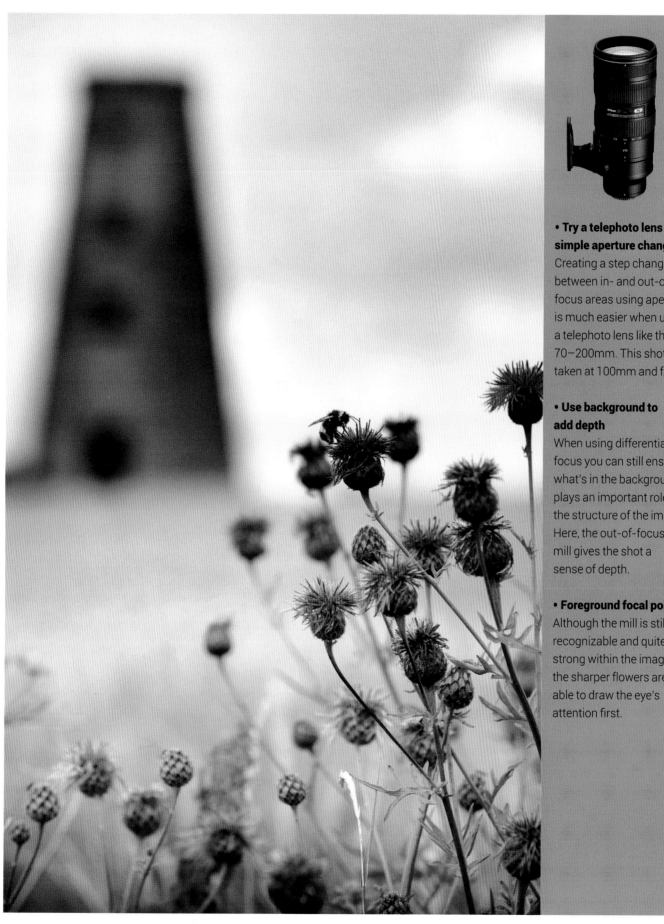

• Try a telephoto lens for simple aperture changes
Creating a step change between in- and out-of-focus areas using aperture is much easier when using a telephoto lens like this 70–200mm. This shot was taken at 100mm and f/5.6.

• Use background to add depth
When using differential focus you can still ensure what's in the background plays an important role in the structure of the image. Here, the out-of-focus mill gives the shot a sense of depth.

• Foreground focal point
Although the mill is still recognizable and quite strong within the image, the sharper flowers are able to draw the eye's attention first.

CREATIVE FOCUS TECHNIQUES

Composition

The way you compose your pictures has a huge impact on how they resonate with viewers. Take time to get it right.

The basic rules

Before we start exploring how best to expose your shots, let's have a quick look at the basic techniques and guidelines that we'll be using. Like any rules and theories, they won't work for every picture and shouldn't be followed slavishly, but they are an excellent starting point for achieving more eye-catching images.

FRAMING AND FORMAT

The very first decision you need to make is whether the shot is going to look best framed in a horizontal or vertical format. Traditionally, subjects such as portraits are shot with the camera upright, while landscapes are shot with the camera horizontal. This has given rise to vertical shots being called portrait format and horizontal ones called landscape format.

However, this doesn't always mean you have to use landscape format when shooting landscapes or portrait format for shooting portraits. In fact, including things such as foreground interest in your landscapes is often easier if you shoot upright. The best advice is to stick to the conventional rules unless you find a good reason for breaking them.

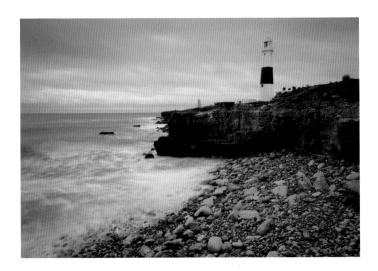

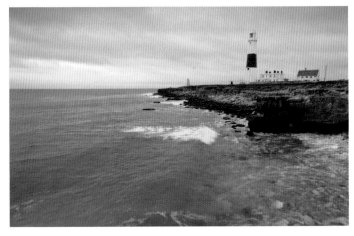

LEAD-IN LINES

These are naturally occurring linear elements in a scene that can be positioned to lead the eye from the edge of the frame in toward the main area of interest (such as the line of the beach). This draws the viewer into the picture, directing attention on to elements or subjects within it.

In landscapes, typical lead-in lines include a wall, stream, road or other man-made linear structure. Rocks and even clouds can produce less obvious lead-in lines, working instead as a subtle guide that directs the eye to the main focal point.

FOREGROUND INTEREST

An element in the foreground of your image can act as a stepping stone to lead the viewer into the frame. It also helps balance the composition if there's a strong element in the background, such as the mountain in the shot on the right. Foreground interest can also provide a sense of scale and distance, inviting viewers to compare the size of objects close to the camera with those further away.

NATURAL FRAMES

Composing an image so that one element of the image surrounds or partially surrounds another can help concentrate attention on the main subject. Looking for a frame within the viewfinder, such as an archway or tree bough, lends natural emphasis toward the subject in the centre of the frame and prevents the viewer's attention from wandering.

RULE OF THIRDS

Positioning the subject, or important elements of the image such as the horizon, in the middle of the frame can make

an image look too static. The best way around this is to use the rule of thirds to position elements in a more pleasing way, arranging them off-centre. Here you simply divide the frame into a grid and align any key linear elements, such as the horizon, with the horizontal and vertical lines. The four grid-line intersections are ideal places for positioning your main focal points, such as the tree in this image.

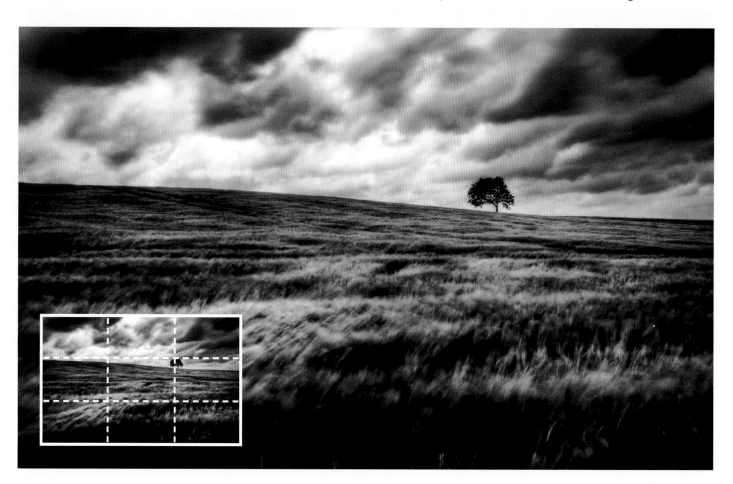

PUT THE RULES INTO PRACTICE

If composition is all about how you arrange the elements of a scene in the viewfinder, much of the skill lies in deciding what to leave out. What you don't include can be almost as important as what you do include. This is because successful composition is often about limiting the amount of information that the viewer sees so your images have more impact, and are much more likely to draw attention.

USING YOUR VIEWFINDER CORRECTLY

Although composition skills can be learned by studying successful images, it's looking through your camera's viewfinder where the process really comes together.

Although a DSLR viewfinder looks directly through the camera's lens, it's still not exactly the same image that will be recorded. The reason for that is that the viewfinder image is shown at the lens's maximum aperture, which has a shallower depth of field than the final image. This means that blurred parts of the viewfinder image may appear sharper (and thus be more distracting) in the final shot. Many DSLRs have a depth-of-field preview function that will allow you to stop the lens down to the working aperture to assess the effect. However, this often makes the viewfinder image much darker. You'll also find that many viewfinders don't show you the entire frame. Often there's a small amount (around 5 per cent in many cameras) of the outside of the image that isn't shown.

IDENTIFY FOCAL POINTS

Composing a shot actually begins long before you pick up the camera. With landscapes, it starts the moment you arrive at your location. Identify the elements that would make a good image and those elements you don't need to include. Simplicity is often the key. Try to look for individual objects such as a rock, tree, building or other element that would make a great focal point in the background, then walk around the location to find other objects that you could include in the middle distance. Finally, look at the elements you might include in the foreground to complete your shot.

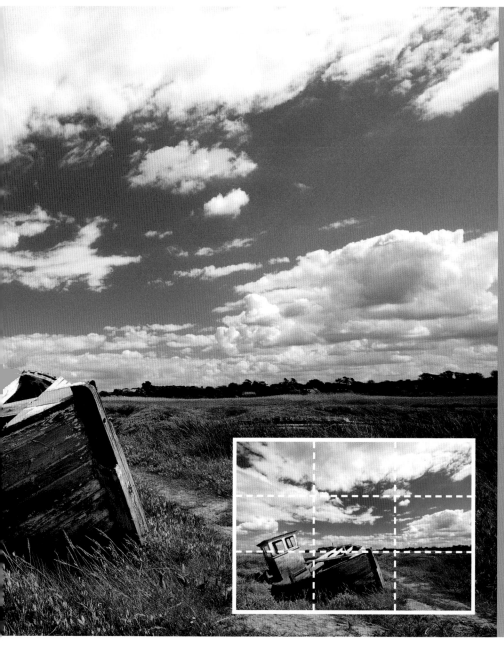

• Clouds
The lines in the cloud create diagonal lines into the frame, which work as lead-in lines to direct the eye.

• Boat
This has been positioned around a third of the way in from the edge of the frame, using the rule of thirds.

• Horizon
This is positioned around a third from the bottom of the frame using the rule of thirds.

• Path
This leads from the bottom-right corner to direct the eye into the frame, acting as a lead-in line and balancing the clouds above.

• Why this picture works
By superimposing the rule of thirds grid over the image, you can see how we used the grid to position the main elements of the composition. The boat aligns with one intersection (bottom left), while the horizon aligns with the lowest horizontal line. At the same time, the clouds and path form dynamic diagonal lead-in lines.

Once you've identified the things you want to include, it's time to pick up the camera and compose the image using the viewfinder. This is where the rules of composition can really help – try positioning the main elements according to the rule of thirds and look for potential lead-in lines.

Although we often recommend that you use a tripod, don't fix your DSLR in position at this point. Handhold the camera while you try various viewpoints and focal lengths that allow you to include the elements you identified earlier. Holding the camera gives you much more freedom of movement, so you can experiment with your composition more easily.

Once you've found the best viewpoint, fix the camera to a tripod and fine-tune the composition. Using a tripod is a great way of slowing you down, because it helps you to concentrate more intently on the height of the viewpoint and the exact composition you're going to use.

This may sound long-winded and time-consuming, but you'll eventually become quicker and more confident at assessing the potential of a scene within just a few seconds of arriving at your location.

BREAK THE RULES

Once you've learned how to use the various rules and
theories of composition, it may seem odd to suggest that
you should go out of your way to break them. But as useful
and valid as the rules are, they don't work for every shot or
in every situation. Breaking the rules can help you achieve
more impact or drama, and offer a fresh take on an over-
familiar subject by presenting it in an unexpected way.

Although breaking the rules implies that anything goes,
there are some more accepted ways of composing your shot
that don't conform to the normal composition standards.
Here are just a handful of ideas showing how to successfully
break the rules.

Central composition
Framing the subject right in the middle of your
viewfinder goes against every rule in the book,
but there are times when central framing is the
most dramatic option. A classic example is when
the scene is symmetrical (such as this lavender
field or reflections). Note the use of diagonal
lead-in lines still applies here.

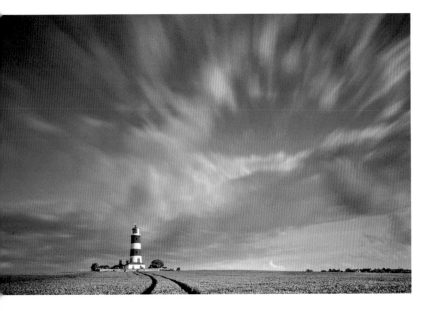

Low horizon
When there's a strong focal point on the horizon but very little foreground
interest, you can try positioning the horizon almost at the bottom of the
frame. This gives the strongest elements of the scene room to "breathe"
and makes them more dominant in the frame. This is also a great way
of making the most of dramatic skies and sunsets.

Another rule-breaking idea is to position the horizon very high in the
frame (or indeed, crop it out of the frame altogether), which is a great
solution for when the sky is dull and uninteresting, or when the main
points of interest are in the foreground.

No eye contact
It's generally accepted that when the viewer
can make eye contact with the subject, a portrait
image has greater impact. For this reason,
photographers usually ask their subject to look
at the camera. But sometimes, it pays to have
the model looking out of the shot. While this
dilutes the direct connection with the viewer,
it can create a different mood or meaning.

Sloping horizon
Getting the horizon level is usually the goal for outdoor images, but you can also go to the opposite extreme for a more dynamic result. The key here is to make sure that the horizon is well away from horizontal (if it's just a little way off it'll look like a mistake). This can be a successful technique when shooting action, portraits and any scenic shot where you want to emphasize drama.

Light

Light is the photographer's most important raw ingredient, and mastering it will unlock the door to professional-looking results.

Get to grips with the basics of light, and you'll begin to see the world in new and exciting ways. Whether you shoot portraits, landscapes, wildlife, macro or still life, understanding and knowing how to control light will give your photography a creative edge.

Light can determine the mood and feel of an image and can be the difference between a drab, uninspiring shot and an award-winner with drama and impact. And it can change from minute to minute, so you need to be ready to react when conditions are right.

Sunrise and sunset

The first and last hours of light in the day are referred to as the "golden hour" or "magic hour". This is because the low sun produces a warm, soft light that makes virtually any subject look beautiful.

Daytime sunshine

Harsh midday sun is challenging but not necessarily a barrier to great pictures. It's just that the light is much harsher, and shadows are hard and defined. Reflections, abstracts and silhouettes are all great subjects to shoot during the day.

THE EARLY BIRD
During sunrise and sunset, light colour (or temperature) changes dramatically over a short period of time, so make sure you arrive at your location early and are ready to record the changing hues.

Blue hour

Once the sun has set and the warm orange light has faded, blue hour starts. In reality, it's not a full hour, but you'll certainly get a few minutes where the light is distinctly blue, giving images a cold feel.

How light changes during the day

Sit in the same position for an hour in the morning or evening, and you'll see just how quickly light changes. The fewest changes occur during the middle part of the day due to the sun's high position in the sky. This light can be very harsh, especially if there's little cloud, because it is intense and shines directly down on the landscape.

Cloudy conditions

Clouds are ideal for shooting portraits, giving soft, even lighting on the face free from harsh shadows. They can also add texture to blue skies so are great for landscapes too.

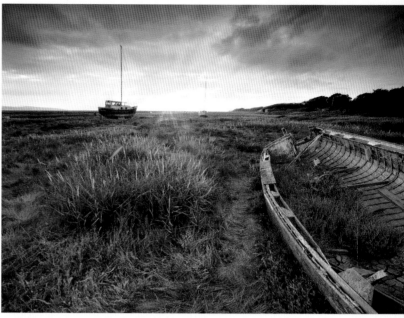

Golden hour
The first and last hour of sunlight are the best times to take pictures, because everything is bathed in a warm, soft light. The low angle of the sun is great for portraits, especially when positioned behind the subject to backlight them. This gives images a dreamy look, often with orange lens flare.

Sunset
Just because the sun dips under the horizon doesn't mean it's time to pack up and go home. Light is still being scattered up into the earth's atmosphere, resulting in brightly coloured skies like this one. If there are broken clouds in the sky, even better, since they will reflect the coloured light on their underside.

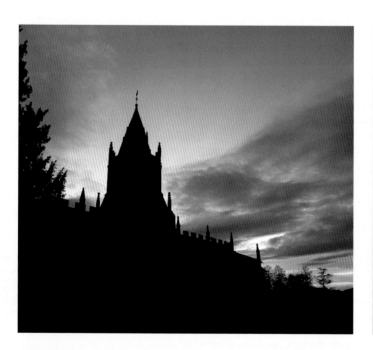

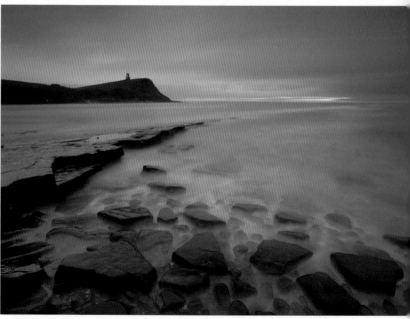

Silhouettes
Silhouettes rely heavily on the direction of light and are harder to shoot than they appear. This image works because the church has a very distinctive shape, so its outline is very recognizable against the colourful sky. Silhouettes are easiest to shoot around sunrise and sunset.

Blue hour
Just after the golden hour has finished, blue hour begins. Everything takes on a blue hue, which can create very atmospheric results. Obviously, with such low light levels, a tripod is always necessary.

UNDERSTANDING COLOUR TEMPERATURES FOR MORE ACCURATE RESULTS

Light is a photographer's greatest weapon and the key to more creative images. All light sources emit light at different temperatures, and so different kinds of light appear as different colours. Lower temperatures give off warmer (redder) light, while higher temperatures produce colder (bluer) light. This is where your camera's white balance (WB) dial comes into its own, allowing you to correct these colour casts and produce neutral results. Auto white balance (AWB) will make a decent job of this in most situations, or you can opt for one of the WB presets if AWB isn't quite accurate. You can even take full control in trickier multi-light-source scenarios and take a custom white-balance reading. The human eye automatically compensates for these differences, so we essentially see the world through neutral white-balance eyes. But our cameras aren't as sophisticated, so sometimes we need to tell it how to see. Colour temperature and white balance can be used to add impact to a shot, especially if you're shooting at sunrise or sunset and you want to capture the full range of colours in the sky. It can also be used for creative effect – using the "wrong" white-balance settings can sometimes create eye-catching results.

THE COLOUR TEMPERATURE/WHITE BALANCE SCALE – FROM WARM TO COLD

Got a halogen lamp? Chances are it has an orange/yellow colour bias. How do we know? Take a look at the scale to the right to find out. Colour temperature is measured in kelvins (K), and the lower the temperature, the warmer the light. Candlelight typically flickers at around 1000K and has a red colour bias, as does a typical household bulb. Try taking a shot in your living room after dark, and you'll notice the lights appear very orangey with auto white balance. Knowing where different light sources sit on this scale and also what their colour bias is will allow you to select the most suitable WB setting. You can also warm up and cool down colours for creative effect. Don't be afraid to experiment!

When set to auto white balance, the camera has correctly reproduced realistic looking colours. But by selecting other white balance presets, it's easy to give the images a warmer or cooler tint, which can be used for creative effect.

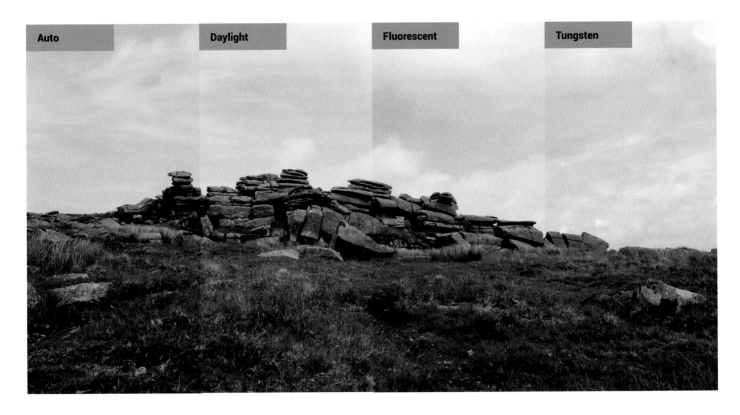

Auto

Daylight

Fluorescent

Tungsten

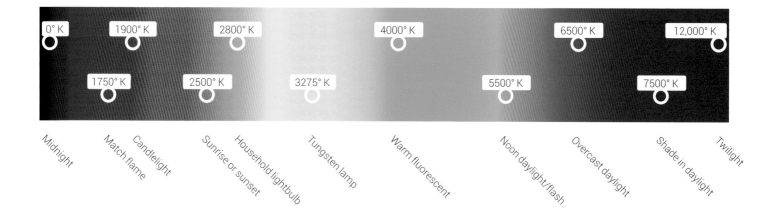

0° K	1900° K	2800° K		4000° K		6500° K		12,000° K	
	1750° K	2500° K	3275° K		5500° K		7500° K		

Midnight Match flame Candlelight Sunrise or sunset Household lightbulb Tungsten lamp Warm fluorescent Noon daylight/flash Overcast daylight Shade in daylight Twilight

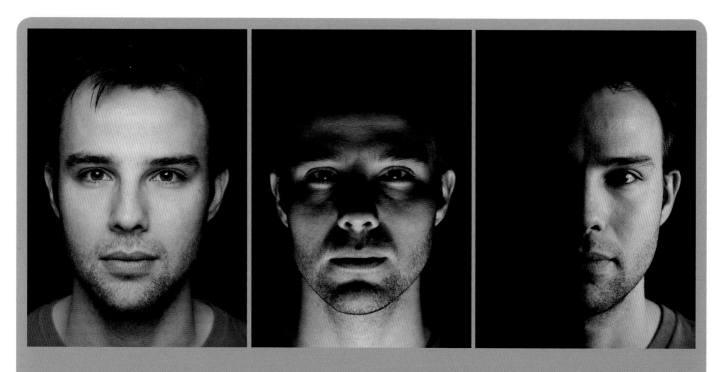

LIGHT DIRECTION

The direction of light dramatically affects the way shadows fall in a scene or on a subject. Here are some simple examples of how light direction changes the look of a head-and-shoulders portrait.

Top lighting

Lighting from a high angle is what we're most used to, because of the sun's high position in the sky. With portraits, this can result in shadows in the eye sockets and under the nose and under the chin. These can be reduced by using a reflector to bounce light back into these dark areas.

Up lighting

This is the most unnatural type of lighting because we're used to light coming from above rather than from below. This effect is very unflattering and requires artificial light to achieve it. It's great for horror but not very much else!

Side lighting

This is where one side of the subject is illuminated while the other side is in shadow – often referred to as "split lighting". It's a classic lighting style for moody male portraits because it accentuates the rugged look of your model.

THERE'S NO SUCH THING AS BAD LIGHT

The curse of bad light seems to continually plague keen photographers in their bid to shoot consistently creative photos. However, this doesn't need to be the case. If you go out to shoot a great landscape at sunset and are hoping to have wonderful directional light, only to be faced with heavy cloud cover and drizzle, then yes, that's not really what you want to take a stunning image.

But over the last few pages we've discussed and explained the numerous skills that will equip you to take full control of your camera – and that means you are now a totally adaptable photographer, whatever the conditions. You should be able to read the conditions, analyse the light and tailor your creative approach as a direct response to it. So, if you are a creative photographer bad light doesn't exist, only different types of light, and you can work with any of them. So long as you have light, any light, you can shoot a photograph.

As you know, the quality of light changes through the day, and the direction of light will have an impact on a typical outdoor scene. Understanding how this affects your shooting is important, but don't let it hamper your creative thinking. Beautiful, warm light is something we all enjoy shooting in, but it's far from essential for great photographs. In fact, it would be tedious if every day was the same endless haze of sunshine. We might curse the weather from time to time, but it gives us the potential to shoot varied, dramatic and atmospheric images.

With the understanding you've gained from the last few pages, you can look out of the window and think about what you can shoot in the given conditions. Yes, you can choose not to shoot, but it's far better to come up with a fresh approach than to constantly give in to it. That attitude won't swell your portfolio with interesting and contrasting photographs. So let's take a look at some of the options you have.

Golden light

Warm, evening light bathing a scene looks very inviting. On evenings like this, we could shoot gorgeous textural landscapes, backlit macro photos, or frankly anything we like. We won't even have to work too hard, as at this time of day virtually everything looks beautiful. But let's not take it for granted – how about shooting directly into the sun and allowing a little

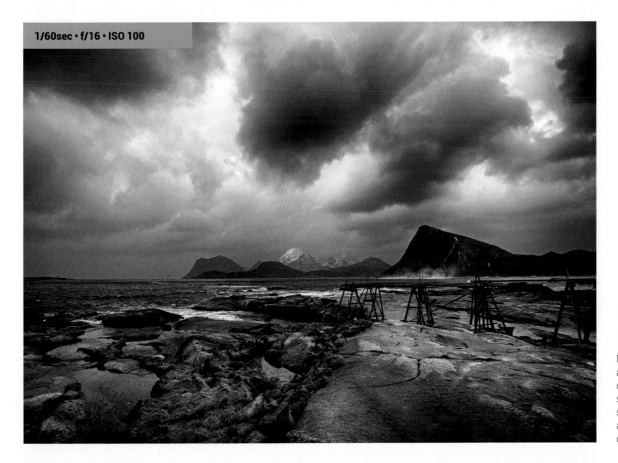

1/60sec • f/16 • ISO 100

Most landscapes are shot in sunny conditions. But stormy, overcast skies also work well, adding mood and drama to a scene.

flare to burst through the frame and lift the composition. If you are shooting JPEG, switch white balance to cloudy or shade to boost those deep orange tones even further. Make sure you walk around your subject too and explore how the strong light is changing structures and accentuating shapes. But if the light's low and behind you, watch out for your own shadow creeping into the shot.

Overcast or rainy days

Shooting action on a rainy day should not be a problem. In fact, for genres such as motorsport, the spray can add another dimension to the shot. You may just need to crank up the ISO and open up the aperture to get a shutter speed fast enough to freeze the action. So when everyone else puts their camera away and hides under an umbrella, it's time to start shooting. Overcast days are brilliant for portraits too. Just open up your aperture as far as you can, bump up the ISO, and shoot away. You don't have to worry about contrasty light throwing ugly shadows across your subject's face, and if there's a handy puddle left over from a recent rain shower then get them to jump in it.

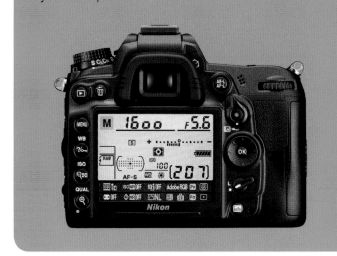

SHOOTING INTO THE LIGHT

Camera meters are easily fooled when shooting into the light, because they immediately think there is more light than there really is. Shooting directly into the sun, work in manual and then overexpose the shot by 1 stop to keep the details crisp in the shadow areas. It's easy to check the results you get on the LCD and adjust as required.

1/1000 · f/4 · ISO 400

1/1000 · f/8 · ISO 100

1/125 · f/2.8 · ISO 1600

Too bright or almost no light

If it's noon and there's not a cloud in the sky, your shot is going to be full of contrast and might not work so well in colour. But instead of worrying about it, try using that contrast to your advantage by going black and white for a punchy landscape (above). There might be other occasions when natural light has gone and you're left with a only a small light (above right). Here's where you explore the upper levels of your camera's sensitivity. Don't worry about noise. Watch how the light falls off your subject. If it throws a bit of a colour cast, then embrace it and use it to add some warmth to your photograph.

WHEN TO USE YOUR POP-UP FLASH

Whether it's a hint of fill-in flash to bring a portrait to life or a tricky lighting situation that needs sorting out, your camera's pop-up flash can really save the day.

The pop-up flash on DSLRs is a widely underused feature, but in the right scenario this hidden gem will help enormously with exposures. Simply press the flash button and the camera will do the rest.

A lot of photographers are put off using the pop-up flash on their DSLR because its harsh light can produce unflattering results. But used at the right time and in the right way, your built-in flash can be an invaluable tool. Its most useful function is as a fill-in light, brightening up harsh shadows on sunny days. Of course, it doesn't have a huge range but if your subject is within a few metres of the camera, it should have an impact. When you pop up your flash, your camera will assess the camera settings, focus distance and adjust flash output accordingly. You don't need to do anything. However, if you want you can adjust its brightness using flash exposure compensation. Depending on the mode, either hold down the same button that you pressed to activate the pop-up flash, then rotate the main command dial, or find the flash exposure compensation settings in your camera's menu. If you're unsure, check your user manual.

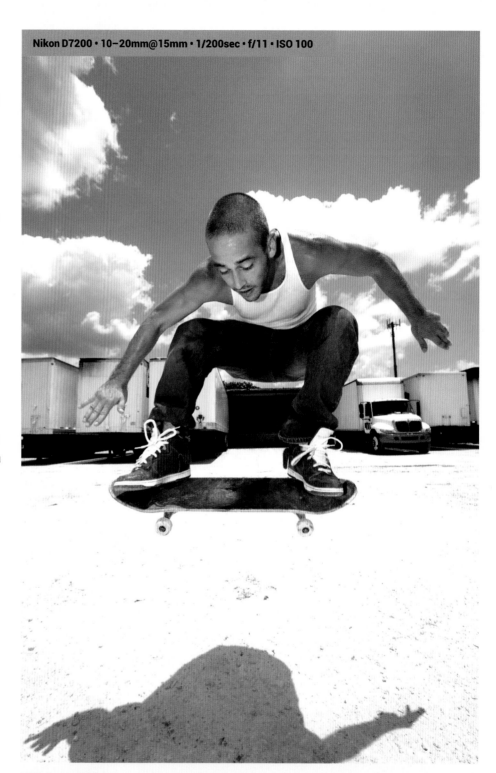

Nikon D7200 • 10–20mm@15mm • 1/200sec • f/11 • ISO 100

Fill in harsh shadows
If part of a close-up subject is in shade, like this skater's face, your pop-up flash is ideal for lifting the shadows, giving a much more attractive result.

When to underexpose your flash

Using your pop-up flash outside is great for adding a hint of catchlight in your model's eyes and for filling in harsh shadows. But sometimes this added light can be over-powering and leave the face overexposed. This produces a very flat portrait with the person appearing like a cardboard cut-out. For a more natural image, try underexposing the flash for your outdoor portraits – this will add just a hint of light and not have any effect on the background.

When to overexpose your flash

Sometimes you can find yourself in extremely dark conditions, where increasing the ISO to its limit still won't correctly expose an image. This is when you need to boost the power of your flash to really light up an area. Shooting large groups of people is a perfect example of this. With the extra flash power, you can now take a few steps back to get everyone in the shot, and still have enough light reaching them.

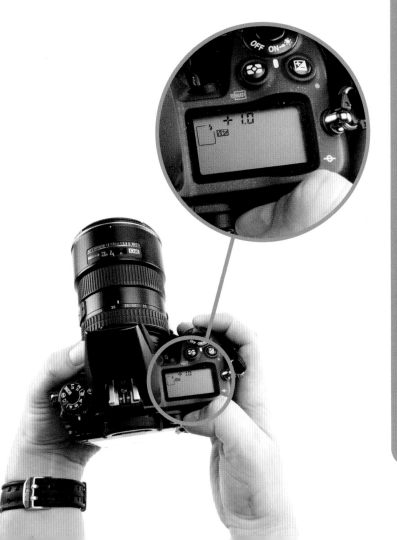

MAKE YOUR OWN FLASH DIFFUSER

If your camera's pop-up flash is still too harsh and unflattering, you could always create your own diffuser. This is possibly the easiest camera accessory to make, as all you need is a piece of tracing paper, scissors and tape. Cut the paper to a small square shape, place it over your flash in a curve and attach to your DSLR with two pieces of sticky tape. Since you're blocking a proportion of the light, you may need to dial in +1 flash compensation, but the tracing paper will act as a diffuser and shine a more pleasing and softer light on to your subject. This is a really useful technique for portraits.

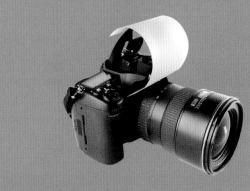

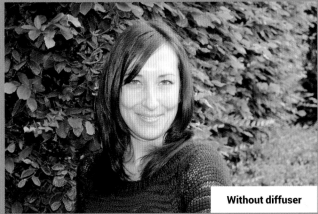

Without diffuser

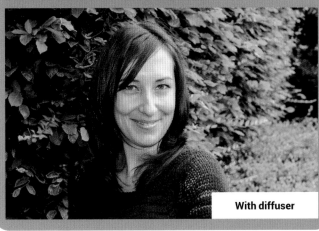

With diffuser

Metering

Metering is the process by which your camera assesses the amount of light in front of it and calculates how much it needs for a balanced shot. Think of it as the brains behind getting the exposure right.

Understanding metering modes

The good news is that modern metering is sophisticated enough to give perfect exposures most of the time.

But as you take your photography further, it's useful to understand the different metering modes so you can give yourself every chance of choosing the right one for a given situation. In most situations, you'll be fine using evaluative (also known as matrix), since this takes a reading from across the whole frame. But in some circumstances it may not allow you to get the exposure that's perfect for your subject – particularly when the lighting is tricky. That's when one of your camera's other metering modes may be more useful. Most DSLRs now offer evaluative, spot, centre-weighted and partial metering modes.

MATRIX OR EVALUATIVE METERING

This type of metering reads light from right across the frame. So when you use this mode, you know it will take a reading from highlights, shadows and midtones, then intelligently calculate an exposure based on an average. This is a pretty useful mode that is the default metering method on all DSLRs. However, it's not foolproof. Shoot a landscape with a wide exposure range between the land and the sky, and it can't end up with the perfect exposure for both areas. That's why we use accessories such as graduated neutral-density filters to help balance the exposure. For a scene where the tones are relatively uniform, like the house shown below, it will produce a really accurate reading.

SPOT METERING

Spot metering takes a reading from a very small area of the frame – less than 3 per cent. This is often the point at the centre of the frame, although with some cameras, this can move to the active focus point. If yours is the centre of the frame, you will need to call the exposure-lock button into action, so you can take a reading from the most appropriate place in the frame and recompose without losing the exposure selected. Spot is useful for tricky situations such as the picture of the woman below. Here, the most important thing to expose correctly is the face, so a spot-meter reading was taken from it. Consequently, other areas of the frame have fallen into deep shadow.

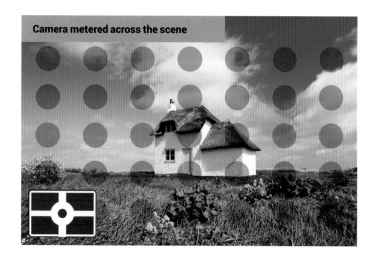

Camera metered across the scene

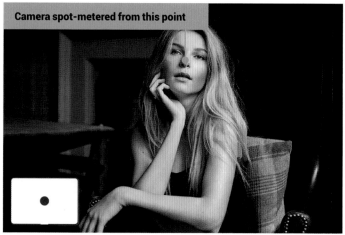

Camera spot-metered from this point

CENTRE-WEIGHTED METERING

Centre-weighted metering takes most of its reading from the area in the middle of the frame, but it still takes into account light levels from elsewhere. You can picture it as a central hotspot (larger than spot) that is feathered out toward the edge of the frame. It can be useful for portraits and generally tricky exposures.

PARTIAL METERING

Partial metering is similar to spot, but it measures the intensity of the light over a slightly larger area. Usually, this is around 10 per cent of the frame, with the remaining 90 per cent having no effect at all. Just like spot, this small area follows the active focus point on some camera models, but is fixed in the centre of the frame on others. Partial metering is useful for portraits, as well as dark objects with bright backgrounds.

By metering for the sunlit building rather than averaging light from across the whole frame, partial metering produces a much more attractive shot.

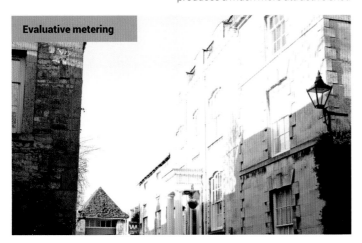

Evaluative metering

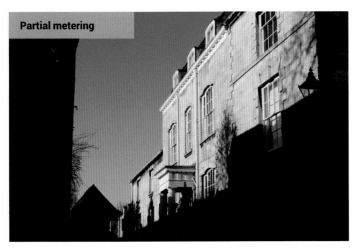

Partial metering

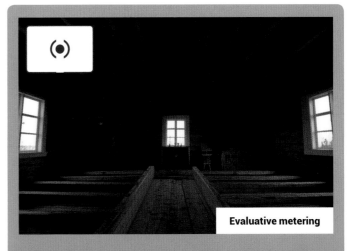

Evaluative metering

USING THE DIFFERENT MODES

If you've never switched between the different metering modes on your camera, it's worth experimenting to see the difference it makes. For example, this scene of bright highlights and deep shadows gave a reasonable exposure with evaluative metering (above), albeit slightly dark. Spot metering initially produced a horribly underexposed image (below). This was because the reading was taken from the central window. However, by placing the spot meter point on to the church wall to take a reading from a midtone, the exposure was improved dramatically (bottom). If you do experiment, make sure you select a tricky scene like ours, rather than an evenly toned one where the differences won't be as obvious.

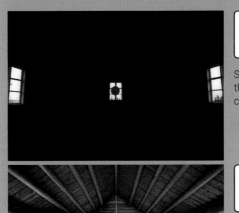

Spot-metered from the window in the centre of the frame.

Spot-metered from the walls of the church.

HOW YOUR CAMERA SEES THE WORLD

Cameras translate the world we know and recognize into a range of tones from black to white and the metering system is responsible for doing this as accurately as possible. While it doesn't always get this right, LCD screens allow us to spot poorly exposed shots instantly.

As we've seen, modern metering systems are generally very accurate, with matrix/evaluative metering topping the table thanks to calculating exposure from the entire frame.

So why does a camera sometimes guess the exposure inaccurately? The metering system is designed to meter for an 18 per cent midtone grey, which is a shade of grey halfway between black and white that reflects 18 per cent of the light. Most scenes are full of midtones, for which the camera has no trouble exposing. Others that have extreme highlights and shadows can cause the camera problems.

USING A GREY CARD TO METER DIFFICULT PHOTOGRAPHIC SITUATIONS

Once you know the limitations of DSLR metering, it becomes much easier to take control of exposures for better end results. So camera meters read everything as midtone grey and suggest exposure based on this. One way around this problem is to use a grey card for exposure. This is a pop-up card like the Lastolite EzyBalance Grey/White, which has an 18 per cent grey surface. Taking a meter reading from this under the light conditions you're shooting in will provide a correct exposure.

What the eye sees
The human eye is infinitely more complex than a camera and can make natural adjustments for different light sources and light levels. Assuming good vision, the eye sees colour and detail in both shadows and highlights. This backlit subject, once the eye has adjusted, is no problem at all.

What the camera sees
The metering system sees everything as black and white, basing exposure on the assumption that the largest area/subject in the frame is midtone grey and reflects 18 per cent of the light hitting it. Here, the light grey areas and the white around the moth may cause exposure problems.

Midtones for metering
This shot shows the areas of the frame that are roughly midtones and perfect for metering. We spot-metered from the end of the moth's abdomen for a correct exposure. If we'd used matrix metering, the backlighting would have underexposed the shot.

Meter from the grey card
Position the grey card so it is in front of the subject you're going to shoot. Make sure it's facing the direction you'll be shooting from, so that light hits exactly as it would the subject. Set your camera to manual mode, and compose with the grey card occupying the whole frame.

Set exposure in manual
Set ISO to an amount that is suitable for the light conditions, and turn the mode dial to M. Set the aperture, then change shutter speed until the light-meter scale only has a single line below the zero, as in the diagram above. Now remove the grey card and shoot the subject.

HOW TO USE EXPOSURE COMPENSATION

Exposure comp allows you to take advantage of manual exposure control while enjoying the convenience of semi-automatic shooting modes. With this level of control, you can be sure of perfect exposures every time.

With everything you've already learned about metering, you should now understand that it's sometimes necessary to change or override the exposure suggested by the camera.

Exposure compensation is a camera control used to manually tweak exposure when shooting in aperture-priority and shutter-priority modes. When metering produces shots that are too light or dark, you can use exposure compensation to fool the camera into correct exposure. The way to assess how much is needed is to view shots on the LCD screen before dialling in exposure compensation as a stop or fraction of a stop and then taking another shot to assess.

This wooden carved face (right) contains a higher proportion of tones lighter than midtone grey, so the straight camera exposure has underexposed. This is because the camera has brought the light tones down to midtone grey.

Adding 1.3 stops of overexposure (which shows up as +1.3 on the camera) has corrected the exposure by telling the camera to overexpose photos by this amount when a meter reading is taken.

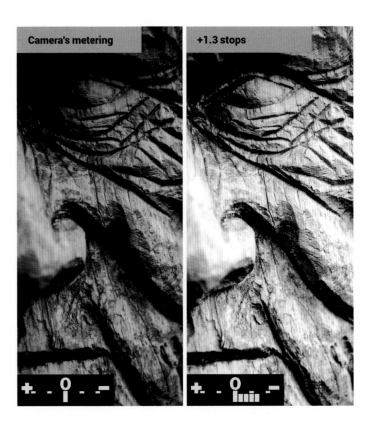

How to set exposure compensation

Once over- or underexposure has been identified when shooting in one of the semi-automatic modes, you have to dial in exposure compensation to fix the problem. This is done differently depending on your DSLR model, but usually you have to hold down the +/- button and rotate the thumb wheel to add the desired amount.

A good way of working is to add light in 1-stop intervals until you find the optimum exposure. Don't forget that you can set exposure compensation in thirds of stops for precise control. The main thing to remember is to reset this control to zero when you've finished.

How it works

Knowing how much exposure compensation to use in any given situation is one of those things that simply becomes second nature the more you do it. However, as a guide to help you start assessing the amount you need, it's handy to know that pure white is 2 stops lighter than mid-grey, and pure black is 2 stops darker than mid-grey. Use this as the foundation for exposure assessment when you're out shooting, and you'll soon be using the exposure-compensation facility on your DSLR with confidence.

Shooting a sheet of black card
Shooting a black piece of card fooled camera metering into overexposing so the black has become grey. Dialling in 2 stops of underexposure has darkened the shot to reproduce the black card correctly.

Shooting a sheet of white card
The white card has caused a similar problem, but this time we're looking at underexposure. Again, the card has reproduced as grey, so 2 stops of overexposure were required to lighten the shot by the right amount.

BRACKETING YOUR PHOTOGRAPHS

Shooting a selection of images at different exposures may seem like a lot of hard work, but when you're faced with tricky lighting situation, the ability to bracket can be a huge advantage.

Bracketing is when you take a series of shots of the same scene at different exposures. Doing this gives you a better chance of getting the correct exposure.

It was a very popular technique back in the days of film, when you didn't have the luxury of being able to instantly view images and so gauge if you had the correct exposure. These days, with advanced RAW-processing software, you can pull back lost detail or brighten up images at the click of a button. But don't rely on software to dig you out of a hole. Getting a correct exposure at the point of capture is still an important grounding to any image, so bracketing is a great way to ensure one of your shots is correctly exposed.

You can bracket manually by tweaking exposure by hand, or you can use the autobracketing function. This allows you to select not only how many frames you want to over- and underexpose but to change the increments at which you shoot. Whether these are as small as a third of a stop, or a whole stop and beyond, the more frames you select, the greater your choice of exposures.

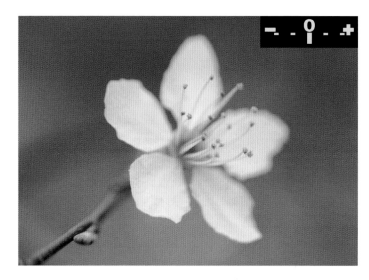

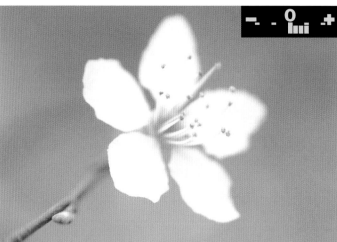

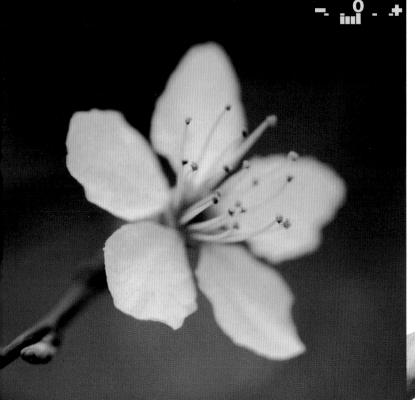

How bracketing can help

This white flower really stands out against the background, making it a very high-contrast image, and is a great example of how bracketing your frames can help. The shot at the top of the page shows the exposure that was suggested by the camera in evaluative mode, lacking contrast. When exposed at -1 stop (left), the colours are more vibrant, the background is darker and the definition in the petal is much clearer, showing how bracketing has benefited this scene. When the scene is overexposed at +1 stop (above), it becomes washed out, and detail is lost in the petals.

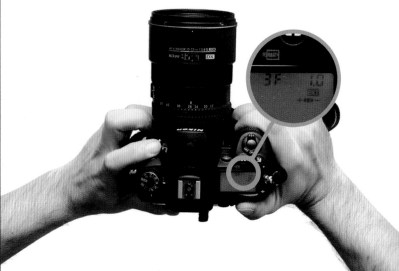

HOW TO DEAL WITH TRICKY SITUATIONS

The more you get out and about shooting, the more likely you are to come across difficult lighting situations. These are times when light and tones in the scene can play havoc with metering, resulting in under- and overexposed photos. The main reasons for this can be high contrast between shadows and highlights, or when a large part of the frame is very bright or very dark. Snow in particular can be a problem, because it often fools the camera into underexposure. The same goes for sand on bright sunny days, because it too reflects a lot of light.

The two images on this page show examples of tricky shooting conditions that could easily catch you out.

LUCKY THREE

Shoot a minimum of three frames when bracketing to ensure the best possible exposure: one at the camera's suggested exposure, one at -1 and another at +1.

The key to dealing with these situations is using the most appropriate metering mode and one of two techniques – bracketing or exposure compensation.

Camera spot-metered from this point

Meter from a highlight
This shot of a wooden fence shows high contrast between the shadows and highlights. A general exposure would have made the highlights blow out and the shadows light and muddy. In this situation, you have to decide whether you want detail in one or the other, and for this shot we chose the highlights. We spot-metered off the fence post in focus to retain detail here.

Meter from a midtone
This shot has very subtle issues but they are there. On the left, there's the waterfall, with white water reflecting lots of light. On the right-hand side there's a cave that's pure black. In this situation it's most important to retain detail in the water, since this is the main focal point of the shot. The cave is much less important and is, in any case, far too dark to bring into line with the rest of the image.

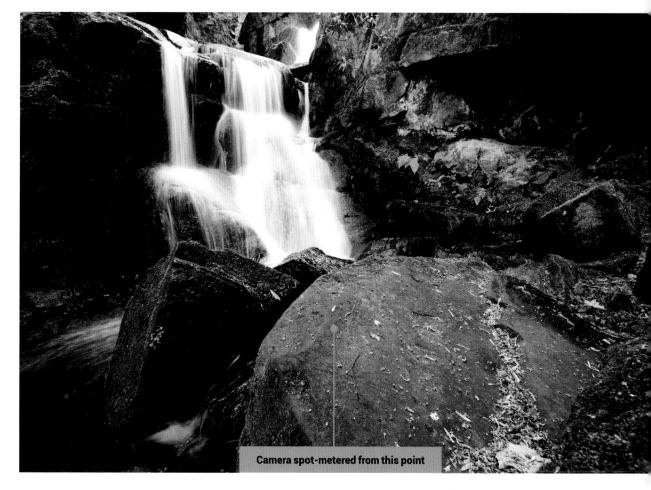

Camera spot-metered from this point

SHOOTING DIRECTLY INTO THE LIGHT

The art of shooting into the light is a tricky technique that can be difficult to get right. The problem is, if you get it wrong you could end up with some highly undesirable results that you may not be able to rescue in editing software. The key to success is metering correctly and setting the right exposure. When light pours into the lens from around the subject, this becomes even more critical. We're going to show you two simple techniques that will give you completely different results when shooting a dark subject against a bright background. Remember, to avoid eye damage, do not look directly at the sun, and especially don't look at the sun through a camera.

FILTERS OFF

When shooting into light, filters can cause undesirable flare where dust shows up. If you're shooting with flare in mind, remove any filters from the lens for best results.

Use the light to capture moody landscapes
Shooting into the light won't always guarantee you high-contrast results like silhouettes and bleached-out backgrounds. If the exposure difference between the sky and ground is minimal, results can be much more subtle. Shooting into the sun when the sky is cloudy can produce moody results like in the shot below. For situations like this, you often, but not always, need neutral-density graduated filters (ND grads) to balance exposure between the sky and ground.

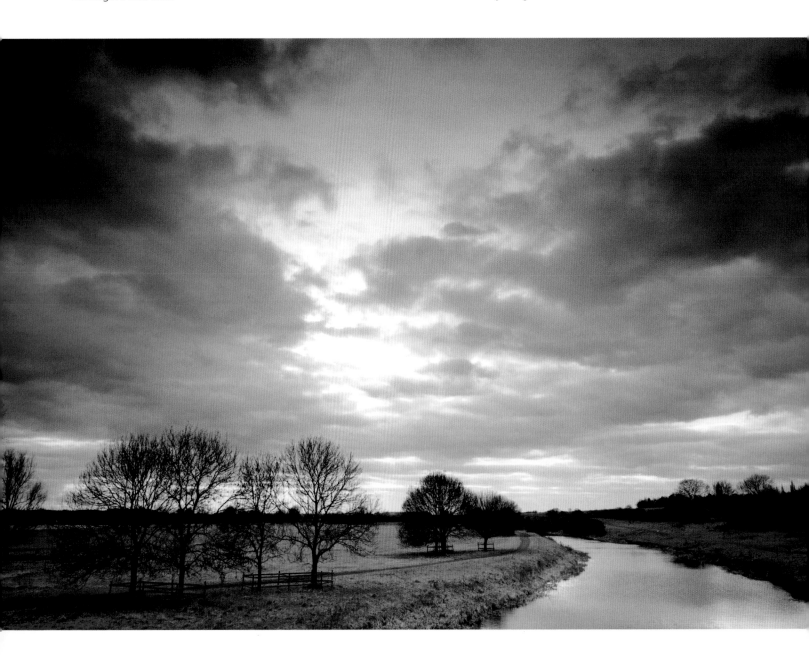

Metering for the sky

If you meter for the brighter part of the frame when you have a backlit subject, the result will be a silhouette. This happens because the exposure time is too short for the darkest parts of the frame to be correctly exposed, causing them to be recorded as pure black. If you shoot for silhouettes at sunrise or sunset, it's easiest to capture the colour of the sky. For silhouettes, set the metering mode to matrix/evaluative and dial in negative exposure compensation if necessary.

Metering for the subject

If your aim is to expose for the subject while leaving the brighter background to burn out, you need to set the metering mode to spot metering or partial metering. One thing to be aware of is that if the sun is directly behind the subject, it can become hazy and lack contrast. More contrast can be added post-capture in processing software if desired.

Shooting in manual

To really run free and make the most of your camera and your own creativity, explore manual shooting.

Are you ready for your next step in becoming the boss of your camera? If you are already shooting in aperture- or shutter-priority mode, this means you're already most of the way toward taking total control. We're going to give you the confidence to make that final leap and master your DSLR's manual shooting mode.

Remember, once you know how to use manual mode, you don't have to use it all the time. It's the best mode for some situations but certainly not all. The key to success is knowing which mode is most appropriate to any given subject or situation based on the depth of field or shutter-speed effect you're aiming for.

Having learned the exposure compensation technique on page 47, aperture-priority and shutter-priority modes are often just as effective as shooting in manual. But manual comes into its own for studio work, off-camera flash photography, astrophotography, live-music shots and other really tricky lighting situations.

WHAT DO ALL THOSE NUMBERS MEAN IN MY VIEWFINDER?

When shooting in manual mode, all the information you need to correctly expose photos can be found in an illuminated settings strip at the bottom of the viewfinder. This displays all the key exposure variables, so you can tweak settings without having to take your camera away from your eye. To the untrained eye, it can all look quite daunting. But once you know what everything is and how it can be used to aid exposure and creativity, it'll be your best friend. The most important elements here are the exposure meter and the shutter-speed and aperture-settings display. These will instantly show you if you're under- or overexposed.

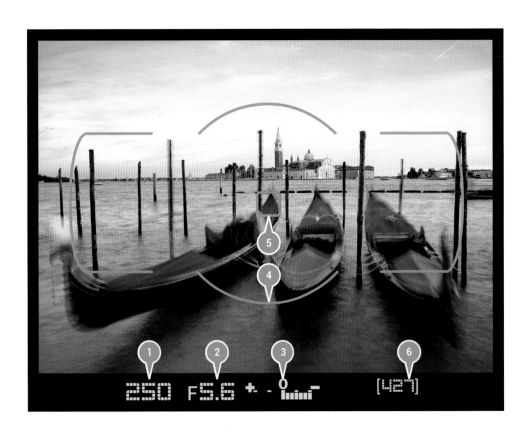

1 Current shutter speed is displayed, so you can see which setting you're using without moving your eye away from the viewfinder.

2 Aperture is also displayed, so you know exactly which value you're using.

3 The exposure meter is one of the most important elements here because it shows whether a potential shot is over-, under- or perfectly exposed. When lines extend out to the plus sign (+) it means the shot will be overexposed, and when they extend to the minus symbol (-) the shot will be underexposed. When there is just a single line below the zero or main centre line, the shot will be perfectly exposed according to the meter reading.

4 Focus area shows the portion of the frame where the autofocus points are located.

5 The active focus point is usually highlighted with the focus area, so you know which one you're using.

6 "Shots remaining" shows how many shots at current quality settings can be stored on the memory card.

Using the top-plate or the rear LCD

All DSLRs have an exposure meter visible through the viewfinder and on the rear LCD screen. Some also have one on the top-plate (the LCD display on the top of the camera). This screen can be useful for setting exposure without looking through the viewfinder when the camera is set up on a tripod. In this situation, you need to have already composed the shot and manually focused so the focus doesn't change.

Canon's 80D has a light meter on both the rear LCD and the top-plate LCD.

UNDERSTANDING MANUAL SETTINGS

Shooting in manual mode is much easier than most people think. To prove it, we're going to show you how it's done in just three steps. Don't forget that practice makes perfect, so be sure to try it for yourself.

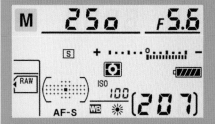

1 Set main control

In the first instance, set ISO to the desired setting and decide whether choosing a specific shutter speed or aperture is more important. We'll assume aperture is most important in this instance, so we've opted for f/5.6 – this setting will remain fixed until you next change it.

2 Balance the exposure

Next, we need to balance the exposure – remember, unlike in the semi-automatic modes, the camera won't do this for you. Turn the shutter-speed dial, keeping your eye on the exposure meter until it displays 0.

3 Tweak your settings

If you decide you want to tweak one of your settings, you'll need to balance exposure by adjusting one or more of the others. For example, if the shutter speed is too slow and you increase it, you'll need to use a wider aperture and/or a higher ISO to compensate.

How to shoot sharper shots

There's nothing more frustrating than getting home after a successful day's shooting only to discover your images are slightly soft, especially if they looked fine on your camera's LCD. We've all been there, but don't worry – there are a few simple steps you can take that will get you pin-sharp results every time.

It's not always possible to handhold your camera when taking pictures. Sometimes, when light levels are particularly low or you need front-to-back sharpness and have to use a narrow aperture, you need to rely on extra support to ensure the results are as good as possible. There are several methods to consider from basic in-camera techniques, to simple yet essential accessories.

TRIPODS

A tripod is, as its name suggests, a three-legged camera support that allows for much slower shutter speeds and/ or longer-focal-length lenses to be used. They're also incredibly versatile accessories. They can be used indoors in low-light conditions or outdoors in gale-force winds, and they can be extended for a higher viewpoint or inverted for ground-hugging low-level shooting.

You should always use a tripod when you need sharp shots without camera shake. It will also force you to slow down and really consider your composition and settings. If you're shooting in manual mode, you can't afford to rush, especially if you're getting to grips with the basics of shutter speed, aperture and ISO. So if you only splash out on one photographic accessory, you should make sure it's a tripod.

MONOPODS

Tripods aren't the only kind of camera support. Monopods are essentially one-legged poles that steady the camera and allow for more mobility than their three-legged siblings. For obvious reasons, monopods aren't designed to support a camera independently, so they need to be held and controlled at all times (and yes, we've seen people let go – it only ever ends badly). They're lighter and easier to carry than tripods so are ideal for shooting moving subjects, allowing you to achieve sharp results as slow as 1/30sec. The flipside is that they don't offer the same level of support and stability.

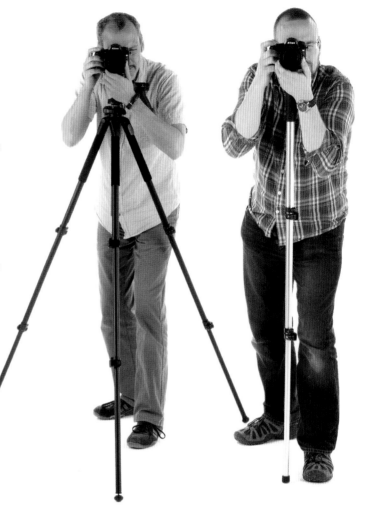

Tripods are essential Never leave home without your three-legged friend if you're shooting in low light levels, when you need front-to-back sharpness or when you're using neutral-density filters.

Monopods are useful too If you're shooting moving subjects and you need more mobility than a tripod affords, think about buying a monopod. They're lighter and easier to carry, but aren't as stable.

CABLE RELEASE OR SELF-TIMER

Even with your camera fixed to a sturdy tripod, there's still no absolute guarantee that your images will be pin-sharp. Something as simple as your finger pressing the shutter button, for example, can cause unwanted camera shake. There are, however, extra measures you can take to increase your chance of getting sharp shots. A cable release is a useful device that allows you to trigger the shutter remotely;

it typically attaches to your camera via a cable, as its name suggests. Also available are wireless triggers, which work via infrared or radio signals, and these allow you to trigger your camera remotely from a distance, often up to 100m away. If you don't have a cable release, you could use your camera's self-timer function, which delays the shutter firing by 2–10 seconds.

NO TRIPOD?

If using a tripod or monopod simply isn't an option, you can increase the ISO to achieve a fast enough shutter speed to comfortably handhold. Start off at ISO 100 for the best-possible image quality, but if this is gives you a shutter speed that's too slow to handhold don't be afraid to increase your ISO to 200 or 400. This will then allow you to increase your shutter speed by 1 or 2 stops, so 1/60sec becomes 1/125sec (ISO 200) or 1/250sec (ISO 400). You can also combine higher ISOs with wider apertures.

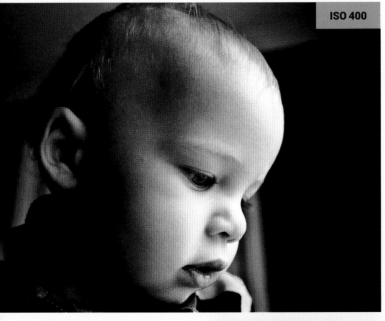

ISO 400

Don't be afraid to push ISO
This indoor portrait was shot at ISO 400. Light levels were fairly low, and a shutter speed of 1/60sec at ISO 100 was too slow to comfortably handhold. Increasing ISO by 2 stops to 400 meant that a shutter speed of 1/250sec was possible.

SHOOTING WITH FAST LENSES

A "fast" lens is simply a lens with a wide maximum aperture – typically f/2.8, f/1.8 or f/1.4. There are several advantages to using a fast lens – they let in more light and so allow for faster shutter speeds, making them ideal for low-light photography, and you can create incredibly shallow depth-of-field effects with them, so they are perfect for portraits. Due to the engineering involved, fast lenses are usually primes, which means they don't have a zoom. The 50mm prime is very popular and inexpensive, boasting a maximum aperture of f/1.8 or f/1.4. Canon, Nikon, Sony, Pentax and Sigma all make one.

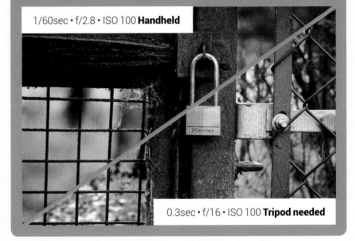

1/60sec • f/2.8 • ISO 100 **Handheld**

0.3sec • f/16 • ISO 100 **Tripod needed**

IMAGE STABILIZATION

Optical image stabilization is designed to help eliminate camera shake when shooting handheld in low light. It works using a series of tiny motors connected to either a lens element or the sensor. These compensate for small camera movements to help eliminate motion blur. Most modern stabilization systems offer a four-stop advantage. This means you only need 1/16 of the light that you'd need without stabilization to get pin-sharp results. In other words, a stabilized image shot at 1/4sec should be just as a sharp as an unstabilized image shot at 1/250sec.

PART 2
THE PROJECTS

Landscapes

Have you ever been walking in the countryside, come across a fantastic view and thought to yourself, "This will make a great photo"? You then return, full of great intentions, fired up to take the shot and armed with a DSLR and tripod, only to find that it's almost impossible to get a good viewpoint. The scene begins to lose its charm, and you're left feeling defeated. This is a common problem, because good views don't always make great photos. Learning to think photographically when you're out and about will help you to "see" the landscapes that will work. The following pages are packed with information that will help you find these locations and then take great photos of them.

PUTTING THE ELEMENTS TOGETHER

The shot below was taken at a location that didn't immediately scream out "great landscape". Positioned on the flat top of a hill, the windmill is certainly impressive, but making it work photographically took some thought. By exploring the available viewpoints to find one that worked, we settled on a low shot to incorporate the daisies in the foreground and the windmill in the background. The daisies act as foreground interest to help draw the eye into the image, while the windmill acts as a focal point in the background. The overall composition is held together using the rule of thirds, by positioning the horizon two thirds of the way up the frame.

GET ON YOUR BIKE!
Travelling by bike will allow you to quickly cover ground where a car can't go. Mountain bikes are the best option because they can be comfortably ridden off-road.

With a clear focal point, foreground interest, and a well positioned horizon, this landscape image works on every level.

EXTRA GEAR TO HELP YOU SHOOT LANDSCAPES

You can tackle landscape photography with basic kit, but there's no getting away from the fact that your chances of getting good shots are greatly increased with the right lenses and accessories. Here's a selection of the gear we think is best suited to landscape photography.

A wide-angle lens will yield the best results, but your DSLR sensor size ultimately dictates what you'll need. For an APS-C DSLR, a 10–24mm lens is ideal. For full-frame, try something like 17–40mm.

With the lens stopped down to a narrow aperture like f/22 for a large depth of field, exposure times can increase, creating the risk of camera shake. Use a sturdy tripod and a cable release to avoid any camera movement during exposure.

Getting the horizon straight is essential for successful landscapes – a wonky horizon will ruin even the best photos, and cropping to straighten up can lose important elements of the shot. A hotshoe spirit level is the best way to keep horizons straight.

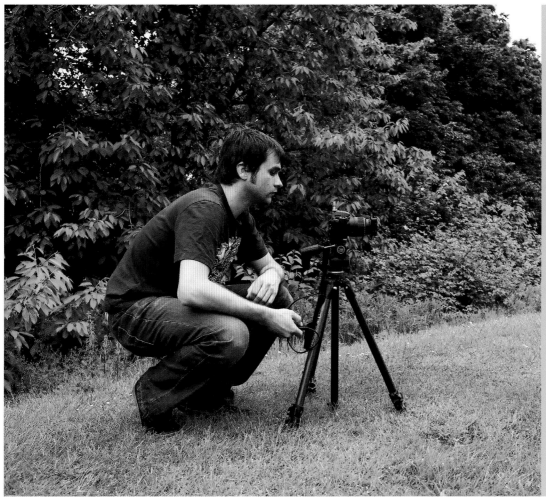

- Shooting from eye level doesn't always produce the best results. Explore various viewpoints at the location and find the one that works best for the situation.

- Shooting with narrow apertures in the morning or evening will mean shutter speeds are slow. Use a tripod to keep the camera steady during long exposures.

- With landscape photography there are a few accessories that make life a lot easier. A cable release, hotshoe spirit level and neutral-density graduated filters (ND grads) can be invaluable.

FILTERS

Many of the most stunning landscape photos owe their success to the use of photographic filters. There are three main types of filters that photographers frequently use to enhance their landscape shots, and these are the ones we'll look at here: polarizing filters, neutral density (ND) filters and ND grads. Of course, it is possible to reproduce the effects of some filters in Photoshop and, merge exposures to copy others, although you're unlikely to achieve such high-quality results as you would with filters.

Polarizing filter

Circular polarizing filters perform a variety of useful functions, meaning no kit bag should be without one. The most obvious application of polarizers is for darkening blue skies. This is most effective when your lens is pointing at a 90-degree angle to the sun. On most circular polorizers, you simply have to rotate the filter until the desired effect can be seen through the viewfinder. Rotating the filter can also reduce or eliminate reflections, which can be useful when photographing water. Simply twist the end until the reflection disappears. Polarizers can also be used to increase colour saturation, and thanks to being neutral grey in colour and blocking roughly 1.5 stops of light, they can double up as a 1.5-stop ND filter.

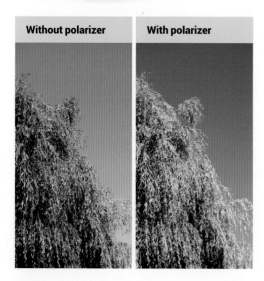

Without polarizer | With polarizer

Far left Without a polarizer, the sky is washed out and unnatural. In this situation, the sky often reproduces as white.

Left Using a polarizer has produced a rich blue sky that stands out, although be careful you don't overdo the effect.

Neutral-density filters

Neutral-density filters are covered with a light-reducing layer that blocks light without affecting colour. These filters are used to reduce exposure time or increase aperture size in certain situations. For instance, if you want to blur water, you can use an ND filter to allow for a slower shutter speed. If it's a bright day and you need to use a wide aperture but your DSLR can't provide a fast enough shutter speed, an ND filter could reduce exposure enough to take a shot. NDs are available in 1-, 2-, 3-, 6- and 10-stop densities.

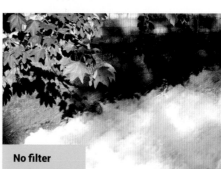

1/100sec at f/8 Without a filter, the fast-moving water has blurred slightly but retains a "frozen" look.

No filter

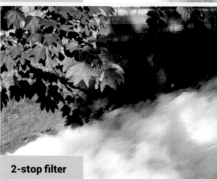

1/40sec at f/8 A 2-stop ND has increased exposure time, resulting in a smoother flow of water.

2-stop filter

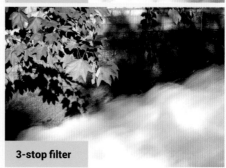

1/10sec f/8 Attaching a 3-stop ND has increased exposure enough to blur the water completely.

3-stop filter

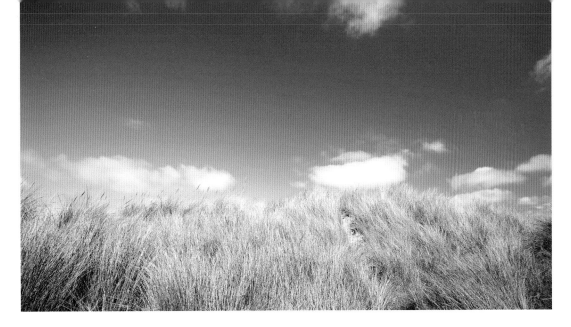

Polarizers and ND grads can both be used to enhance skies, but each works best in different situations. When photographing a scene with a very clear sky like this one, a polarizing filter will work best. For cloudier skies, it's better to use an ND grad instead.

ND grads

ND grads are a variation on standard ND filters. They have a light-reducing layer graduating from the full effect at the top to no effect around halfway down the filter. Their purpose is to cut the exposure in one area of the frame to bring it into line with a brighter area elsewhere. This allows the photographer to correctly expose for the foreground while the filter holds back the exposure of the brighter sky. ND grads, whether the screw-in or sheet-type filters, can be rotated to provide precise exposure control of the desired area of the frame. They're available in three main strengths: 1 stop, 2 stop and 3 stop. Different manufacturers have varying ways of denoting this: 121L, 121M and 121S for the Cokin P system and 0.3ND, 0.6ND and 0.9ND for the Lee Filters system. ND grads are available with either a hard or soft graduated edge.

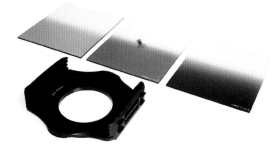

FILTER QUALITY

Just like lenses, you get what you pay for with filters, and there are a large number of options available. If you've just spent a fortune on top-quality lenses, make sure you do them justice by fitting high-quality filters.

SCREW-IN OR SHEET-TYPE ND FILTERS?

This is the big question when it comes to filters, but it's an easy one to answer. If you're going to buy ND grads, sheet-type filters with a holder are the easiest and more successful option to use, but on the downside they're more expensive than screw-ins.

Here's an upright version of our shot on page 58 of the daisies and windmill. The first example was taken without any filters and has resulted in a well-exposed foreground but a light sky. This is because the sky is brighter than the foreground, and it overexposes when exposure is set for the foreground.

Adding a 2-stop ND grad has maintained the correct exposure for the foreground while reducing the sky exposure by 2 stops. The result is a darker, more realistic sky that has retained the small amount of cloud detail present. With the straight horizon line, a hard ND grad was used for this shot.

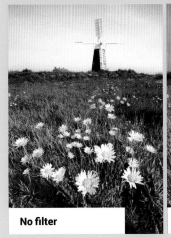

No filter

With 2-stop ND grad

DEPTH OF FIELD

Great photographs of the landscape often have sharpness from the nearest foreground object to the distant background. But when there is a vast distance between the closest and furthest objects, how can we achieve this? The answer lies in depth of field and the art of hyperfocal distance focusing.

Depth of field, or the amount of the scene either side of the point of focus that appears sharp to the naked eye, is controlled and managed by the lens aperture.

When a lens is focused, the light from a spot on the focal point converges at the same position on the sensor. However, light reflecting from other parts of the scene, away from the point of focus, instead appear blurred. The further away from the point of focus the more an area of the scene will appear out of focus.

Because of the way the human mind works, people are drawn to objects in a photograph that are sharp and ignore the blurred objects. So, using lens aperture to alter the extent of depth of field enables a photographer to emphasize some objects (by making them appear sharp) and de-minimize or hide completely other objects by blurring them.

By controlling depth of field what you are actually doing is deciding which parts of the scene and which objects in the scene get the most emphasis. Quite literally, you are attempting to control which parts of a picture people look at and which they ignore.

In landscape photography it is often desirable for the whole image to appear sharp from foreground to background, since all visual elements in the scene are of equal importance. When this is the case, you should set a small aperture to increase depth of field.

However, it's worth experimenting a little, because some landscape images can be made to look highly effective by isolating specific areas of the scene and hiding others.

WHY NOT JUST SET THE NARROWEST APERTURE?

Smaller lens apertures result in greater depth of field, so if you want to maximize depth of field, then why not simply set the highest possible f/number that the lens allows? While this technique does work, in practice there is a very good reason for avoiding it, and it's an optimal imperfection called diffraction. This causes a noticeable reduction in image quality, the extent of which is governed by the sensor size and the exact aperture used. Without going into the science behind this issue, the smallest aperture that should be used with an APS-size sensor DSLR (that is non full-frame) is around f/16, assuming you'll be printing to A4 size. For full-frame digital cameras, the smallest usable aperture would be around f/22.

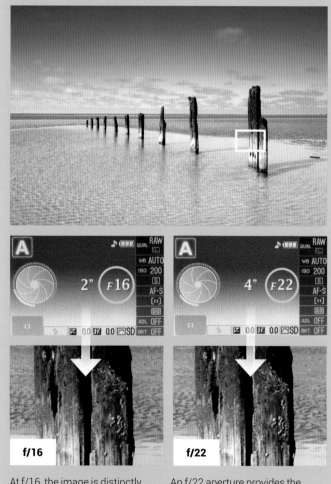

At f/16, the image is distinctly sharper than the shot taken at f/22. The downside to this is that depth of field is reduced slightly.

An f/22 aperture provides the greatest front-to-back sharpness, but ironically, the least general image sharpness.

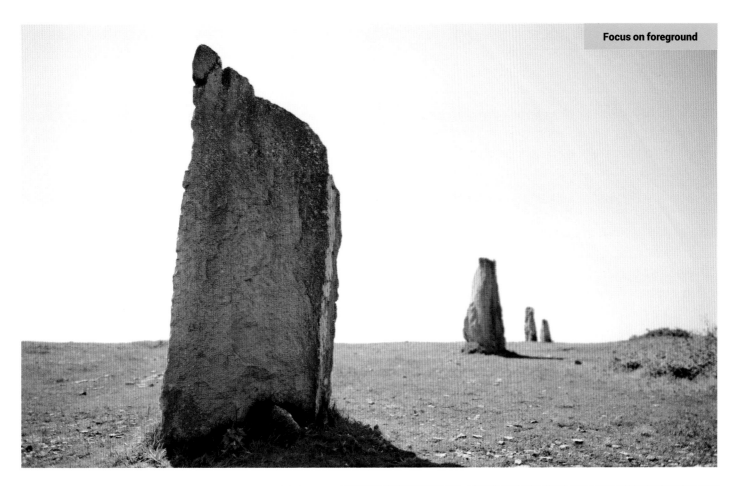

Focus on foreground

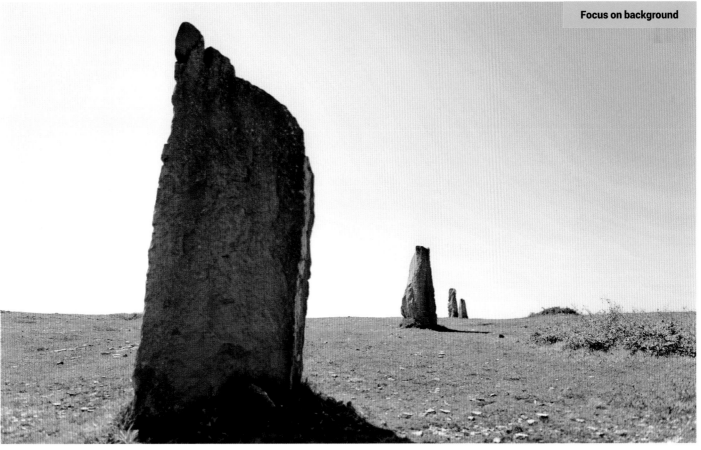

Focus on background

LANDSCAPES

HYPERFOCAL DISTANCE FOCUSING

If you want everything in your scene to appear in focus, the chances are this won't happen with a wide aperture setting such as f/4. But you don't simply want to select the smallest aperture either, because although this gives the maximum depth of field, image quality is relatively poor.

But there is a technique for maximizing depth of field at mid-range apertures: hyperfocal distance focusing. The hyperfocal distance is the closest distance at which a lens can be focused while keeping objects at infinity acceptably sharp – that is, the focus distance with the maximum depth of field. When the lens is focused at this point, all objects at distances from half of the hyperfocal distance out to infinity will be acceptably sharp.

There are three ways of calculating the hyperfocal distance, two of which are somewhat subjective. The first is to focus the lens at a point roughly one third of the way into the scene. The problem with this technique is that it is not precise enough because it's almost impossible to gauge distance with any degree of accuracy.

The second method is to use the depth-of-field preview button (if your camera has one) to stop the lens down to its current working aperture. Technically, this will enable you to see the point in the scene at which acceptable sharpness begins. This is the hyperfocal distance. The problem with this method is, even at relatively large apertures, such as f/8, it becomes almost impossible to see anything through the viewfinder, let alone work out which objects appear sharp.

The third and best way is to use a hyperfocal distance chart that provides the exact hyperfocal distance for any combination of focal length and aperture setting.

FOCUSING USING HYPERFOCAL DISTANCE

If you focus on a subject at 6m using a 50mm lens on an APS-size sensor DSLR at f/22 depth of field would extend from 3m to infinity. But image quality would suffer because the lens aperture is set to f/22. Increasing aperture to f/16 would overcome the loss in image quality but would reduce depth of field to between 11.5ft and 64ft – sharpness at infinity would be lost. However, by refocusing the lens to the hyperfocal distance – in this example, 27.1ft – then depth of field would extend from 13.55ft to infinity.

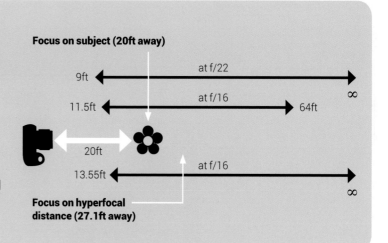

Focus on subject (20ft away)

9ft — at f/22 — ∞

11.5ft — at f/16 — 64ft

20ft

13.55ft — at f/16 — ∞

Focus on hyperfocal distance (27.1ft away)

Setting up your DSLR

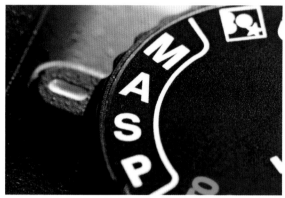

1 Set the focal length
Choose the focal length you want to use, then set your camera on a tripod and compose the image in the viewfinder. Take care to get the horizon straight.

2 Select the mode
Set the camera's exposure mode to aperture priority (A or Av). This will allow you to control aperture while the camera selects the shutter speed.

3 Calculate the distance
Decide on the nearest object you want to appear sharp in the image, and calculate its distance from the camera by focusing on it. Now look at the focus distance scale on the lens, where the focus distance can be viewed in metres and feet.

4 Choose your aperture
Using a hyperfocal distance chart, find the aperture at which both the closest object and infinity fall within the zone of acceptable sharpness and, therefore, will appear in focus.

ISO SETTINGS
When shooting landscapes, it is common practice to set the lowest ISO value possible. This will provide you with the best image quality and the smallest amount of noise with your DSLR. The impact of this will be slow shutter speeds, especially when coupled with the narrow apertures required for a larger depth of field. However, having your DSLR set on a tripod and using a cable release will allow you to shoot this way. If you're working in RAW, turn off long-exposure noise reduction in your camera's menu. It is better to correct it manually later in editing software.

Wide-aperture landscapes

Long summer days mean more shooting time. And with many of us on our holidays in beautiful locations, it's the perfect chance to take some landscape shots. So, whether you're off to far-flung exotic beaches or travelling just a short distance from home, there will always be photo opportunities waiting to be found. And here we're going to show you how to find creative landscape images that break away from the normal conventions.

LEARN THE RULES

Landscape photography is one of the most popular options for beginners and experts alike. You can't beat a well-composed image of a scene shot under dramatic light conditions. The classic landscape shot will always be popular. It traditionally works along the principle that the entire scene is in sharp focus, thanks to shooting with camera settings that create a large depth of field. A shallow depth of field will produce a narrow band of focus, while in a landscape photo a large depth of field will render everything from the front of the scene all the way to the back perfectly sharp.

BREAK THE RULES

We're going to turn this notion completely on its head by shooting landscapes that have a shallow depth of field. The idea here is that you find an interesting object to focus on in the foreground, and by using the right camera settings the background will fall out of focus. But rather than becoming an unimportant part of the image, the out-of-focus background should remain recognizable to give the foreground object context. This ultimately means the background is just as important as the foreground, despite being out of focus.

Even with this type of landscape photography, composition remains an important consideration, and for this technique we'll be focusing on two devices – the rule of thirds and foreground interest. Foreground interest is an object that's placed in the foreground to fill empty space, and, more importantly, act as a visual stepping stone into the image. This needs to be relevant to the scene, like the stack of rocks in the beach image opposite.

CHOOSING THE RIGHT SUBJECT

The great thing about this technique is that it forces you to think differently. But more importantly, it opens up more shooting potential because you can take shots in locations you wouldn't normally expect. When considering a location, you need one where there's a strong subject in the foreground, such as rocks or flowers. You then need a pleasing background that relates in some way to the object in the foreground – like our beach shot.

1 Perfect all-round exposures

Your camera's metering system will ensure most of your shots are exposed correctly. However, if the exposure is slightly off, adjust exposure compensation to brighten or darken the shot.

2 Pleasing subject

When considering your focal point, or main subject, don't settle for any old thing. Make sure the object is relevant to the location and that the background itself remains recognizable. This will provide context, and together these elements will tell a story.

3 A defocused background

The defocused background helps to emphasize the subject because it contrasts with the crisp edges of the in-focus area of the shot. This was achieved using a wide aperture.

4 Successful use of composition

By using the rule of thirds to position all of the elements of the scene, we've maintained visual balance. The rock stack sits on the bottom-right power point, while the defocused pier building sits on the top-left point to create a kind of symmetry in the shot.

Using Live View to focus and compose is useful when shooting at awkward angles such as from ground level.

CAPTURING A SENSE OF PLACE

Sharpness, or even a lack of it, is the key to a successful photo. And with this technique we'll be taking advantage of both, aiming for a pin-sharp subject set against a background that's out of focus. This isn't the most common way of approaching landscapes, but that's part of what makes it so appealing.

Landscape photography is all about creating a sense of place. So the challenge with this technique is finding a distinctive location that has foreground interest opportunities and a background that relates to it in some way. Even though the background will be dropped out of focus, it will remain recognizable, so it shouldn't be distracting or ugly.

To ensure that the background is out of focus, you'll need to select the most appropriate aperture setting. Aperture priority is the best shooting mode to use because it allows you to control aperture and ISO, while the camera takes care of shutter speed for you. To find out what the best aperture settings are, take a look at the images at the bottom of this page.

Control aperture with your kit lens

Kit lenses are incredibly versatile, thanks to a focal range that allows you to shoot landscapes, portraits and everything in between with a single lens. With these lenses set to anything but 18mm, the widest aperture you can use is f/5.6. This will work perfectly for the technique discussed here, but if you use a narrower aperture such as f/8, f/11, f/16 or f/22, the background will appear too sharp.

Using a prime lens

If you have a prime lens, you'll be able to take advantage of shooting at even wider apertures. An aperture of f/1.8 will produce an ultra-shallow depth of field.

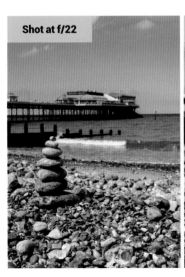

Shot at f/22

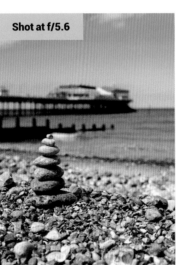

Shot at f/5.6

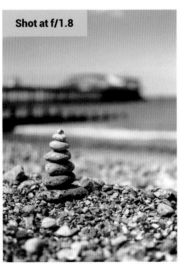

Shot at f/1.8

SET THE RIGHT FOCUS POINT

Your camera has two main autofocus modes that can be used in different situations. One activates all points, and the camera calculates where it thinks the subject is located and focuses on this area. In many situations it works well, but as you'd imagine, it can be hit or miss. The second mode activates a single point, which can be selected using the D-pad on the back of the camera. This option is best for this technique because you can select the focus point closest to the subject. By default, the central point will be selected, so make sure you change it before shooting.

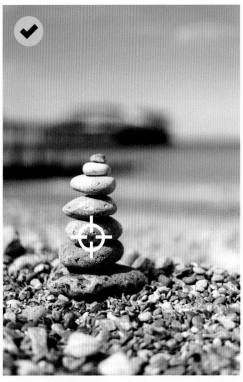

SET YOUR LENS'S FOCAL LENGTH
Most kit lenses provide a focal range of 18–55mm. Set the lens to 35mm, because that produces the perfect field of view for this technique.

Setting up your DSLR

1 Set picture style and quality

Open your camera's menu and set the picture quality to Fine-quality JPEG. Then find the picture style options, and select Standard. Set white balance to Direct Sunlight or Daylight, and flick the autofocus switch on the lens to AF. Also turn on image stabilization if available on your lens. Switch the camera's ISO to the lowest setting of 100 for maximum image quality and least noise. Finally, zoom in to around 35mm, though 55mm may work better for your shot.

2 Select the widest aperture

Turn the mode dial to aperture priority (marked A or Av). Select the camera's widest aperture setting to give the shallowest possible depth of field. On a kit lens, this will be around f/5.6, but if you're using a 50mm prime lens, it will be f/1.8.

3 Enable viewfinder grid

To help you compose your shot, activate the camera's viewfinder grid, which splits the frame into nine equally sized rectangles. This will make it easier to adhere to the rule of thirds. Not all models offer this option, so check your manual if you're not sure.

4 Choose the metering mode

Most DSLRs have several metering modes to choose from. For this, use matrix/evaluative metering. This will give a balanced exposure based on light from the whole scene but with more emphasis placed on the point of focus.

GEAR UPGRADES FOR WIDE-APERTURE LANDSCAPES

Nikon 35mm f/1.8G DX

Designed specifically for DX-format cameras, this 35mm (50mm-equivalent) wide-aperture prime can produce a very shallow depth of field. It comes fitted with a Silent Wave Motor (SWM) for fast and quiet focusing.

Manfrotto PIXI tripod

This well-constructed mini tripod is ideal for keeping your camera perfectly still when shooting near ground level. It's strong enough to support a load of up to 1.1kg, so is suitable for an entry-level DSLR with a kit lens or 35mm prime.

Hoya circular polarizer slim filter

Available for lenses with thread sizes ranging from 37–82mm, this thin-profile filter will cut out atmospheric haze, give deeper blue skies and reduce unwanted reflections, without adding a colour tint. A protective hard case is included.

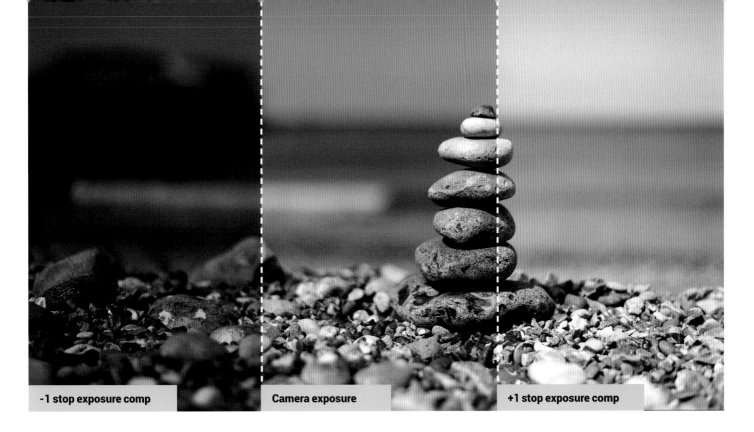

-1 stop exposure comp

Camera exposure

+1 stop exposure comp

TWEAK BRIGHTNESS WITH EXPOSURE COMPENSATION

Most modern cameras are fairly accurate when it comes to intelligently deciding on the correct exposure. But sometimes you'll shoot a scene where the camera doesn't quite get it right, and you'll need to make a small tweak using exposure compensation. This is simply a way of forcing your camera to let in slightly more or slightly less light than it thinks it needs.

The exposure-compensation button is usually situated on the top-plate of the camera next to the shutter button, and it's represented by a small +/- symbol. To adjust exposure comp, compose your shot, then hold in the +/- button while turning the camera's dial. Turn the dial to the right, and as you look through the viewfinder you'll see 0EV change to a positive figure, which means more light is reaching the sensor and the image will be brighter. Turn the dial to the left, and less light will reach the sensor, producing a darker image. Usually, each click on the dial is 1/3 of a stop of light, with the +1, +2 and +3 representing 1, 2 and 3 stops of light respectively. One full stop either way is often more than enough.

Exposure compensation is a quick and easy way to brighten or darken your shots.

ADD A POLARIZER FOR DEEPER SKIES

A polarizing filter is a must-have piece of kit for landscape photographers, because it helps to reduces haze, cuts out unwanted reflections, and produces deeper, more saturated colours. The filter can be rotated to filter two pieces of polarizing glass that can be twisted against each other, filtering out light reflected into the lens from a certain angle. They work best when pointing the camera at 90 degrees to the sun. A decent-quality polarizing filter is relatively inexpensive.

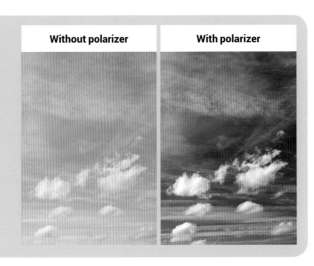

Without polarizer

With polarizer

Running water

Water is a hugely versatile photographic subject. From tiny droplets to vast oceans, it offers unlimited creative potential and plays its part in virtually all natural-world images in some way, shape or form. It's particularly well suited to long-exposure photography, where a shutter speed of 1/30 sec or slower allows you to achieve really creative effects.

PROTECT YOUR LENS

Cascading waterfalls are a classic subject to practise on – the longer the exposure, the more the water appears as a smooth cotton wool-like blur. You could also practise on a running tap and achieve the same effects in the comfort of your own home – it just depends how bad the weather is!

If you opt for an outdoor location, keep safety in mind. Wet rocks are great to photograph but can also be incredibly slippery, so take care, and always wear a sturdy pair of boots if you plan on getting close to the action. Splashing water hitting your lens can be a nuisance, so make sure your lens hood is in place to minimize the spray, and pack a lens cloth to wipe away any drops – the closer you get, the more you'll need to do this. There's nothing worse than droplet residue on your lens ruining your shot.

The best time to shoot water outdoors is just after heavy rainfall, when streams and rivers are high and waterfalls are looking their best. This will give you the perfect subject to work with.

THREE WAYS TO ENSURE YOUR TRIPOD IS STABLE

Extend the upper legs
Start with your tripod at its minimum height (with none of the leg sections extended). If you need extra height, always extend the thicker upper legs nearest the head first, as these are the most stable. Extend the lower leg sections and centre column only if absolutely necessary.

Tighten the knobs
You don't want to spend ages fine-tuning your composition only to let tripod "creep" subtly shift the camera's position and spoil your shot. Make sure the tripod plate is firmly attached before mounting the camera, and always tighten the knobs on the tripod head.

Get your camera level
Many tripods feature built-in spirit levels that allow you to check the horizon is level. Failing that, you could buy a hot-shoe spirit level or use your camera's Virtual Horizon feature, which can be found in Live View mode. Just make sure you check before pressing the shutter – there's nothing worse than a wonky horizon.

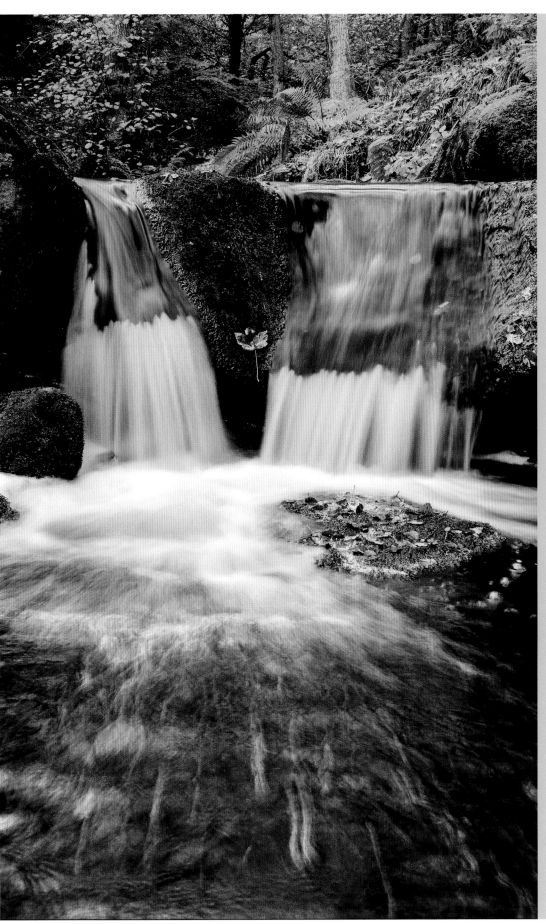

1 Long exposure

When getting creative with shutter speeds, you're moving beyond simply recording what's in front of you. The longer the exposure, the more movement you'll capture (this will vary according to the speed at which the water flows), so you'll need a shutter speed of 1/30sec or slower to create the blur effect you're after.

2 Composition

We left plenty of space at the bottom of the frame to allow the blurred water to radiate toward the viewer. This adds depth to the image by giving the flowing water somewhere to move from and to.

3 Static objects

We included some colourful leaves on a rock at the foot of the waterfall to ground the shot and to emphasize the water's movement. This is an important pictorial element, so look for suitable static subjects, even if it's just the kitchen tap! Don't be afraid to add a static object if a natural one isn't obvious – this is a trick that many professionals employ!

RUNNING WATER

USING SHUTTER SPEED FOR CREATIVE BLUR

Composition is the glue that holds an image together. Whether you're using the rule of thirds, lead-in lines, foreground interest or breaking the rules with a centrally positioned subject, composition is always at the heart of a photo.

Composing shots of moving water follows the same traditional conventions of any landscape image, so use the rule of thirds as a guide and try to incorporate other devices if the scene allows for it. Remember that for the rule of thirds to work you have to imagine the viewfinder is split into nine equally sized rectangles by two vertical and two horizontal lines. The subject should be placed on one of the four points where these imaginary lines would intersect.

The ideal visual elements to place at these points are solid objects like rocks or trees. Having pin-sharp elements such as these in the photo helps to emphasize movement as the water blurs past, but most importantly it helps to anchor the shot to reality by showing sharpness in the scene. Focusing only on water and allowing it to blur would result in an abstract photo, and that's not what we're aiming for.

With composition under control, exposure is the next key element of taking a long-exposure water shot. ISO and aperture are important, but shutter speed really determines the success of the shot. Using ISO and aperture effectively will help you get the right shutter speed for the job.

- Ideally, you should use a cable release to avoid touching the camera during exposures and causing camera shake. If you don't have a cable release, use the self-timer function set to a 2-second delay.

- Set up the tripod using the thicker legs at the top before using the thinner legs at the bottom. This will ensure the tripod is as solid as possible.

- When photographing waterfalls, it's always best to go out with a friend. It's obviously dangerous to be shooting in wet and slippery places, so take someone with you for safety.

- Position yourself at the water's edge to avoid capturing grass at the edge of the frame. If the water is shallow, you could even wade in. Just make sure the tripod isn't in a position where it could be swept over.

1/250sec: Almost frozen solid
At shutter speeds of 1/250sec and faster, water is frozen and individual droplets can be seen. For flowing water such as waterfalls, however, this doesn't provide the most aesthetically pleasing results.

1/60sec: How your eye would see it
With the shutter speed set to around 1/60sec the camera captures flowing water in a way that's considered close to how the eye perceives movement. This is usually the fastest shutter speed used for flowing water.

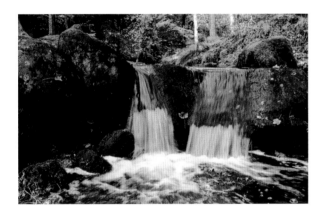

1/15sec: Just starting to blur
As soon as you drop the shutter speed to below 1/30sec, water takes on a more blurred appearance, but texture remains on the surface. A setting of 1/15sec is an achievable shutter speed without using filters to reduce exposure.

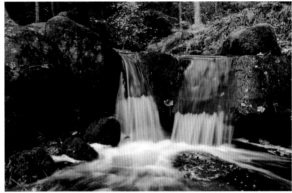

1/2sec: Really blurry for ethereal results
Shooting at shutter speeds of half a second or slower produces beautifully blurred results. To achieve milky smooth water, you have to shoot at shutter speeds slower than 1 second.

WATCH THE HIGHLIGHTS

One of the biggest problems you'll encounter when shooting waterfalls is highlight burnout. It mostly occurs at the point where the falling water churns in the pool below, and the result is pure white highlights showing no detail. For long, exposure water photography, this is a cardinal sin, and should be avoided at all costs. Check results on the LCD, and use highlight warning if your camera has the function. If highlights are blowing out, use exposure compensation.

Correct exposure

Overexposed

Setting up your DSLR

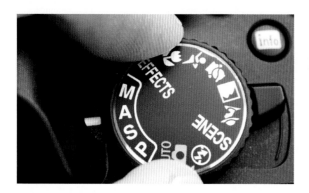

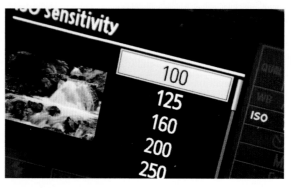

1 Set the aperture

With your camera set securely on a tripod, switch to aperture-priority mode, marked A or Av on the mode dial. Now change the aperture to the largest f/number available, which on most lenses is around f/22–f/32. This will allow you to achieve the slowest possible shutter speed for the available light. If you would prefer a faster shutter speed, increase the size of the aperture.

2 Select a low ISO

When shooting moving water, a very slow shutter speed is only possible using a low ISO, even if you're shooting with the smallest aperture. A setting of ISO 100 is the best place to start, this is where images have the best quality and the least digital noise. The method for changing the ISO varies from camera to camera, so check your manual for instructions.

THE RIGHT SETTINGS FOR CREATIVE BLUR

The aperture is an adjustable opening inside the lens that allows light into the camera and on to the sensor. The smaller the aperture, the less light can pass through, which means you can have a slower shutter speed to achieve the right exposure. In other words, a big opening for a short time can give the same exposure as a small hole open for a long time.

In this case, we want a slow shutter speed, so we'll need to use the smallest aperture (largest f/number) available, since this lets the minimum amount of light possible into the lens and requires the shutter to be open for longer to achieve a balanced exposure.

USE ND FILTERS FOR LONG SHUTTER SPEEDS

Using the smallest available aperture and the lowest possible ISO will give the slowest shutter speed your camera is capable of in a given situation. But on a bright day, the slowest shutter speed you can achieve might only be 1/20sec, which isn't slow enough to give you the blurred effect you want. Unfortunately, without any extra kit your camera is simply incapable of letting in less light. However, for a few pounds you can buy a neutral-density (ND) filter.

This is effectively a piece of tinted glass that screws on to the end of the lens to limit how much light can enter. This means you'll need a slower shutter speed with the filter on to get the same exposure as when it's off. ND filters come in a range of strengths to block the light to varying degrees.

No ND filter **With ND filter**

Both these images are exposed correctly, but one has a much slower shutter speed. This is because we used a neutral-density (ND) filter, which significantly limited the amount of light coming in and so required a longer exposure.

CUT REFLECTIONS WITH A POLARIZING FILTER

Photographing water can be difficult because the surface is so reflective. This can stop the camera being able to "see" what's beneath the surface of the water, even if it's completely transparent. The only way around this is to use a circular polarizer. Like ND filters, most polarizers screw on to the end of the lens and can be used in conjunction with other filters. The filter, which consists of two pieces of glass, limits the amount of reflected sunlight reading the camera's sensor from a specific angle. Twisting the polorizer changes that angle. With your camera set up, adjust the filter until the reflection on top of the water disappears. You may even be able to see right to the bottom of the water.

Because polarizing filters limit the light from some angles, you will lose about 2 to 3 stops of light, so you'll have a slower shutter speed to achieve the same exposure. This means a polarizer could be used in place of an ND filter if you need a slower shutter speed.

In the foreground, the water's surface has very few reflections with the polarizer on, allowing the camera to record the light from the stream bed.

USE MANUAL FOCUSING

These days, autofocus is fast and accurate enough for most subjects. But when using a tripod, switching to manual focus is a great way to ensure your subject is absolutely pin-sharp. Activate Live View, so you can see your scene on the rear LCD. Use the zoom buttons on the camera body (marked by + and -) to magnify the image by 5x or 10x, and then navigate around the frame with the D-pad until you can see your subject. Next, change the lens to manual focus using the switch on the lens barrel, and rotate the focus ring until the subject is perfectly sharp. Because the image is so magnified, it should be easy to see the subject in fine detail and achieve very precise focus. Note that if you're using an ND filter, you may have to focus the image before you attach the filter to the lens, depending on filter density.

Urban landscapes

For successful urban landscape photography, and indeed landscapes generally, there are a few key skills that will guarantee technical success with your shots every time. The aim with this genre is to maximize depth of field with correct focusing and the use of an appropriate aperture setting. However, a side effect of achieving this when shooting at low ISO settings such as 100 is a drop in shutter speed that can cause camera shake. This is what we'll be looking at in our basic introduction, with a review of using different shutter speeds for creative blur.

USEFUL ACCESSORIES

A polarizing filter is a good option for urban shots. It can be used to bring out the blue of the sky and/or eliminate reflections from glass and water. It blocks around 1.5 stops of light, so your exposures will be affected by using one, but this is all taken care of by your in-camera metering system.

A narrow aperture has produced a large depth of field, which has ensured everything in the image from the extreme foreground to distant background, appears sharp.

CHOOSE YOUR LOCATION

Location is an important consideration for all genres, but for the urban landscape it can be everything. Look for subjects where shape and colour can be used to create interesting compositions.

To push these elements further, you can shoot at night to emphasize architectural lighting and colour, which is exactly what we did with this simple shot (top right). It works because of the strong form of the building and is brought to life by the coloured lights and the dramatic sky in the background.

For the shot of the escalator (right), the escalators provide strong lead-in lines that draw the eye from the dark foreground to the purposefully overexposed background. The shot was taken at a slight angle to add an element of dynamism.

Above right If your lens has image stabilization, it can be invaluable for taking low light shots. Take care when shooting at night. Wear light coloured or preferably reflective clothing to make you stand out.

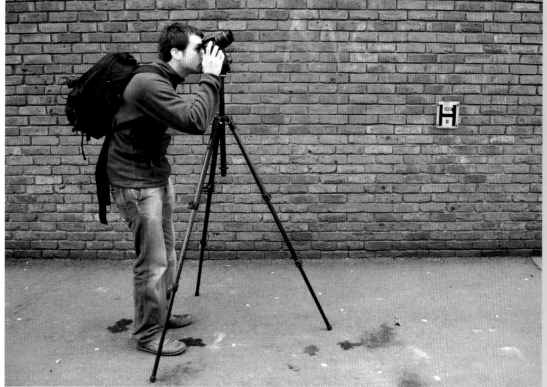

- Focus a third of the way into the scene and set an aperture between f/11 and f/22 to maximize depth of field.

- Using a tripod and cable release will allow you to take shots at slow shutter speeds with narrow aperture settings.

- At some locations, the use of tripods is prohibited or only allowed with prior permission. Make sure you check before going out to avoid problems on the shoot.

Setting up your DSLR

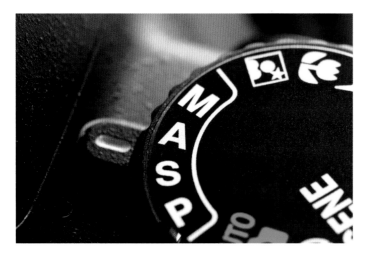

1 Select the mode

Set your DSLR to aperture-priority mode, with aperture set to f/11. In this mode, your DSLR will automatically balance the exposure. Keep an eye on shutter speed in case it drops below 1/60sec, which could allow camera shake to creep into your shots. If you do shoot below this and you have image stabilization, switch it on.

2 Set the ISO

To help your shutter speed remain at or above 1/60sec, set ISO to 400 when handholding. It's always best to use the lowest ISO setting possible, so on bright days you might get away with ISO 100. If you're using a tripod, you can select slower shutter speeds. Our settings on the day were ISO 400, 1/60sec at f/11, with a polarizing filter to help saturate the blue sky.

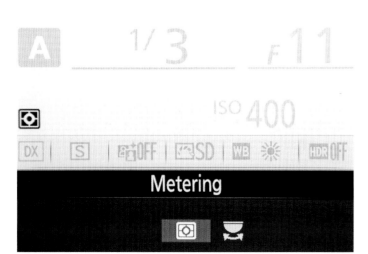

3 Choose the metering mode

When shooting scenes with light and dark areas, such as sky, reflective surfaces and shadows, obtaining a reliable meter reading can be difficult if using the incorrect metering mode. The best metering mode to use in this kind of situation is evaluative/matrix, which uses light readings from different parts of the scene to calculate a rounded exposure.

4 Select focus point

Set focus mode to single point AF and use the D-pad to choose an appropriate point. This should be one third of the way into the image for front-to-back sharpness. Choose a narrow aperture of around f/16, which will produce a large depth of field, ideal for this type of shot.

PERFECT YOUR COMPOSITION

Your viewpoint, or where you position yourself to take a shot, is a make-or-break factor that deserves some consideration. All three examples below are composed to conform to the rule of thirds, but it's the image with the lowest and most angled viewpoint that's the strongest. This is because the other two lack the strong lead-in lines and compositional balance of this shot.

Our best shot (top) was taken 10 minutes after the first two. If possible you should go back and reshoot if you're not happy with what you've got.

Traffic trails

Once the sun goes down, roads become the perfect locations for eye-catching low-light images, or traffic trails. And while these impressive rivers of light may look like the end result of a serious Photoshop session, they are actually surprisingly simple to create in-camera.

To expose an image in low light, we usually need to use a much slower shutter speed than we would in the daytime. During this long exposure, any moving lights will create bright streaks that cut through the dark. Normally we'd try to expose for highlights to avoid "burning out" areas of our photo, but in this type of shot, strong highlights are exactly what we're looking for.

CHOOSE THE RIGHT LOCATION

For the most dramatic photos, you will need to find a location with a constant flow of traffic. A main road with a bridge over it is a great choice, because the moving cars will be relatively reliable, and shooting from the elevated position will provide the ideal viewpoint.

There are some golden rules for working near roads. Never set up too close to the road's edge, and never use flash, since both of these things can distract drivers and increase the risk of an accident. A high-visibility jacket will make other road users aware of your presence too.

With the long shutter speeds needed for light-trail images, stability is key for sharp shots. A tripod is essential, while using the self-timer or a shutter-release cable can help prevent camera shake caused by pressing the shutter.

Shoot too early and you won't capture traffic trails.

Time it right and shutter speeds will be much longer.

It's best to set up the camera and compose the shot in daylight, so arrive at your location at least half an hour before sunset so you can be ready before it gets dark. Take a torch, though, so you can check settings after the sun sets.

TAKE YOUR SHOTS AT THE RIGHT TIME

For the best traffic trails, you need to be ready and in position to start shooting at twilight. This is the period just after the sun has disappeared beneath the horizon. At this time it's dark enough for car lights to really stand out, but there's still plenty of colour left in the sky. Start shooting too early, and you'll struggle to achieve the slow shutter speeds needed for trails. Shoot too late and you'll miss the deep blue twilight skies that act as the perfect traffic-trail canvas. Any streetlights will now also have turned on, improving your image's ambience and enabling you to turn these static lights into twinkling starbursts.

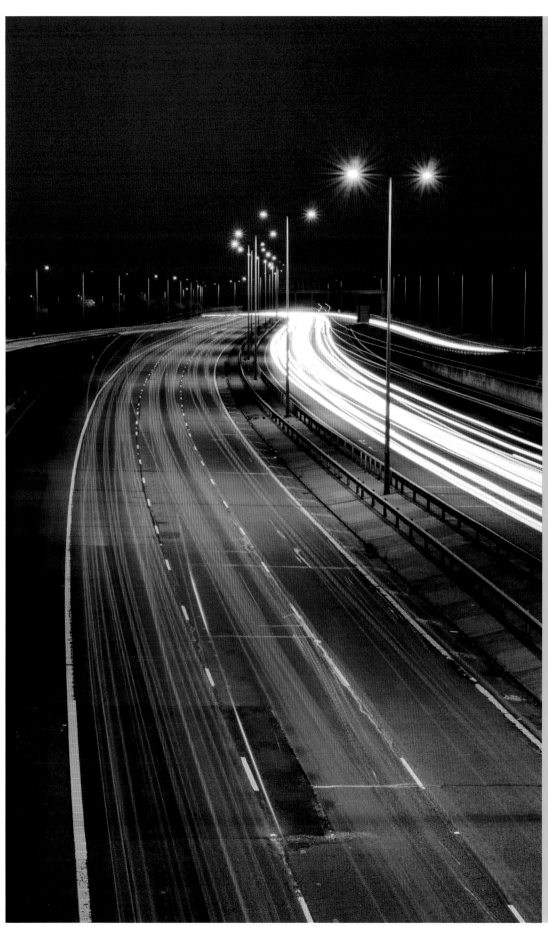

1 Complete traffic trails
A slow shutter speed is essential to this technique – here a 30-second exposure ensures uninterrupted streaks.

2 Narrow aperture
An aperture of f/22 results in front-to-back sharpness, as well as starbursts in the streetlights. This really brings our traffic trail to life.

3 Strong composition
Lead-in lines, the rule of thirds, a level horizon and an interesting angle have combined to produce a dynamic photo.

4 Perfect overall exposure
Using aperture-priority mode and a touch of exposure compensation ensures a well-exposed image.

TRAFFIC TRAILS

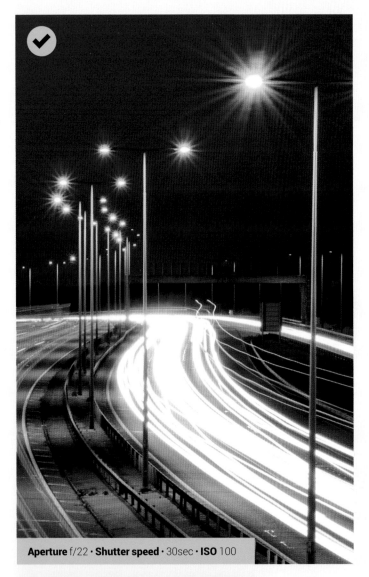

Aperture f/22 · **Shutter speed** · 30sec · **ISO** 100

CREATING STARBURSTS

For the most impressive results, use the slowest possible shutter speed your camera will allow. The longer your shutter is open, the more cars will be able to move through the frame during the exposure. To achieve a slow shutter speed, select a narrow aperture (large f/number) to limit the amount of light passing through the lens, forcing a much longer exposure time. On most kit lenses, the minimum aperture is f/22, making this the best setting to use.

You'll also need to set your ISO to the lowest possible value (usually 100), which is where your camera's sensor is least sensitive to light. Again, this will help you to achieve a long exposure and give you optimal image quality with minimal digital noise.

As well as producing slow shutter speeds, a narrow aperture brings with it other advantages, including a very large depth of field, so everything in the scene appears sharp. You'll want this when shooting urban or rural landscapes with wide-angle lenses. In addition, a narrow aperture causes bright points of stationary light, such as streetlights, to take on a starburst appearance. The number of rays coming from the starburst will depend on how many diaphragm blades there are inside your lens.

If the road has streetlights, you may notice your images have an orange cast, since the light they emit is not pure white. To compensate for this, simply set your camera's white balance to Incandescent or Tungsten. Your shot will now have a cooler, more natural-looking hue.

KEEP YOUR CAMERA STILL
Even when mounted on a tripod, your camera can still shake in strong winds, so stand upwind of the camera to shield it from any strong gusts.

Aperture f/8 · **Shutter speed** 2sec · **ISO** 100

ADJUST EXPOSURE COMPENSATION

Metering for traffic trails can be a difficult job for your camera, since some parts of the scene are extremely dark, while other parts are very bright. For this reason, don't be surprised if it doesn't always get the exposure exactly right. Luckily, it's quick and easy to make adjustments using your camera's exposure-compensation function. Simply press the button marked with a +/- symbol while turning the finger dial. If you move the dial to the right, you'll notice the exposure value (EV) is positive, which makes the image brighter. If you scroll to the left, the exposure value becomes negative, making the image darker. You will probably have to adjust exposure to a minus figure, though this will depend on the scene.

FOCUS ACCURATELY

Ensuring your image is focused correctly can be difficult in the dark, because your camera's AF system is less effective in low light. For this reason try to be on location half an hour before it begins to get dark. This will allow you to both focus and compose your shot in daylight, before it's time to start shooting.

For a large depth of field, focus one third of the way into the scene. To do this, select single-point autofocus (AF-S), then set the active focus point to one that covers the right part of the viewfinder. Once focused, set the camera to manual focus and leave it there.

Focus one third of the way into the scene for front-to-back sharpness.

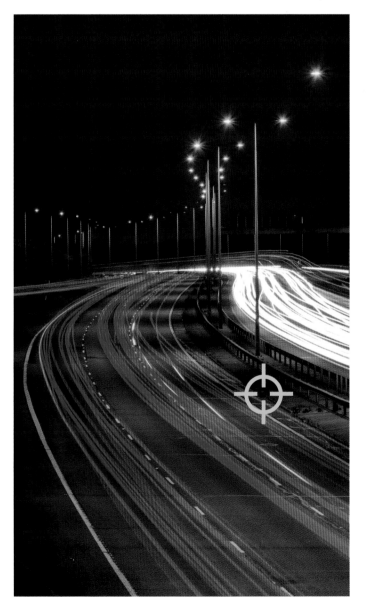

Left Exposure comp allows you to fine-tune how bright or dark your scene appears.

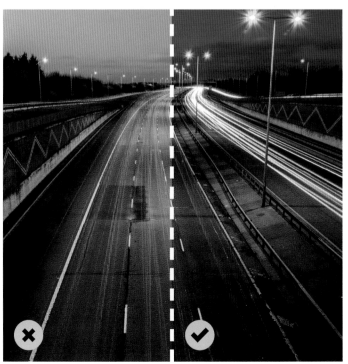

PERFECT YOUR COMPOSITION

To shoot the strongest image, remember to follow the rules discussed on pages 30–35. Imagine your frame is divided into nine even rectangles. Position the horizon of your scene along the top horizontal line, with the sky occupying the top third of the image. It's always best to position yourself above the tail lights because they are less bright than headlights, so they need to be directly in front of the lens. With this type of shot, it's essential to have a level horizon. A wonky horizon will look like an accident rather than a well-considered shot.

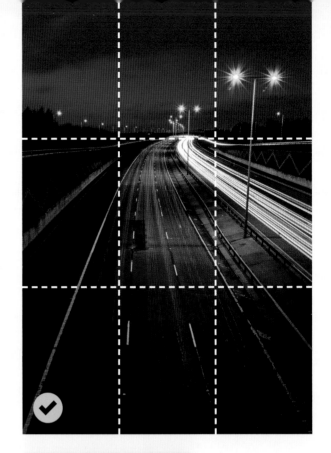

COVER THE EYEPIECE

When shooting traffic trails, the shutter will be open for a long time, which means there's an increased chance of light entering the viewfinder – especially when cars with bright headlights are using a road behind you. This light can, believe it or not, find its way to the sensor to create bright hazy streaks in your images. To avoid this, either use the eyepiece cover that came with your camera, or drape a glove over the viewfinder when shooting. This will stop stray light entering your image.

Avoid placing the horizon in the centre of the image.

Headlights from passing cars have caused light to enter the viewfinder and leak on to the sensor (far left). To avoid leaking light, cover the eyepiece.

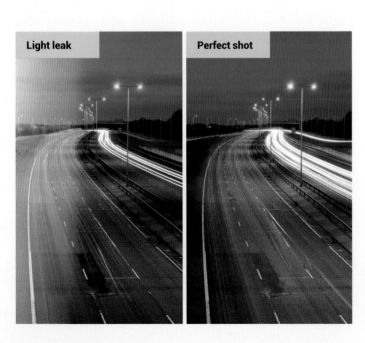

Light leak

Perfect shot

Setting up your DSLR

1 Set quality and WB

To get started, set white balance to auto. This is because there will be mixed light sources in the scene. In the camera's shooting menu, set your images to record Fine-quality JPEGs. Next, set picture style to Vivid. Your camera will now process your files with a higher contrast and saturation level than Standard, making it perfect for traffic trails. Depending on traffic volume, you'll need an exposure between 5 and 30 seconds, so set aperture to f/22 to help facilitate this. A narrow aperture will also help you to achieve a large depth of field, which is essential.

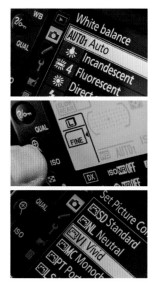
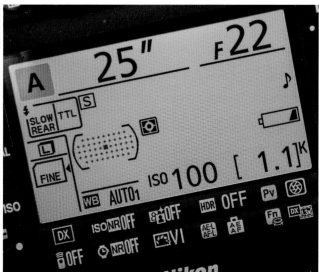

2 Set the ISO

For the best image quality and to make the camera sensor the least sensitive to light, set ISO to 100. In conjunction with an aperture of f/22, this will help you to achieve a slow shutter speed once light levels have dropped enough to begin shooting.

3 Set the focus

Autofocus one third of the distance into the scene while it's still light. Now switch the camera to manual focus to lock focus at this point. If you don't, the camera will refocus every time you take a shot, and when it gets dark the camera could struggle with focusing.

4 Select the self-timer

If you have a cable release, use this to release the shutter without touching the camera. If you don't have one, set the camera to self-timer mode. When you press the shutter button, there will be a delay before the shutter is released. Set the delay to 2sec.

EXTRA GEAR TO HELP YOU SHOOT TRAFFIC TRAILS

Nikon MC-DC2 remote cord
A cable release makes it possible to activate the shutter without touching the camera. This eliminates the risk of camera shake, giving sharp and blur-free images.

Manfrotto 190XPRO4 tripod and 496RC2 ball head
A sturdy tripod is essential for shooting long exposures. This tripod-and-head set from Manfrotto will provide the stability you need for your camera in a lightweight and portable package.

High-visibility vest
Standing at the roadside when it's dark brings with it obvious dangers. To make yourself as visible as possible to passing motorists, wear a hi-vis vest. They're cheap to buy and will give you added peace of mind when shooting traffic trails.

Graphic architecture

Architectural photography has become increasingly popular in recent years, and for good reason. It's an amazing subject that's easily accessible for most people. In the right conditions you can shoot images any professional photographer would be proud of.

Modern architecture can be found in the majority of towns and cities. The number of buildings often depends on the size of the town, but with office blocks, bus stations and even shopping centres being revamped continually, it's easy to find a suitable subject. Buildings featuring glass fronts and made up of lines and simple shapes always photograph well, especially when you find a dynamic angle to shoot from.

The key to success is seeing buildings as a collection of individual parts. Focus on smaller areas of interest for more abstract results. Trying to incorporate an entire building into the shot means capturing the surrounding environment, which may not work photographically. Using light, shape and form works well for black-and-white architecture photography, which is how we'll be shooting in this section.

There's a great deal of debate about what you can and can't photograph in the street. And the reality is that if you're on public land, you can legally shoot privately owned buildings. If you happen to stray on to private land, this is the only time a security guard can ask you not to take photos.

Shooting handheld is the best option for architecture in the middle of the day. Being free from the restrictions of a tripod means you can experiment with viewpoint to find the most interesting angles.

Without any detail in the sky (left), this amazing building looks surprisingly dull.

TAKE YOUR SHOTS AT THE RIGHT TIME

If you're shooting colour images, the best time to shoot architecture, like landscapes, is around sunrise and sunset. However, for black-and-white architecture you can shoot at any time of the day. Bright sunny days with cloudy skies are ideal. Exposing for highly reflective buildings in these light conditions often means the sky will underexpose and be reproduced darker than usual. The result is a graphic and high-contrast image where blue becomes almost black. If there's too much cloud in the sky, the results will be flat and boring, so it's always best to wait for a break in the clouds.

1 Front-to-back sharpness
Shooting at f/11 produces sharp images with a large depth of field. You'll often be able to work handheld with this setting.

2 A strong composition
The rule of thirds gives the shot balance, while the rows of discs create lead-in lines to draw the eye through the shot.

3 Cloud detail in the sky
Clear blue and overcast skies can appear dull. It's best to shoot on days when there's cloud detail in the sky.

4 Well-exposed sky and subject
Exposing for a reflective building in bright conditions means the sky will underexpose – ideal for mono.

GRAPHIC ARCHITECTURE

PERFECT YOUR COMPOSITION

To achieve the strongest image, remember the compositional devices discussed on pages 30–33. Use the camera's viewfinder grid to help you compose your shot. Avoid filling too much of the frame with your chosen structure, and imagine its divided into nine even rectangles. Position the structure so that it fills roughly two thirds of your frame and the sky one third for a balanced result. Finding an interesting angle will result in more exciting shots. Achieving a level horizon isn't essential, especially when shooting modern buildings. Try to work with the patterns found in the structure when deciding your image's composition. A strong line can draw a viewer into and through your shot.

USING EXPOSURE CONTROLS

Setting up a tripod in the tight confines of an urban location isn't always possible, especially if you're standing on a pavement or walkway where you could be causing an obstruction. For this reason, architectural photography is usually done handheld, allowing you to compose your image, tweak your settings and get your shot in a few seconds. But without a tripod, it's important to achieve a relatively fast shutter speed to eliminate the risk of camera shake. As a general rule, 1/160sec or faster should be fine – any slower than this and you risk unwanted blur. However, if your lens has image stabilization, which most kit lenses do, you should be able to get sharp handheld shots at shutter speeds as slow as 1/15sec.

But it's not just shutter speed that ensures pin-sharp results. The aperture you choose also has a big impact. This is because wide apertures (small f/numbers) mean a shallow depth of field where the depth of in-focus areas is very shallow. Shoot an architectural image at f/3.5, and you'll probably notice your foreground isn't sharp. At the other end of the scale, a very narrow aperture (large f/number) gives a much

Above Use the camera's viewfinder grid to help compose your shot.

Left Avoid filling too much of the frame with your chosen structure.

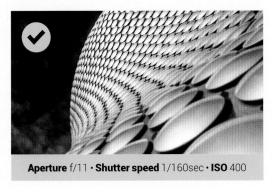

Aperture f/11 · **Shutter speed** 1/160sec · **ISO** 400

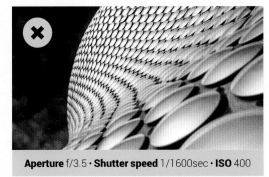

Aperture f/3.5 · **Shutter speed** 1/1600sec · **ISO** 400

Above left A shutter speed of 1/160sec or faster should be enough to eliminate camera shake.

Above middle and right A narrow aperture means a large depth of field, enabling you to achieve front-to-back sharpness.

Right and below The exposure-compensation function allows you to tweak the overall exposure of your image should your camera not get it quite right.

larger depth of field, though a lens's image quality won't be so good. A mid-range aperture of f/11 will give us a large enough depth of field so that everything is in focus, and optically it's where the lens performs best. Compose your image at your lens's longest focal length, usually around 18mm, in order to give you the largest possible field of view.

Adjust exposure compensation

Getting an even all-round exposure can be tricky in architectural photography, since very reflective building surfaces – such as the one in the image to the right – mean your camera may not always guess at exactly the right setting. Luckily, it's easy to tweak how bright or dark your image appears using your camera's exposure compensation, which is represented by the +/- button on your camera. Simply press and hold while turning the thumb dial and watching the LCD. A plus figure (+) will allow more light down the lens and give you a more brightly exposed image, and a minus figure (-) will produce a darker image. A good tip is to expose for the highlights in your shot, because ideally you don't want any areas to burn out.

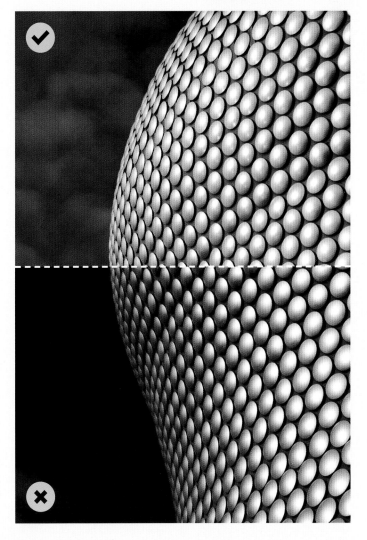

FOCUS FOR SHARPNESS

For most architectural photography, you'll want to achieve front-to-back sharpness so that the entire building is in focus. To do this, autofocus roughly one third of the distance up the building from the place you're standing. Set your camera to single-point AF, since this will allow you to choose your point of focus more accurately, and then look through the viewfinder so you can select the point you want. The method for doing this varies between cameras, so if you're unclear on AF mode selection, check your instruction manual before heading out to shoot.

Use autofocus

In normal daytime conditions, your camera's autofocus is by far the fastest focusing method available to you, and it's very accurate on modern digital cameras, so you should use it. Turn it on by flicking the autofocus on the side of the lens. Some cameras also have an AF switch on the body, so turn it on here too.

IMAGE STABILIZATION

Unwanted blur can be created in images by tiny camera movements during an exposure. This is known as camera shake. With shutter speeds over 1/125sec, blur can be avoided, but achieving these often requires the use of higher ISOs that reduce image quality. The easiest way to help minimize the presence of camera shake is to turn on any available image stabilization. This usually comes in two forms – in-lens optical stabilization or in-body sensor shift stabilization. Both of these systems compensate for small camera movements, enabling the use of slower shutter speeds.

Right Focus one third of the distance into the scene to help maximize depth of field.

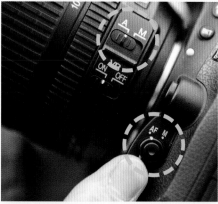

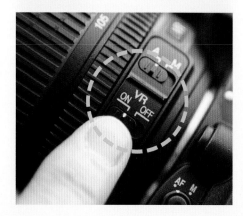

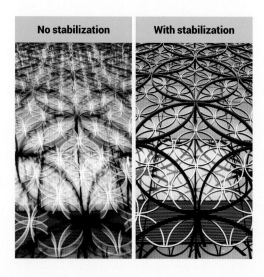

No stabilization With stabilization

By turning on image stabilization, we were able to take the same image with much less camera shake.

Setting up your DSLR

1 Set quality and WB

To get started, set your images to record as Fine-quality JPEGs. Next go to the custom setting menu and set the picture style to Monochrome. Your camera will now process and preview your files in black and white. Turn on your camera's viewfinder grid display, since this will help you to compose your images. Set the metering mode to evaluative, or matrix. This setting calculates an average exposure based on light and dark areas of a scene for a fairly reliable (but not foolproof) light reading. As we're shooting in monochrome, white balance can be left on any setting.

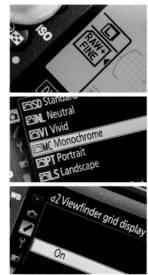
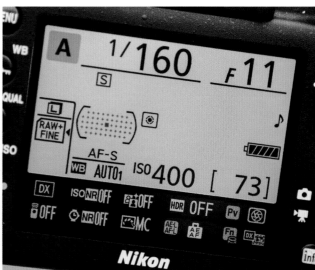

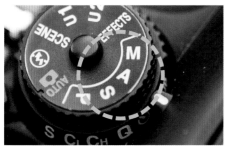

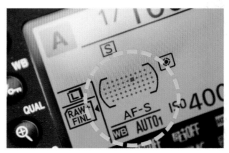

2 Select the mode

Set your camera to aperture-priority mode. In this setting you dictate the aperture used, while the camera automatically selects the shutter speed required for a well-exposed image. Set your aperture to f/11 for a large depth of field.

3 Set the ISO

Use the lowest ISO level possible that will allow you achieve a shutter speed of 1/125sec or faster. In bright conditions, ISO 100 will ensure optimum image quality, but don't be afraid to push this level up to ISO 400 on days that are more overcast.

4 Select focus

Set your camera to its single-point AF mode. Select a focus point that suits your composition using the D-pad, and focus one third of the way into your scene. This is one third of the way in distance, and not one third of the way up the frame.

EXTRA GEAR TO HELP YOU SHOOT ARCHITECTURE

Sigma 10–20mm f/4–5.6 wide-angle lens

Wide-angle lenses allow you to get physically closer to your subject and still fit it into your frame, exaggerating perspective for dramatic results.

Tiffen circular polarizing filter

From reducing reflections from office windows, to creating deep blue skies, a polarizing filter offers a whole host of benefits to the architectural photographer. Fitted to the front of a lens, a circular polarizing filter can be rotated to maximize or minimize its effect as desired.

Manfrotto 681B professional monopod

A well-built monopod is much less obtrusive than a tripod and will allow you to create images free of camera shake when using slower shutter speeds. Collapsible to 65cm, the 681B is perfect for traversing city centres while on the hunt for photogenic architecture.

Wildlife

Wildlife is a highly rewarding photographic subject but is often perceived as one of the most difficult genres of photography for beginners. The trickiest part is the unpredictability of animals, although when you're at a zoo it's much easier to anticipate behaviour than in the wild. At a technical level, everything is much simpler, with only a few key techniques required to ensure success. As in most other subjects, exposure controls are what make shots work, so it's these that we'll be looking at for freezing movement and isolating subjects from their backgrounds.

ANIMAL BEHAVIOUR

Part of the art of wildlife photography, whether truly wild or captive, is being patient and knowing when to press the shutter button. In short, you want your animal to be showing some kind of interesting behaviour, or at the very least be in a position where you can avoid a messy background. This means watching your subject carefully. Once you have

a good grasp of how it moves and behaves, then you should follow it with the camera to your eye. Don't spend too long reviewing your photos – you can guarantee this is when it will suddenly do something really interesting and you'll miss your moment. It also pays to spend a considerable time with one group of animals rather than flit from species to species. Remember, a zoo is open every day, so you can come back again. We spent several hours with our lenses trained on the elephants. This gave us the knowledge to start predicting some of their behaviour so we could be in the right position to get some interesting shots.

USEFUL ACCESSORIES
A monopod is the ideal accessory for wildlife. Not only does it provide you with the support you'll need for shooting at long focal lengths and slow shutter speeds, but it's also light and compact – ideal for carrying around a busy zoo all day.

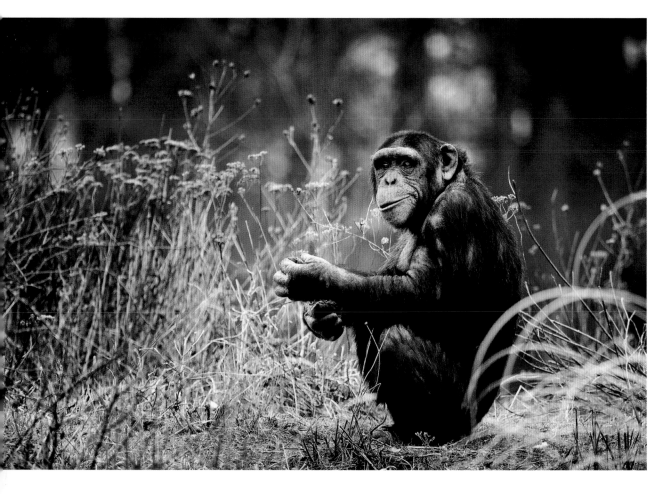

It may look like this chimpanzee is posing for us, but this shot is the result of waiting patiently for the right moment.

Left Here we've captured the moment this elephant has sprayed dust on its back. However, the fence in the background is slightly distracting.

Below The adults completely frame the youngster and obscure the perimeter fence behind.

- There's no getting away from the fact that for most types of wildlife, you're going to need a long zoom of at least 200mm. If you have a 300mm or 400mm lens, even better, but they're not essential for good results.

- Using a tripod is often difficult in busy places like zoos, so a very good alternative is a monopod. This will give you the support you need for shooting with long focal-length lenses.

- Even the most open zoos have obstacles that you'll have to shoot through. See overleaf for all the tips you'll need for shooting through glass and wire.

SHOOTING THROUGH OBSTACLES

One of the main obstacles you'll come across when shooting your images at zoos are the glass and wire barriers between you and the animals. These are rightly in place to protect both the public and the animals, but they can be the last thing you want blocking your lens. Shooting through them successfully is a make-or-break factor that can be the difference between a mediocre shot and one that's outstanding. Fortunately, it is possible for us to shoot through both glass and wire fences in such a way that they practically disappear. Put the following guidelines into practice for obstacle-free zoo photography.

Shooting too far from a fence and capturing its bars results in an unusable image. It is sometimes possible to incorporate enclosures into shots but it doesn't work in this photo.

The backlit fence behind the viewing area has created a large distraction across the entire window.

How to shoot through wire fences

The key to shooting through wire fences is to get up close, with your lens aimed through the centre of one of the gaps. This will knock the wire in front of the lens's out of focus and render them invisible. Make sure you attach a lens hood to protect the front element.

How to shoot through glass

When shooting through glass, the likelihood is that light will also be low, so you might need a monopod and a high ISO setting. Get up close to the glass and use your arm to block reflections if necessary. If reflections are still visible, some black cloth can be draped over the top of the lens hood.

In this shot of a wolf, there's little to give away the fact it was taken through a fence. You may end up with a few patches of low contrast. If this occurs you can correct it in Photoshop.

Shooting fast-moving subjects such as chimpanzees with shutter speeds as low as 1/10sec can be really tricky. Wait for a pause in activity, and then seize the moment. In this image, we were able to eliminate reflections on the glass enclosure.

CHOOSING YOUR EXPOSURE

Correct exposure is achieved using a combination of shutter speed, aperture and ISO. In a zoo situation, you have a number of variables to consider in order to get a correct exposure. For this exercise, we are assuming you are working with a handheld camera or a camera on a monopod. The first thing you need to consider is whether your shutter speed is going to be fast enough to allow you to take a sharp shot. When shooting action subjects handheld, there may be movement in both the subject and camera, so a fast shutter speed is necessary to freeze everything. Camera movement will be further accentuated if you are using the longest focal length you have available, especially if you don't have image stabilization.

Let's assume you are handholding your camera and lens and trying to photograph a moving animal. You have a 70–300mm lens, and it is zoomed out to 300mm. The light isn't very good, so at ISO 100 and with your lens at its widest aperture of f/5.6, you are only getting a shutter speed of 1/60sec. This is just not fast enough. You need to boost that shutter speed to at least 1/500sec. Since you are already working at the maximum aperture (f/5.6), the only option is to boost the ISO.

The final thing you may need to consider is exposure compensation. We discussed this on page 47. As a quick reminder, if you are shooting a dark animal against a similar background, you may need to dial in -1 or -2 stops of underexposure to get the right detail in the animal's face. Do the opposite for a very light-coloured animal. In even light, you may not need any exposure compensation at all, but it's definitely a trick worth having up your sleeve for when the occasion arises.

LENSES FOR WILDLIFE

Realistically, a long telephoto lens is a must for really effective wildlife photographs. In a wild situation, they will help you fill the frame with an animal that won't come close to you or when it's too dangerous or unethical to go near to it. In a zoo, it helps to bridge the gap between your position and that of the animal in its enclosure. However, you don't have to own the big, expensive 600mm lenses used by professionals. Even if your lens only goes up to 200mm, this will allow you to get close enough to capture plenty of interesting subjects. Many zoos have animals roaming free that you can get very close to. Just be patient and respectful when trying to photograph them.

A 70–300mm lens is perfect for general zoo photography. An alternative way of keeping the camera steady is to rest the lens on a beanbag as shown here.

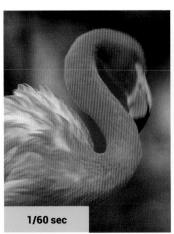
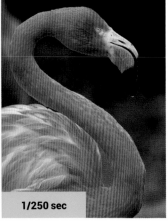

1/60 sec

1/250 sec

Too slow

Take a look at these two shots of a flamingo. With a slow shutter speed of 1/60sec (far left), we've managed to hold the camera reasonably steady by using a monopod as the support. Consequently, the body of the flamingo is sharp. However, animals are rarely still. The bird's head has moved during the exposure, so appears blurred. However, increasing the ISO allows us to shoot with a shutter speed of 1/250sec and get an acceptably sharp photo (left). It's vital that you get this balancing act just right.

1 Background
The dark background is perfect for showing off the mara, but its dominance in the frame had to be considered when making the exposure.

2 Focus
This is on the eye of the animal in the foreground. An aperture of f/5.6 then helps to render both the mara in the distance and the background itself nicely out of focus to add depth to the image.

3 Shooting position
By lying flat to the floor, you can get down to the animal's eye level. This gives us direct contact and adds impact.

4 Backlighting
The direction of light is from slightly behind the animals. This gives a lovely rim-light to the maras' fur, helping to separate them from the background.

BOOSTING ISO

ISO represents the sensitivity of the sensor to light. The lowest and least sensitive setting is usually 100. At the other end of the scale, settings such as 6400 or 12,800 allow you to achieve fast shutter speeds in lower-light situations. The downside is that at higher settings more noise is visible on the photo. Each camera model deals with high-ISO noise with varying degrees of success. Keep your ISO as low as possible for optimum quality, but make sure this isn't at the expense of a sharp shot of your animal.

Image at 200%

FOCUS POINTS AND FOCUS MODES

When shooting wildlife, accurate focusing is crucial, so it's important to understand AF modes. If you're shooting static or slow-moving animals, it's best to have the single focus point closest to the eye active – just like for portraiture. The best focus mode in this situation is single shot. If you're shooting fast-moving animals, it can be helpful to activate all focus points, but doing this means you may not get the eye sharp. It's more difficult to have a single point active, but the results can be significantly better. For moving subjects, you'll need to set the focus mode to continuous, but don't forget to change back to single shot when you've finished.

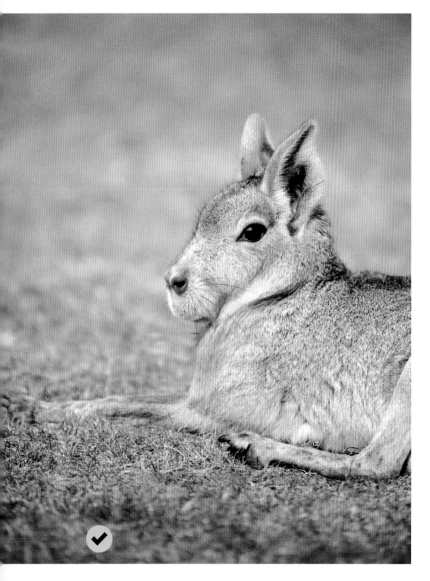

MAKE IT LOOK NATURAL

Isolating subjects from their man-made backgrounds is essential for helping to make zoo animals look like they are in a natural environment. This is achieved by controlling aperture, which determines depth of field. Shooting at wider aperture settings is ideal, since it helps to achieve fast shutter speeds and results in a shallow depth of field. We covered depth-of-field in more detail on page 62. Longer focal lengths magnify background blur, giving the impression of an even shallower depth of field. They also force you to move away from the subject to achieve the correct composition, which creates a "compressed" perspective and usually a more attractive image.

The aperture setting of f/2.8 has produced the ideal amount of subject isolation. If your lens doesn't have this setting, shoot at f/5.6 for best results.

APERTURES FOR DIFFERENT SITUATIONS

The exact aperture you'll need to let the background fall out of focus depends on the subject's distance from it. For animals that are close to their background, as in this picture (left), the best results come from shooting at f/2.8. However, f/5.6 – the maximum on most long zoom lenses – will be adequate.

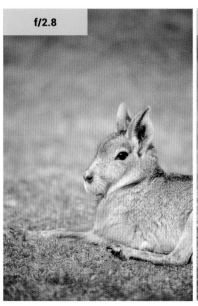

f/2.8

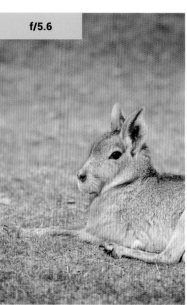

f/5.6

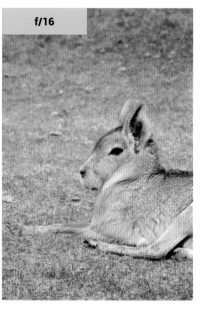

f/16

Shooting at f/2.8 has provided perfect subject isolation, and the results at f/5.6 also help the subject stand out, albeit to a lesser degree. Shooting at f/16 provides too much back-ground sharpness and also means a slow shutter speed.

CREATE A SENSE OF MOTION

Adding a sense of movement to your wildlife images can create dramatic results and offers a solution to some of the problems encountered when photographing captive wildlife. A carefully composed, well-executed photograph that uses the aesthetic effects of blur to capture the essence of motion is one of the most rewarding challenges in wildlife photography. It's also harder to master than you might think.

There's a fine line between an effective motion-blur image and an image that simply looks blurred or out of focus. There must be sufficient blur to create a sense of movement but not so much that the subject becomes unrecognizable. Too little, and the effect will be akin to unsightly camera shake.

MAINTAIN YOUR FOCUS

It's important to remember that although the end result will be a blurred image, the subject must still be in focus. Our preferred technique is to set the camera to continuous AF and to set a focus sensor that targets the animal's eyes.

To secure a shot like this (bottom right), you need to be in control of your shutter speed, so set the camera to shutter priority. While the exact shutter speed will always need to be relative to the subject being photographed, for most mammals an exposure of between 1/20sec and 1/50sec will create the right amount of blur.

If it's a bright day and you're struggling to get a shutter speed slow enough, make sure you've set a low ISO value. If that doesn't help, use a neutral-density filter to reduce the amount of light entering the lens.

With the camera controls set, the technique for creating a sense of motion involves camera panning. This takes some practice, but your persistence will be rewarded with fantastic images.

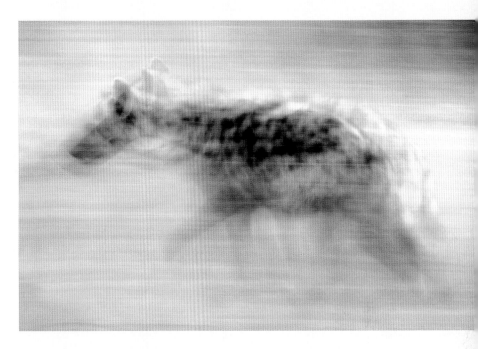

Overdoing the panning effect can render the subject almost unrecognizable. There's a hyena lurking behind this double-exposure/streaked photo. This is usually the result of too slow a shutter speed, so if this happens to you, make the shutter a stop or two faster and try again.

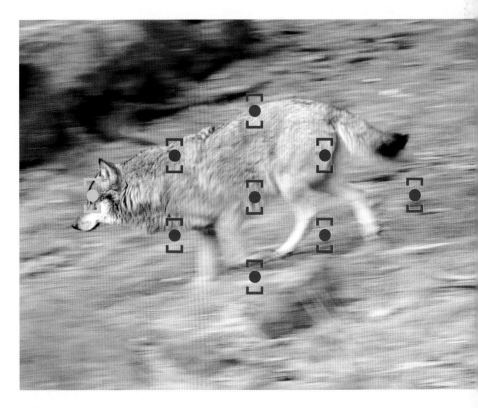

Make just a single focus point active. It should be the one nearest to the animal's eye so this is the sharpest area.

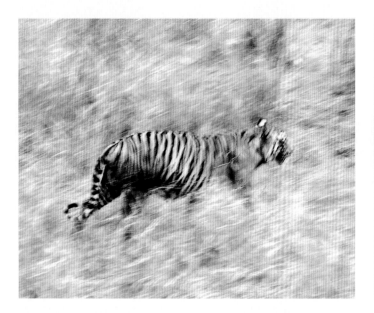

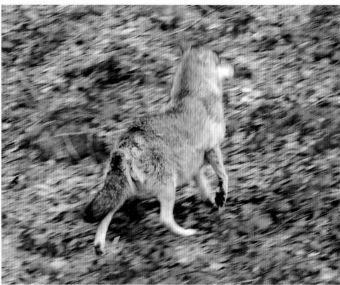

This tiger is moving steadily through the frame, but instead of a left-to-right horizontal pan, the technique here involves a left-to-right diagonal pan. The slight contrast in movement between animal and background helps to create a painterly feel to the image.

If the animal is moving away from you (as wild animals are most likely to do), you'll end up with a rear-end photo like this. Not only is it impossible to pan effectively with the movement, it's also an ineffective shot. So choose your moments to pan carefully.

PANNING WITH YOUR SUBJECT

The basic idea behind panning is to track the subject as it passes from left to right (or vice versa) in front of you and to continue tracking it as you release the shutter.

The most commonly used technique involves panning the camera at the exact same speed at which the subject is moving, effectively keeping the animal in the same position in the viewfinder. Using this approach, the subject will appear sharp against a streaked, blurred background.

For an even more creative effect, a little like an Impressionist painting, try panning the camera slightly faster than the subject is moving. This will create two different blur effects – one the streaking of the background, the other a slower, less pronounced blur in the animal. This effect can also be combined with moving the camera in a different direction to the subject's movement – for example, diagonally down rather than straight across. Each technique will create a slightly different result. It's best to experiment and use the playback image on the LCD to gauge how successful you've been, making any adjustments to shutter speed or panning speed if necessary. Compositionally, the subject's face needs to be visible, so make sure it isn't moving away from you (resulting in what's known as the "bum" shot!)

To make sure you get a smooth blur, keep in one position with your feet still and rotate the top half of your body at the waist as you track your subject. Select a target zone for taking the image (the area in the frame that gives you the best composition) and then, with the camera in continuous shooting mode, start shooting just before the subject reaches this zone. Keep the shutter firing as the animal passes through the target zone and continue panning for a second or two after the last picture is taken.

There is a real skill to successful panning, so it takes practice. Our advice is to head out with your camera, find a moving subject that you can practice on – birds on a pond or cyclists riding past and keep going until you crack it. Then, when the perfect opportunity arrives, you'll have the technique perfected.

Setting up your DSLR

1 Find your subject

For an effective motion-blur shot, you need the subject to be moving quickly and parallel to or diagonally toward the camera (rather than straight toward it). An animal walking won't create the right effect, so wait until you have a running subject.

2 Set shutter speed

Set the camera to shutter priority (S or Tv on the mode dial), and select an initial shutter speed between 1/20sec and 1/50sec. The exact shutter speed for an effective shot will depend on how fast the subject is moving, so take a couple of test shots and adjust the exposure accordingly. If there's too much blur, select a faster shutter speed. Too little? Slow it down.

3 Compose the image

When composing, frame the subject in the centre of the viewfinder and leave an open area around the edges to give the animal room to move within the picture space. Cropping too tightly in-camera is liable to cause the feet, tail, ears or head to disappear out of the frame.

4 Pan the camera

Irrespective of which panning technique you decide to use, make sure you move the camera smoothly through the panning cycle, always keeping an eye on the position of the subject in frame and make any adjustments necessary to keep the subject framed roughly in the centre. You may find it best to set the camera to continuous (multi-frame) shooting mode (3–5 frames per second is sufficient) and to take a series of images beginning just after you start panning, right through until just before you stop.

CAN YOU CAPTION THE SHOT?

When you look through the viewfinder, ask yourself the question, "How do I caption this image?" If the only answer you can think of is the species' name, then you've only captured a record shot. More compelling wildlife images are easy to caption – for example with behavioural information (a wolf displaying submissive body language) or with an amusing or emotional comment. The trick is observation and firing the shutter at the right moment.

Nature close-ups

There are few subjects more captivating than the natural world, especially when photographed very close up. If you've ever tried using your kit lens to capture a very small object, your attempts will probably be frustrated by the fact that it just won't focus close enough to give you an eye-catching result. This is because the minimum focusing distance of standard lenses is around 25cm, from which point a small flower or insect takes up only a tiny proportion of the frame. To get around this, a dedicated macro lens can be used, allowing much closer focusing and a 1:1 magnification ratio. If you don't have one, you can create your own using a reversing ring.

REVERSING RINGS

Reversing rings are used to attach a lens to a DSLR body the other way around. This allows you to use standard lenses to shoot extreme close-ups at a fraction of the cost of buying a dedicated macro lens. The ring attaches to the lens filter thread on one side and has a lens mount on the other side to attach it to your DSLR. You'll lose autofocus and shutter-priority mode, but manual and aperture-priority modes are possible in most cases. Focus is performed by moving the DSLR backward and forward slightly using a "rocking" focus technique (see step 3 opposite).

The best lenses to use with a reversing ring are older manual-focus lenses with an aperture ring, because these allow you to control aperture by hand. But it is also possible to use kit lenses-though with limited functionality. With a modern kit lens, it's best to zoom out to the longest focal length. On some models, including Nikon's, the aperture is by default stopped down to f/22, so depth of field is at its largest. However, some lenses have an aperture lever on the lens mount, allowing you to open the aperture to its widest setting if desired. For other manufacturers, including Canon's, the default aperture diaphragm position is wide open, and this can't be adusted manually.

Reversing rings are simple devices with a screw thread on one side to attach to the front of lenses. On the back there's a lens mount for attaching to DSLRs. Make sure you buy the right size for your lens and DSLR. Focusing technique changes when a lens is attached backward. Sharp focus is achieved by fractionally moving the camera towards and away from the subject.

Using a reversing ring is the cheapest way of getting close to a 1:1 ratio. The downside is that using it is fiddly than a true macro lens.

Setting up your DSLR

1 Reverse your lens

Attach the reversing ring to the filter thread of your kit lens – make sure you buy a ring with the correct thread size. Remove your lens from the camera and attach backward using the lens mount on the back of the ring. Again, make sure this matches your DSLR lens mount. Zoom the lens out to its longest focal length.

2 Open aperture

Move in close to your subject, and if desired, flick and hold the aperture lever on the back of the lens (if available). Use the tip of your left index finger so your other fingers don't obstruct the lens. Flicking this lever will allow a faster shutter speed but a much shallower depth of field.

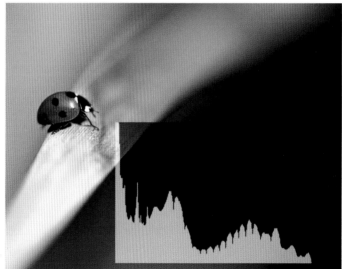

3 Focus by rocking

To focus, move in close to the subject and use a rocking technique to obtain a sharp image. This simply involves gently moving the camera backward and forward until the part of the subject you want to be in focus becomes sharp. You'll need to control your breathing and have a steady hold.

4 Assess exposure

Some DSLRs will work in aperture priority, but others will only work in manual mode, so you'll have to experiment. In manual mode, you can use your DSLR's light meter for exposure, but if this doesn't work with a backward lens, you'll have to guess exposure using the LCD screen and histogram.

ATTENTION TO DETAIL

When shooting subjects close-up, especially with macro lenses, even the tiniest piece of dirt or slightly damaged petal can stand out like a sore thumb. It's really important to choose your natural subjects well, picking only the most perfect specimens you can find. A certain amount of repair work can be done in Photoshop, but this is best left for small amounts of damage only. Replacing large parts of plants and flowers is bad practice and can be difficult to do well.

Something else to watch out for is small amounts of debris on and around your subject. Soil on leaves and petals looks messy but can be easily removed using a blower brush to avoid any damage. Rogue twigs, leaves and other objects should also be removed with tweezers before shooting because they can be distracting. Our example shot below is extreme, but you'll be looking for less obvious distractions such as specks of dirt.

Choose your subject wisely. Small imperfections can be tidied post-capture, but don't set yourself an insurmountable task.

CLOSE-UP FILTERS

Close-up filters (also known as close-up lenses) can be used to accomplish macro-style photos without the expense of a dedicated macro lens. They vary in cost and are available in a variety of strengths, with the most common being +1, +2, +3, +4 and +10 dioptres. A dioptre is a unit of measurement referring to the optical power of a lens. A +10 filter will take

you closest to a 1:1 ratio, but achieving it depends on the focal length and native minimum focusing distance of your lens. A useful feature of close-up filters is that different strengths can be combined to create a stronger effect. For instance, a +1 and +4 combination will give you +5 dioptres, and +4, +2 and +3 will give +9. Stronger filters should be placed closest to the lens.

CONTROLLING BACKGROUNDS

The most common way to control backgrounds is to use a shallow depth of field to drop them out of focus. However, some backgrounds can be so messy that it's practically impossible to hide them this way. In these situations, replace the background using a sheet of coloured card. Greens, browns, yellows and black are most successful for natural subjects like plants. Simply place the sheet of card behind the subject, and hold it in place using garden canes.

Messy background

The main shot here was taken with a +3 dioptre close-up filter. This allowed much closer focusing than the kit lens without any filters attached. The inset image was shot without any filters, which has resulted in the subject filling less of the frame.

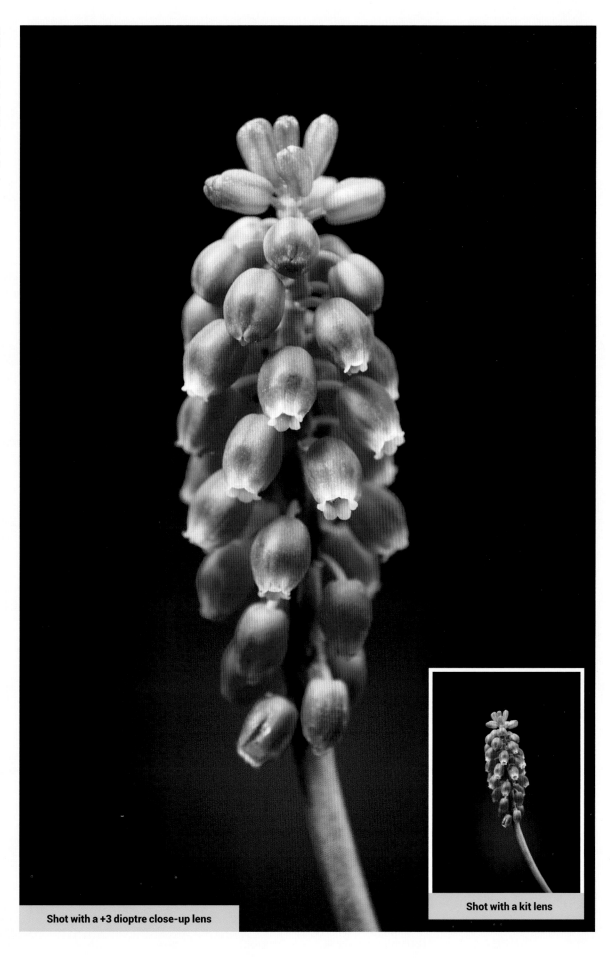

Shot with a +3 dioptre close-up lens

Shot with a kit lens

MACRO LENSES

The easiest and most effective way to get close to your subject is to shoot with a macro lens. While the other options we looked at provide workable alternatives, there's no beating the real thing. A macro lens drastically reduces minimum focus distance and can produce a 1:1 ratio, which is when the subject is reproduced at life size on your camera's sensor. One thing that makes macro photography so special is the ability to reveal minute detail that's imperceptible to the naked eye. Even individual hairs on a fly's legs can stand out with definition in the world of macro photography.

MIRROR LOCK-UP

Macro photography involves high levels of magnification, and that applies not just to the subject but to everything, including vibrations that cause blur. To minimize the effects of vibrations caused by the reflex mirror in your DSLR, use the mirror lock-up function (typically found in the Shooting menu).

Setting up your DSLR

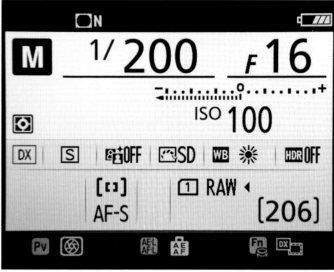

1 Find your subject

When seeking wildlife subjects, even very small ones, we often think of exotic destinations. But the best location might actually be under a leaf in your own back garden. The best time to look for macro subjects is first thing in the morning, because many insects are less active at this time.

2 Set your exposure

Set the camera to manual mode, the aperture to around f/16 and shutter speed to the camera's flash-sync speed (usually between 1/60sec and 1/250sec). Pop up your flash, take a few test shots and check the exposures in the playback screen. To adjust for either under- or overexposure, use the flash exposure-compensation function.

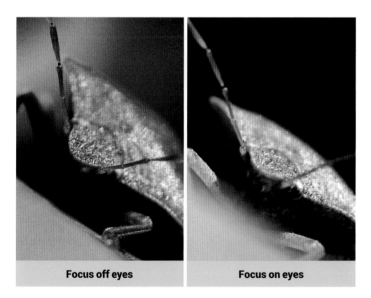

Focus off eyes Focus on eyes

3 Compose the image

With wildlife subjects, the most important features are the eyes, so these should be your focus point. Be careful not to crop other important features, such as legs or feelers. Also, keep an eye on the background for distracting objects, such as bright colours or highlights, and make sure to compose the image so they don't appear in the frame.

4 Focus and shoot

Once you've composed the image, manually focus the camera on the eyes (or head). If the subject moves, rock the whole camera backward or forward to keep the focus distance the same. This will take some practice and you'll need to move quickly. As soon as the eyes are in focus, take the shot. The flash willl help freeze any movement.

FOCUSING TECHNIQUE

In macro photography, depth of field is extremely shallow, even at the smallest lens apertures (for example, f/22 or f/32). So, to get a sharp image of an active subject, your focusing technique must be spot-on.

If you want the entire subject to be sharp, then it must lie parallel to the focus plane. For example, if photographing a butterfly's wing, then the wing must be positioned so that its whole area is an equal distance from the sensor. Being even a fraction out can make all the difference.

When photographing a moving subject, focusing is even more complex, because focus distance is constantly changing. With non-macro subjects, such as wildlife or sports, you might opt to set your camera to Continuous AF mode (AI Servo in Canon terms) and hope that the camera tracks the subject's movement. This technique is unlikely to work in macro photography, where even the slightest movement will result in the subject becoming completely out of focus.

Instead, it is preferable to use the rocking focus technique mentioned earlier (see page 105). This approach has the further advantage of ensuring the framing and composition remain constant.

For completely static subjects, such as a flower on a very still day, you might try focusing manually using Live View. Once Live View is active, simply press the zoom button (marked by a magnifying glass icon) once or twice on the back of the camera body to magnify part of the frame by at least 5x. Use the D-pad to navigate to the focal point of your image, then carefully turn the focus ring until the subject appears sharp. This is a particularly useful technique for close-ups, as the ultra-shallow depth of field makes extremely precise focusing adjustments vitally important. As this method is relatively slow, it's unsuitable for moving subjects.

- Head outside in the morning when insects are less active after the night. Once the day warms up, the insects won't sit still.

- Your own back garden and the local park are two of the best places to find insects. Your garden is better for quiet and privacy.

- Focus on the eyes of the insect to obtain correct sharpness. Focusing on antennae is a common mistake we often see.

- When shooting close-up with a macro lens, depth of field is extremely shallow, so you'll need to stop down.

HANDHOLD YOUR CAMERA

Macro photography requires tiny, precise movements of the camera, which must often be held at unusual angles to keep the subject parallel to the plane of focus. And if the subject is active, these movements are almost always constant – all of which often makes using a tripod impractical.

If you are adamant about using a tripod, consider a focusing rail with four-way adjustment, which enables shifting the camera body along both side-to-side and front-to-back axes, making it easier to compose and focus the image precisely. It is also worth considering a tripod with independent, multi-positional legs that will allow the camera to be positioned at almost any angle. In the majority of situations, the best and often only option is to handhold your camera. However, because even tiny amounts of camera shake will ruin a macro image, there's a bit more to it than you'll encounter in other photographic genres.

The trick here is to use flash, which provides the main exposure. Because light emitted from the flash unit lasts for just 1/10,000sec to 1/30,000sec, the effective shutter speed is so fast that any movement of the subject or camera will still appear frozen, giving a sharp result.

Flash light can look very artificial, though, and you want to create an image that looks like it was shot under natural light. Position the flash unit very close to the subject, and use a diffuser to soften the light and avoid unpleasant harsh shadows.

Exposure can be set manually using the camera's manual mode. Choose a narrow aperture (around f/16), to increase what little depth of field you have, and set shutter speed to the camera's flash-sync speed (usually between 1/60sec and 1/250sec). A slower shutter speed will ensure you don't get a completely black background. Focus manually using the rocking technique described on page 105.

Flower close-ups

Spring and summer are the perfect time of year to get out in the garden and capture the incredible colour and beauty of nature. In the following pages, we're going to get up close and personal with flowers, zooming fully in and focusing at our lens's minimum focusing distance to take eye-catching high-impact images. The idea is to achieve a slightly artistic composition with the flower filling most or all of the frame, without much background on show. You won't need a specialist macro lens to shoot your images either – all you need is a DSLR or CSC (compact system camera) with kit lens. You'll also need a tripod to keep your camera still. This project isn't about capturing a realistic representation of your entire subject, but recording a smaller area of detail for artistic effect.

CHOOSE YOUR FLOWER CAREFULLY

Since you're not working with a proper macro lens, you have fairly limited magnification available to you, so if your flower is too small, you won't be able to get close enough for it to fill the frame. For this reason, you'll get the best results if you use larger flowers with heads at least 9cm in diameter. Lilies, gerberas, sunflowers and orchids are all relatively easy to get hold of. Over the next few pages, you'll find all the camera settings and shooting techniques you'll need to get this right.

FILL IN UNWANTED SHADOWS

Reduce the risk of extreme highlights and shadows on your flower by working in a shaded area. However, if you feel parts of the flower are poorly lit, such as inside the cup of a daffodil, you can use a reflector to throw some extra light onto this area. Reflectors do not cost much, and usually have several different reflective surfaces to choose from. For macro, we'd recommend the white side, as this gives the softest, most even light. You may need an assistant to hold the reflector in place. Ask them to tilt it until the maximum amount of light is being reflected back onto the flower. Alternatively, use a large piece of white card.

Without a reflector, parts of your flower will be in shadow.

A reflector will help fill in shadows for more even lighting.

Spend your time finding as perfect a flower as possible, because any flaws will be magnified.

1 Sharp focus

When shooting extreme close-ups, accurate focusing is critical, since depth of field is so shallow. In this image, the most important part of the flower is perfectly sharp.

2 Strong composition

The main focus of the flower has been placed on an intersecting third to give the image a sense of balance.

3 Wide aperture

Using the kit lens's widest aperture setting of f/5.6 results in a shallow depth of field, helping to give the image plenty of depth.

4 Even lighting

A reflector was used to throw light back on to the subject to fill in unwanted shadows. The image was also shot out of direct sunlight.

PERFECT YOUR COMPOSITION

As discussed on pages 30–33, the composition you choose can make or break your image. Try to follow the basic guidelines to help ensure that your colourful floral images are always successful. When you look through the viewfinder, Imagine your frame is divided into nine even rectangles, and position the flower stamen at one of the two points where the top horizontal lines and two vertical lines intersect. Compose the flower head according to the rule of thirds, but position the camera so the stem cuts across the frame diagonally. This helps to fill space and, most importantly, it looks dynamic. With the lens zoomed in, you'll have to physically move to change the composition. Move back if the flower fills too much of the frame.

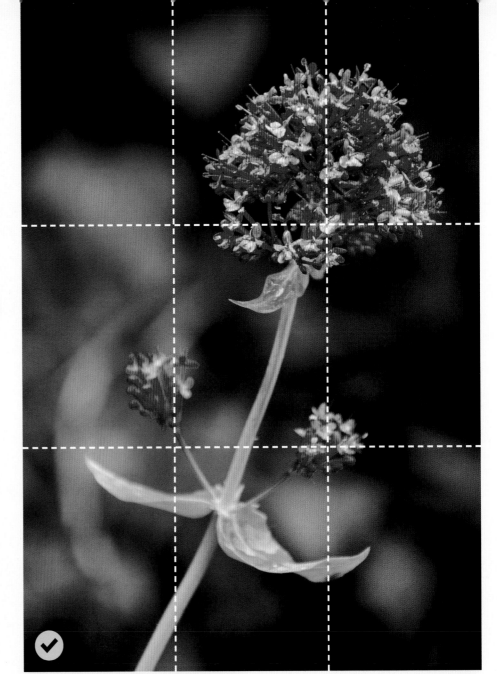

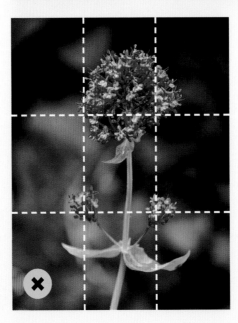

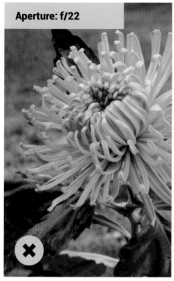

Aperture: f/22

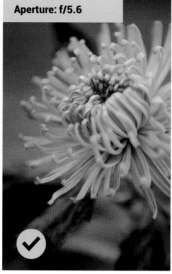

Aperture: f/5.6

USE A WIDE APERTURE TO CREATE A SENSE OF DEPTH

For the best results you want an image that blends a sharp focal point with an out-of-focus foreground and background. When fully zoomed in, most kit lenses have a maximum aperture of f/5.6, producing a shallow depth of field where anything that isn't on the focal plane appears out of focus. Not only does this create a feeling of depth in the image – which is important, since the subject is in fact only a few centimetres deep – but it also helps draw attention to the focal point of the shot. When combined with the magnification produced by the lens at its minimum focus distance, this will dramatically accentuate the scale of the subject. While you could use a much narrower aperture in order to ensure the entire subject is in focus, this would conversely produce a much flatter result.

Get the sharpest result

Using your lens's widest aperture setting isn't only to achieve a shallow depth of field. It also helps to ensure a shutter speed fast enough to eliminate unwanted motion blur caused by a moving subject. This is more of a problem on windy days, when any movement is exaggerated by the subject's magnification. One way to combat this is to try to choose a sheltered location near a wall or fence. Alternatively, shield your subject with a piece of card as you take your photos. With your subject protected, a shutter speed of 1/125sec will give you sharp shots. Mounting your camera firmly on a tripod will not only allow you to carefully find focus

on your subject but will also minimize the presence of any camera shake in your images.

FOCUS ACCURATELY

The closer you focus on an object, the shallower the depth of field. When combined with a wide aperture, this results in shots where the in-focus area can measure just a few millimetres. Consequently, tiny focus adjustments have a massive impact on what appears sharp, so your focusing method has to be very precise.

Mount your camera on a tripod to hold it firmly in position, and enable manual focus by flicking the focus switch of your lens to MF. Carefully adjust your focus ring to bring your subject's main focal point into sharp focus.

Focus in manual

Live View can help ensure that your subject is perfectly in focus no matter how shallow the depth of field. Press the Live View button, and hit Magnify to zoom into your scene on the camera's LCD screen. Navigate to the focal point of your flower (usually the stamen), and carefully adjust the lens's focus ring to find sharp focus.

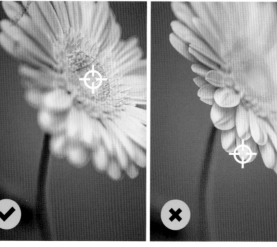

Focus on the part of the flower you wish to draw attention to. This is usually its stamen.

Setting up your DSLR

1 Set quality and style

To get started, set white balance to Daylight. This is because you'll be shooting outdoors using natural light, and this setting will give you neutral results. In the camera's shooting menu, set your images to record Fine-quality JPEGs. Next set Picture Control to Vivid. Your camera will now process your files with a higher level of saturation than Standard. Depth-of-field control is important for this type of subject, so turn the mode dial to aperture priority. In this mode you set the aperture, and the camera automatically sets shutter speed for a correct exposure.

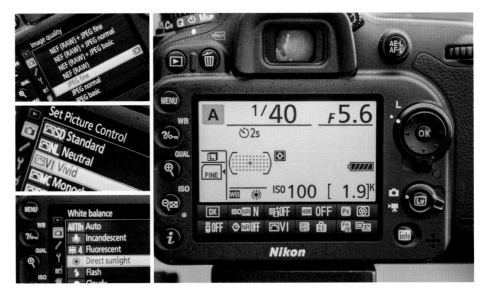

2 Set the ISO

Set ISO to 100 for the best image quality possible. Shutter speeds could be slow as a result, but this won't be a problem if you're shooting with the camera attached to a tripod. Now set aperture to f/5.6. This will keep the flower in focus but will blur the background.

3 Set the focus

Zoom your lens into its longest focal length. On most kit lenses, this is 55mm or 105mm. Now set the lens to manual focus, and turn the focus ring until the desired part of the flower looks sharp. Leave focus locked on this position.

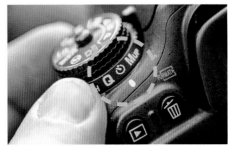

4 Select the self-timer

If you have a cable release, use this to fire the shutter without touching the camera. If you don't have one, set the camera to self-timer mode with a delay of 2 seconds. When you press the shutter button, there will be a delay of 2 seconds before it fires.

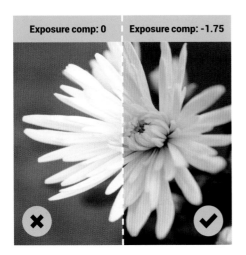

Exposure comp: 0 | Exposure comp: -1.75

ADJUST EXPOSURE COMPENSATION

While the metering modes of modern cameras generally do a pretty good job of adjusting settings for a well-exposed photo, they can still get it wrong. Exposure compensation allows you to fine-tune your image to combat any under- or overexposure. Simply press the button marked with a +/- symbol and turn the finger dial. Move the dial to the right, and the exposure value (EV) will be positive, making the image brighter. Scroll to the left, and the exposure value becomes negative, making the image darker.

You can check the current exposure-comp value by looking through your viewfinder at the light meter and half-pressing the shutter button or by checking your camera's top-plate LCD.

ADD A BACKGROUND FOR A CLEANER SHOT

An unfocused bush in the background of the image can create a pleasing natural backdrop, especially if it contrasts with the colour of the flower you're shooting. But if your garden is full of clutter and you can't create a clean natural background, you'll need to add one yourself. The best material to use is A1-size mount board because it's rigid and available in lots of colours. You could also use A4 sheets of coloured card instead, but the smaller size can make composing shots more difficult if you're shooting a large flower. Large sheets of card are available from good craft shops.

EXTRA GEAR FOR CLOSE-UP SHOTS

Manfrotto PIXI

If you're looking for a lightweight and pocket-size tripod, the Manfrotto PIXI is ideal. It can support up to 1.1kg, which means most cameras. It has a closed length of 18.5cm and stands at 13.5cm when erected.

Lastolite TriGrip reflector

The design of this reflector means you can comfortably hold it while shooting. At 75cm, the Lastolite TriGrip Silver/White is ideal for a range of subjects, including flower photography.

Sigma 105mm f/2.8 EX DG OS HSM

For ultra-close focusing, this medium-telephoto macro lens offers great value for money. Compatible with full-frame APS-C cameras, it provides a 1:1 ratio with a minimum focusing distance of 31.2cm.

A clean and uncluttered background is the difference between a bad flower image and a great one.

Night portraits

Learning how to shoot after dark with a balanced combination of flash and ambient light will transform the look of your night-time portraits. If you've previously tried a low-light portrait using your camera's built-in flash, you probably ended up with a well-lit subject but a completely underexposed background. This is because when the flash is activated, the camera uses settings that meter for the flash light only, leaving everything more than a metre or so from the camera in near darkness. If you force the flash off, you'll have a better-exposed background, but the subject will be poorly lit.

In this section we're going to teach you how to adjust your camera settings to get the best of both worlds – an attractively lit subject *and* background, giving a much more pleasing overall result.

CHOOSE THE RIGHT LOCATION

Just as when you shoot any other portrait, you'll need to think carefully about where you position your subject. Ideally you want plenty of lights in the background. It doesn't matter if the background is cluttered, since you'll be throwing this well out of focus. As with most night-time images, you'll be working with a slow shutter speed, so a sturdy tripod is needed to keep your camera still. Try to avoid setting up in very busy areas such as on pavements – you don't want to cause an obstruction, nor do you want people walking in front of the camera during an exposure.

Using a tripod to keep the camera perfectly still during the exposure means there will be little to no unwanted camera shake. If possible, set the tripod at around head height so it's easy to adjust between shots.

Auto mode at 1/60sec:
the background is too dark.

Manual mode at 1/4sec:
the background is well lit.

USE A SLOW SHUTTER SPEED

In auto mode, the camera's default flash shutter speed of 1/60sec leaves the background underexposed, as it only meters for the light from the flash. When the shutter speed is increased to 1/4sec in manual (M) mode, the background is much brighter, because more ambient light has been allowed into the camera. However, you'll notice that increasing the shutter speed doesn't affect how bright the subject is. This is because the flash happens so quickly that all of the light it produces enters the camera whether the shutter speed is long or short, provided it doesn't exceed 1/200sec (the camera's flash-sync speed).

1 Correct composition

The image is composed so that the subject's eyes are one third of the way from the top of the frame and the top of the head isn't chopped off.

2 Blurred background

Using a wide aperture results in a shallow depth of field, so the background is perfectly out of focus. This helps to make the subject stand out.

3 Sharp foreground

Using precise single-point AF, the subject's eyes are perfectly sharp – a must for any successful portrait.

4 Perfect overall exposure

By combining flash light and ambient light, the whole scene is correctly exposed, which wouldn't be the case in full auto mode.

PERFECT YOUR COMPOSITION

Remind yourself of the fundamentals of good composition to ensure you have the best image. Position the eyes along the top imaginary horizontal line to draw attention to them. Align the body between the vertical lines for a balanced image. When taking a portrait, it is important to avoid framing your subject with an awkward crop. Missing fingers and edges that cut across joints will all create unnatural-looking images. Creative angles can work for some shots, but most portraits look best with a level horizon. A jaunty composition can quickly ruin an image.

The main image here is a very pleasing night-time shot. Avoid compositions that create awkward crops (left).

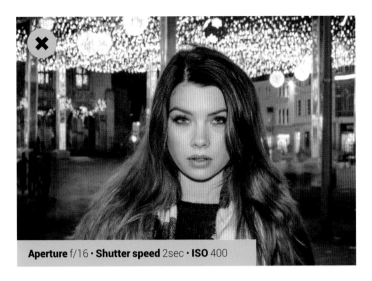

Aperture f/16 · **Shutter speed** 2sec · **ISO** 400

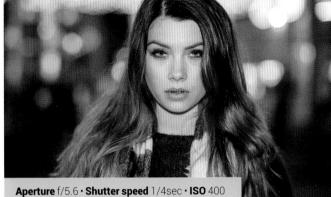

Aperture f/5.6 · **Shutter speed** 1/4sec · **ISO** 400

BLUR THE BACKGROUND WITH A WIDE APERTURE

Portraits work best when the model is nice and sharp and the background has been allowed to blur slightly out of focus. This helps the subject stand out from the background.

When shooting night portraits with flash, the background is an important element. Street lights and the lights from shops can add an interesting dimension to your images, as well as a sense of depth. But left in focus they can become a distraction, so a wide aperture is vital to help the background fall out of focus. If you own a lens with a large maximum aperture such as a 50mm f/1.8, change the aperture to this setting. If you only have a kit lens, the maximum aperture will be f/5.6, which should suffice.

ZOOM IN WITH YOUR KIT LENS

Kit lenses don't have the widest apertures, which means the depth of field is often not as shallow as you'd like. To get the best out of your kit lens, zoom in all the way to the longest focal length, which will magnify the blur, giving the effect of a wider aperture. On the majority of kit lenses, this is 55mm. Then to get your model composed in the frame move backward until everything looks right. Whatever you do, don't zoom out to fit the model in. Doing this will work against the effect you want for this shot.

ADJUST THE POWER OF YOUR FLASH

Pop-up flashes are incredibly useful, not least because they're always there ready to illuminate subjects in a range of difficult lighting conditions. In many situations, the camera exposure will be perfect, but there are times when the flash will be either too powerful or too weak, like in the shot below.

When the subject appears too light or too dark when using flash, you'll need to use flash exposure compensation to adjust flash power. This is achieved in slightly different ways depending on which camera you have, so check the manual if you're unsure. But in a nutshell, if the subject is too bright add underexposure at -1.0 or -2.0. If it's too dark add overexposure at +1.0 or +2.0.

BALANCE FLASH

When shooting long exposures with flash, the burst of light exposes and freezes the subject, while the long shutter speed correctly exposes for the lights in the background.

Flash power output is too strong for the subject, and the image is overexposed.

By using flash-exposure compensation, the power is reduced for more even results.

Right Always focus on the eye closest to the lens (right). Focus in the wrong place (far right) and the face will be blurred.

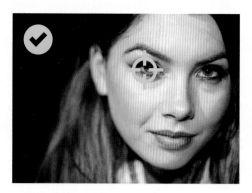

TAKE PERFECTLY FOCUSED SHOTS

It's vitally important that portraits are sharp in exactly the right places. When people look at portraits, they're immediately drawn to the eyes, so this is the point where you should focus. If the model is standing straight-on to you, focus on either eye. But if they're standing at a slight angle, focus on the eye closest to the camera or the "leading eye". For maximum accuracy, set the camera to single-point autofocus. This will make one AF point active so you can select the exact point of focus. The active focus point will show up in the viewfinder and on the info screen on the LCD. Use the D-pad on the back of the camera to change points.

Focus with Live View

In low-light conditions, it can be difficult to compose the shot and focus using the viewfinder. If this is the case, try using Live View instead. Press the Live View button on the camera, then press the zoom button to enlarge the area around the focus point on the LCD screen. Take a shot, then check the results.

USE AN EXTERNAL FLASHGUN

While built-in flash can be a very useful tool, it does have its limitations. The power for this kind of flash is drawn from the internal camera battery, meaning that using it can seriously reduce the amount of images that you can capture from one charge. External flashguns take external batteries, and therefore avoid this problem. They also have increased power levels so their light can reach further, boast a faster recycle time between flashes, and often feature adjustable heads to enable their light to be bounced.

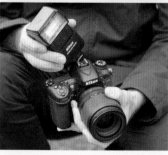

Right The more powerful flash of an external flashgun will reach further into a scene.

Left Focus with Live View
Add more light use a flashgun

Built-in flash

External flash

NIGHT PORTRAITS

Setting up your DSLR

1 Set quality and WB

Set your images to record as fine. This will save your shot as a high-quality JPEG. Then set the picture style to Portrait. Your camera will now process your images with a suitable contrast and saturation for your subject. Switch white balance to Direct Sunlight or Daylight, so that your subject does not have a colour cast. Press the flash button on the side of the camera to pop up your flash. By default, your flash will be set to its automatic TTL (through-the-lens) mode, which means the camera will intelligently set the power of the flash depending on subject distance.

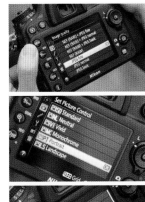

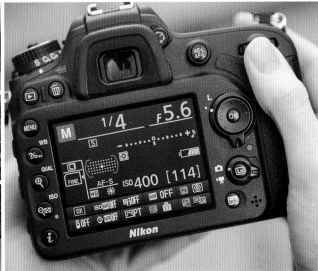

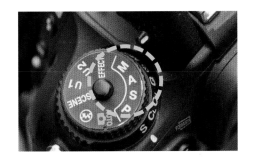

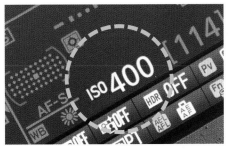

2 Select the mode

Place your camera into its manual shooting mode to take full control of all settings. Set your shutter speed to 1/4sec in order to allow in plenty of ambient light, and select the widest aperture (smallest f/number) to create a shallow depth of field.

3 Set the ISO

Set the ISO level of your camera to 400. This is low enough to maintain great image quality but high enough to pick up plenty of ambient light in most scenes. You can increase or decrease ISO in order to adjust the brightness of your shot.

4 Set the focus

Select the single-point focusing option on your camera, and use the rear D-pad to select a focus point that covers the model's leading eye. Half-press the shutter to find focus before pressing the shutter down fully to capture your image.

EXTRA GEAR TO HELP YOU TAKE GREAT PORTRAITS

Nikon 50mm f/1.8 G AF-S lens
Standard primes offer excellent image quality and fast apertures at inexpensive prices.

Nikon SB-700 Speedlight flashgun
The compact SB-700 Speedlight is a great external flash upgrade for Nikon users. It automatically selects suitable light-distribution angles and features AF assist illumination and a fast flash-recycle time.

Lastolite Ezybox Speed-Lite softbox
For more flattering diffused light on location, Lastolite's Ezybox is the perfect mini softbox for flashguns. Thanks to its ultra-portable design, it swiftly collapses down for packing into a kit bag.

Indoor portraits

Shooting portraits can be daunting, but if you work in the comfort of your own home and make the most of daylight, it's easier than you think to get great results. You might need to move the furniture or ask your model to perch on a windowsill, but you've got more flexibility than you would have in a photo studio, and it'll be a far more relaxing environment, which will inevitably come across in your images.

LOOK BEYOND THE MODEL

The background of a portrait is just as important as the model, since that's where our eye wanders after first engaging with the main subject. Take your time when composing, and continuously check through the viewfinder to make sure it suits your image.

Keep backdrops clean and clutter-free. You might need to do a little tidying up, but it'll be worth it, because if there are toys on the floor or shopping that needs putting away, they'll show up in your pictures even with a shallow depth of field.

Choose somewhere you and your model have space to move around. The more space between the model and the background, the more blurred any potential distractions become, and the more creative you can be with focal length.

Lastly, look for a well-lit location. Natural light is readily available and perfect for portraits.

THREE GREAT LOCATIONS FOR PORTRAITS AT HOME

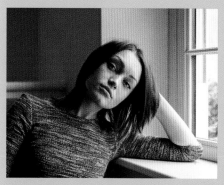

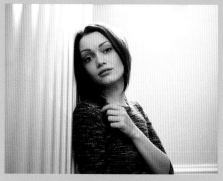

Resting by the window
A large window is the perfect starting place for natural portraits. Your model could lean casually against the wall, rest his or her elbow on the sill or stand in front of it for dramatic backlighting. Just remember to clean the window if it features in the shot.

Leaning on the stairs
An often overlooked but no less versatile location is the stairwell. You could use the bannister as a lead-in line, use its shadow to add interest to the wall (as above) or even shoot through the bannister to frame your model and add a sense of depth.

On the sofa
If you want your model to relax, the sofa should be your first port of call. The type of sofa you use will dictate the style of portrait you shoot – a glossy leather three-seater gives an air of sophistication, while a more natural, textured pillow-back sofa allows for more relaxed shots. Start by asking your model to rest his or her hands on the armrest.

1 Focus on the eyes

The beauty of being close to the light source is that you can see the window's reflection in the model's eyes. This adds a catchlight and really brings her face to life. It's important to focus on the model's eyes (or the eye nearest the camera), because they are the most engaging facial feature and where a viewer will always look first.

2 Find a natural pose

Knowing what to do with a model's hands is always tricky – more so if the model is inexperienced or camera shy. Asking them to rest a hand against their cheek or chin is a good place to start and will help them relax into the shoot.

3 Blur the backdrop

With an aperture of f/5.6 for this shot we were able to ensure an out-of-focus background, which should feel separate from the model. We also metered for her face, so the chair and backdrop fell into shadow, which allows the model to stand out even more.

MAKE THE MOST OF NATURAL LIGHT

You don't need to spend a fortune on expensive studio lights to shoot great indoor portraits. Window light is free and instantly available, and it also tends to give a much softer, more natural-looking image than you'd get using flash.

Choose a suitable location right next to a window with an uncluttered background. It's worth taking a couple of minutes to remove any objects that might draw attention away from your subject. If possible, consider taking down your curtains for the duration of your shoot, or if it's easier tuck them up around the rail so they're well out of the way while you're working. Curtains can significantly cut down the amount of light coming in through the window, which even on bright days is likely to be limited. They can also cause your image to look untidy, especially if they are patterned or made of brightly coloured fabric.

To maximize the amount of light available to you, shoot on a sunny day as close to midday as possible, when the sun is at its brightest. If rays of direct sunlight are falling on the model's face, reposition your model slightly, or it will make it very difficult for you to get your exposure right.

USE A REFLECTOR

If you find that the lighting is too harsh, move the model back away from the window a little. This will reduce the contrast between the shadows and highlights and give you softer, more diffused light to work with.

Alternatively, use a reflector to bounce some light back on to the side of the model's face that's in shadow. It's usually best to use the white surface for the softest light. If possible, ask an assistant to hold it, so they can continually adjust the angle of the reflector for the best results.

- Make sure the clothes your model is wearing are compatible with the type of portrait you are trying to achieve. Plain clothing free of logos, designs or very bright colours works best.

- To let the maximum available light in through the window, take your curtains down or tuck them up into the rail. This also helps make a more minimalist image and focuses attention on the subject.

- Portraits tend to look most natural when shot at eye level, since it encourages a connection between the subject and the viewer. Any lower, and the subject will appear dominant; any higher, and they will appear childlike.

- Even if it means moving furniture around, it's really important to get your subject as close to the window as possible, where there is the most available light. This will give the highest-contrast lighting and enable you to keep ISO as low as possible for better image quality.

THREE FLATTERING POSES FOR PORTRAITS

One of the most crucial factors for shooting a successful indoor portrait is how you position your subject. Not only can an interesting pose make your photo much more eye-catching, but it also determines how the light falls on the model's face, which is vitally important for creating the most flattering portrait.

Make sure your model is sitting or standing right next to the window to make the most of the available light.

If your model is too far away, the difference in intensity between the area of highlight and shadow on the face will be reduced. Not only this, but less light means a higher ISO or a slower shutter speed, which may affect image quality or sharpness.

To keep things interesting, consider asking your model to introduce a hand into the frame or to tilt their head slightly on one side. Position them so the light falls on their face in a pleasing way.

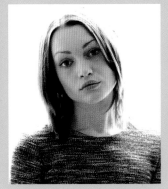
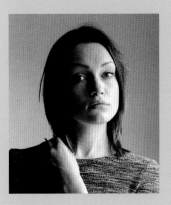
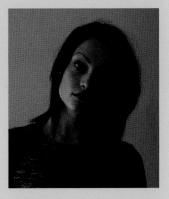

Split lighting
This is a dramatic lighting style where one side of the face is completely lit and the other side is in shadow. As a general rule, it works best for male portraits and is most effective when the model is facing the camera directly.

Backlighting
This gives a soft, even light on the face with very few harsh shadows. It is the trickiest to expose for, because the face is effectively entirely in shadow against a bright background. Use spot metering for best results.

Rembrandt lighting
This is so called because Rembrandt painted his models using this lighting style. Although less dramatic than split lighting, it's usually more flattering. Carefully position the model to get a chink of light on the shaded side of the face.

Poor light
If the model is too far from the window, there won't be enough available light.

BOUNCE YOUR FLASH

The pop-up flash on your camera is a convenient way to throw a little extra light on to your subject. The problem is, direct flash can be unflattering and may create hard shadows (which can clearly be seen on the wall in the right-hand image). To get around this, try bouncing the flash off the ceiling, so the light comes from above. This gives a far softer and more natural-looking light. Simply hold a small piece of white card at an angle in front of the flash (below).

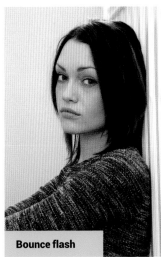
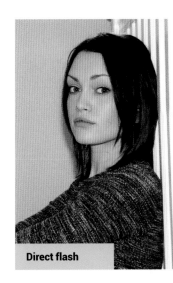

Bounce flash

Direct flash

Direct pop-up flash can create harsh shadows on your subject, but bouncing it off a white ceiling, or even a wall, makes the light more diffused and helps it to look softer and more natural.

Setting up your DSLR

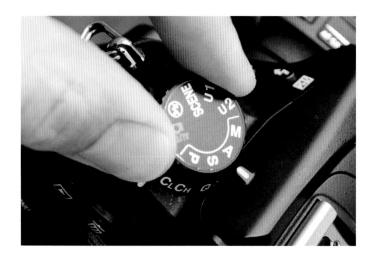

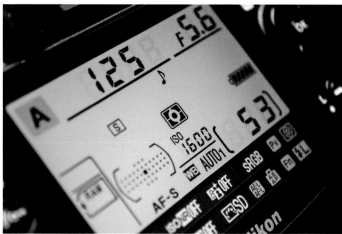

1 Select the mode

Set the camera to aperture priority so you can take full control of aperture. The camera will choose shutter speed automatically, but make sure it's always faster than 1/60sec if shooting at 55mm. Now zoom the lens in to its longest focal length, which is usually 55mm on a kit lens, and set aperture to the maximum setting of f/5.6. Set white balance to auto so the colours appear correct.

2 Set the ISO

When shooting indoors using window light, you'll need a high ISO setting. Set ISO between 800 and 1600 for best results, and make sure you keep an eye on shutter speed. The shutter speed should match or exceed the focal length of the lens – for example, if shooting at 105mm, make sure shutter speed is 1/125sec or faster. Turn on image stabilization/vibration reduction if applicable.

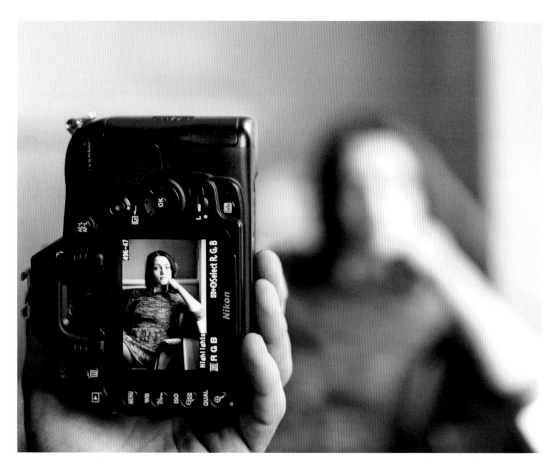

With camera settings pushed to their limits so you can shoot at the lowest ISO setting possible, there's always a danger that shutter speed will become too slow and camera shake will start becoming a problem. Continually check image sharpness on the LCD by zooming in throughout the shoot.

SHOOT IN LANDSCAPE FORMAT FOR CONTEXT

Portrait, or upright, format is the most common way to shoot portraits, but that doesn't mean it's the only way. Landscape format can be perfect for portraiture because it allows you to include more space around the model than an upright shot. The benefit of this is that you can include more of the location the model is in, which is particularly useful when the environment says something about the person in the photo. In this shot (right) our model is sitting at a piano. The immediate assumption you might make about this is that she can play. Whether or not this is true, the inclusion of the piano makes a strong suggestion about her and what she enjoys doing.

Unsurprisingly, portraits that incorporate the subject and their environment are known as environmental portraits. So if you're photographing a mechanic, artist or musician, for example, consider photographing them in a location that says something about what they do. And don't forget to shoot in landscape format to make sure you include their environment.

Whether you're shooting portraits in an upright or horizontal format, you should always focus on the eye closest to the camera.

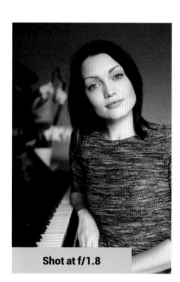

Shot at f/1.8

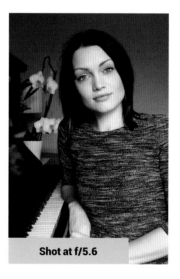

Shot at f/5.6

In the examples above, you'll see that the background in the shot taken at f/1.8 is much more out of focus than the one taken at f/5.6. This shallow depth of field helps to blur distracting backdrops and isolate the subject.

USE A FAST PRIME LENS AND WIDE APERTURE

Prime lenses have long been considered the best type of lens for portraiture for a number of reasons – they provide excellent image quality, and they have fast apertures to let in more light and produce lovely shallow depth-of-field effects. For an APS-C DSLR, a 35mm f/1.8 lens is perfect because it provides an equivalent focal length to 50mm on a full-frame DSLR. The field of view is wide enough for shooting indoors, but allows you to maintain a comfortable working distance from the model. The main advantages over a kit lens are superior image quality and faster shutter speeds due to the wider maximum aperture. However, focusing becomes much more critical when shooting wide open.

AVOID CAMERA SHAKE

If the shutter speed becomes too slow for the lens you're shooting with, any camera movement will be captured during exposure. The result is camera shake, which can be reduced or eliminated by turning on image stabilization/vibration reduction. The switch can often be found on the lens if it has the feature. If your shots continue to suffer from camera shake, you'll have to increase ISO.

Animal portraits

To get started with animal photography, you need to know the basic settings to use when capturing images of static subjects. The settings and techniques you'll need to employ are almost exactly the same as those you'd use when shooting portraits of people. However, if you're photographing an animal that's moving, the settings do vary a little, so we're going to take a look at how to photograph moving subjects as well.

Because most cats and dogs spend the majority of their time lounging around, we're going to start here. Working outdoors is best since it keeps things simple and helps avoid the untidy backgrounds and exposure issues that you could face when shooting indoors.

To ensure that your photos look like more than just casual snapshots, there are some simple guidelines to follow. Focus on the subject's eyes, because they are the focal point of the shot. Ideally, take the shot when your dog or cat is looking at the camera. As a fail-safe, use an aperture of around f/4. This is wide enough to throw the background out of focus, but narrow enough that if the subject moves slightly after focus has been attained, it will still appear sharp. And don't forget to get down to your pet's eye level – whether that means crouching, kneeling or lying on the ground – for better and more direct eye contact.

Portrait format

Landscape format

CHOOSE THE BEST CAMERA ORIENTATION

When it comes to photographing animals full length – showing their entire body – you can shoot in landscape or portrait format, depending on how they're standing or sitting. As a rule of thumb, shoot in landscape format if they're standing side-on to the camera and in portrait format if they're facing the camera. For the latter, you can still shoot in landscape format, but you'll have to work harder to make the composition work. This could mean shooting in a picturesque location with lots of natural light.

For portraiture generally, a central composition can work well in portrait and landscape format, but in landscape format you really have to consider the background, because it becomes an even more important part of the photo. To make landscape-format shots work more successfully, it can help to place animals on one side of the frame. If possible, have the animal's owner holding a treat and sitting on the side where there will be space. Hopefully, this should draw the animal's gaze in that direction, so in the resulting photo it will look as though they're staring into the distance.

Setting up your DSLR

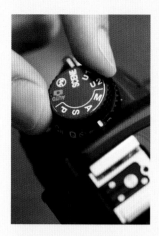

1 Select the mode
Turn the mode dial on your camera to A or Av to activate aperture-priority mode. Set aperture to f/4, because this will help to drop the background out of focus but also provide enough depth of field to keep the eyes in focus if there's a slight focus error.

2 Set the ISO
ISO dictates the sensitivity of the camera sensor to light, but the higher the setting you use, the more noise will be present in your shots. In a portrait situation, it's always best to set the lowest ISO possible for the light conditions. Begin with ISO 100, but if shutter speed is too slow for a sharp shot, increase it to 400. Go higher only if necessary.

3 Choose the metering mode
The fact that dogs and cats can be black and white can fool even the most sophisticated of metering systems if the wrong setting is selected. The best mode to use is matrix/evaluative, because this takes readings of light and dark areas present in the frame and sets an average exposure.

4 Set the focus
When shooting a subject that's relatively still, such as for a portrait, the best focusing mode to use is single shot. In this mode, the camera locks focus on the subject when the shutter button is pressed halfway. If the subject or photographer then moves forward or backward the subject will be out of focus. This process gives sharper results for static subjects than continuous autofocus (used for moving subjects).

AVOID STRONG LIGHT
Strong midday sunlight will cause harsh shadows and unflattering portraits so avoid it when possible.

CAPTURE MOVING ANIMALS

One of the biggest technical challenges that we're faced with as photographers is how best to shoot fast action subjects. Capturing moving animals requires a fast shutter speed and continuous focusing. Animals can be particularly difficult to photograph because they are quick, move unpredictably and don't follow commands as well as humans.

To freeze the action, it's essential to use a wide aperture. The side effect of this is a shallow depth of field, which makes focusing very difficult. This means it's critical to shoot with continuous focusing turned on, so as the subject moves around, your camera will track it and keep it pin-sharp.

It's also really useful to shoot using your camera's frame set to maximum burst mode so that by holding your finger down on the shutter button, you can take lots of images in quick succession. This will give you the best chance of getting that perfect shot. Finally, pushing up the ISO will make your sensor more sensitive to light. While this increases the amount of noise in your images, it enables you to get very fast shutter speeds and eliminate motion blur. Below are some recommended camera settings and how to change them on your camera.

Setting up your DSLR

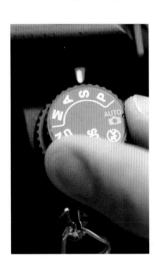

1 Select the mode
Set your camera's mode dial to shutter priority, represented by S or Tv. On cameras without a mode dial, you may need to access the menu to select this exposure mode. Now, use the finger dial to change your shutter speed to 1/500sec or faster. In this mode, your camera will automatically choose an aperture for you.

2 Change to continuous focusing
The way to set continuous focusing varies between camera models, so you'll need to check your manual for instructions. On some cameras, it's called AF-C, and on others it's AI Servo. Now, with your finger half-pressing the shutter button, your camera will track moving objects within the frame and continuously focus to keep them pin-sharp.

3 Select maximum frame burst
Using your camera's frame-burst mode, you'll be able to take lots of shots in quick succession. Again, activating this mode depends on your particular model, so keep your manual close to hand. We selected CH (continuous high speed) on the mode dial, which gave us a maximum shooting speed of 5 frames per second.

4 Set the ISO
To shoot at a shutter speed of 1/500sec or more, you will probably need to increase the ISO, making your camera's sensor more sensitive to light. Start with an ISO of 100, and increase it until the exposure warning turns off. This warning is represented either by a flashing aperture value on your screen or the letters Lo where aperture is usually displayed.

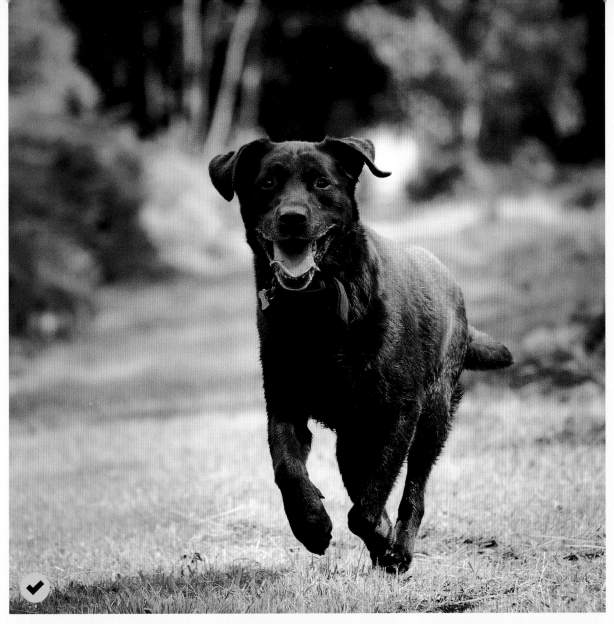

This photo is a great fast-action animal portrait. It has captured a real sense of movement, with the dog's front legs in mid-air as it bounds forward. The camera's continuous focusing did a great job of keeping the dog pin-sharp, and it's perfectly composed within the frame.

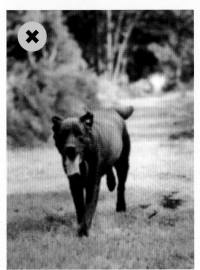

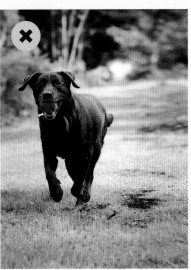

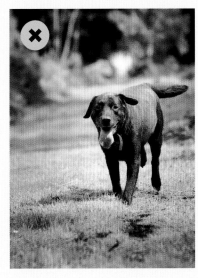

Achieving accurate focus can be incredibly difficult with fast-moving subjects. In this image, the camera hasn't quite managed to get the dog sharp.

Getting your fast-moving subject perfectly composed within the frame isn't always easy. In this shot, the dog is too far toward the left-hand side of the frame.

When shooting moving animals, you ideally want to capture a real sense of movement. In this image it isn't as strong as it needs to be.

ANIMAL PORTRAITS

GET THE RIGHT FOCAL LENGTH

Focal length refers to the magnification power of a lens. Lenses with shorter focal lengths (below 50mm) will be able to "see" more of a scene than lenses with longer focal lengths (above 50mm), which will yield a narrower view but at greater magnification. Focal lengths typically fall into three categories – wide-angle, standard (50mm) and telephoto – and the one you choose will depend on what you're photographing, how far away you are from it, and what kind of effect you're trying to create.

A wide-angle focal length can help you capture more of your subject's surroundings but also means you have to get much closer for it to fill the frame. Cats and dogs can be skittish creatures, so this isn't always the best option. A standard focal length is the nearest to that of the human eye and offers a true representation of the subject and scene, which can be very flattering. A telephoto allows you to work further away from a subject, which is often a good option, especially when you've got a large dog hurtling toward you!

There's no right or wrong focal length, so it's always worth experimenting to see which kind of shot you want to take. Below are examples of photos taken with each of the three options to help you decide which is right for you.

Standard

What you see is what you get with a 50mm, so if you want to shoot the most flattering portrait possible, this should always be your starting point. We combined the focal length with a wide aperture of f/2.8 to limit depth-of-field and blur the background to make the subject really stand out (bottom left).

Telephoto

Longer focal lengths allow you to keep your distance while making it easier to fill the frame. Wildlife professionals use telephotos up to 800mm to photograph skittish subjects. For this shot (bottom centre) we zoomed in to 200mm. Shooting from a distance with a long lens gives the effect of a compressed perspective, in which the distance between the foreground and background appears smaller.

Wide angle

The view is noticeably wider so more of the environment is included, but you have to get very close to your subject to give your shot real impact. But the closer you are, the greater the distortion – think exaggerated noses and features. This image (bottom right) was shot using a focal length of 24mm, and we had to get very close to the cat to fill the frame.

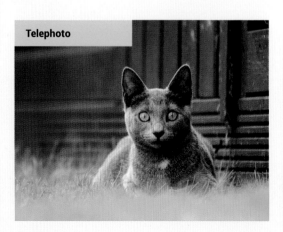

Standard

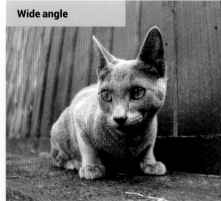

Telephoto

Wide angle

POSITION YOURSELF PROPERLY FOR SHARPER SHOTS

Photographing animals at eye level means getting low to the ground, so use a groundsheet or bin bag to lie on. Lie flat, and dig your elbows into the ground, using your body as a makeshift tripod. Use your right hand to hold the camera grip, and use your left hand to support and zoom the lens. You are now perfectly positioned to shoot with maximum stability.

If you don't need to lie down to meet your subject's gaze, crouch down, resting your left elbow on your left knee. Keep your elbows and legs tucked in to limit movement. If you find it uncomfortable to look through the viewfinder in either position, switch to Live View, and compose and focus using the LCD screen. Keep one hand on the lens so that your camera is held steady. It will also help you aim the camera toward the subject, and then you won't accidently look down at them.

NOT A RUBBISH IDEA

Put a bin bag in your pocket before the shoot – it won't weigh you down but it'll be nicely to hand!

HOW TO MANAGE YOUR MODEL

It's always helpful to have an extra pair of hands at your disposal to help control and direct the subject, especially if you're photographing someone else's pet. Toys and treats will prove invaluable, as will the occasional whistle, click or clap, and always reward good behaviour – they'll be your best friend in minutes!

Shoot crouching
If you don't need to lie down to shoot at eye level, crouch and keep your elbows and legs tucked in to limit camera movement.

Shoot lying down
Use your elbows to create a makeshift tripod and stabilize the camera. Remember to squeeze the shutter release button rather than punch it – this makes a huge difference.

Still life

Still-life photography is a great genre to get your teeth into. It's one of the only times you can have absolute control over your subject, lighting and composition.

Still life was hugely popular with the Dutch Masters of the 15th century. Their paintings usually depicted subjects such as food, flowers and household objects like books and jewellery. You can search for inspiration by looking online, and you may see how simple yet striking the backgrounds and setups are.

PAY ATTENTION TO DETAIL

Renaissance still lifes were meticulously arranged, precisely lit and then painted on to a canvas, and the same care and attention to detail should be demonstrated with modern still-life photography.

Presentation is everything with still life. Whatever your subject, it needs to feel neat and tidy, and it should definitely not be overcrowded, or your audience won't know where to look first. As you can see from the example opposite, the saying "quality over quantity" definitely applies. We used just a few items to create our arrangement. A simple bowl with six larger pieces of fruit and a small bunch of grapes was enough to create an interesting subject yet still feel clean and well composed.

Attention to detail is key when physically arranging the subjects in your scene. We placed the apples at the back on folded up plastic bags to raise them in the formation, and then artistically draped the bunch of grapes over the edge of the bowl.

Backgrounds are also a big part of presentation with still-life photography. To the right, we look at the kinds of backgrounds you can use.

THREE BACKGROUNDS TO TRY

A key consideration when choosing a background is that it needs to complement your subjects, not distract from them. The trick is to keep it simple. You don't have to travel far to find great backgrounds for your work either – many can be found around the house and, if not, are cheap to buy. Below are some examples of easily obtainable backdrops and how you can use them to build your own mini studio.

Textured material
Hessian bags are the ultimate rustic background. They're textured, full of warm tones and, if you haven't got one, you can nip to the supermarket and buy one within minutes. By leaning one half of the bag upright on the wall and securing the other to the work surface, you can create a curved backdrop that will fill the frame. These bags also come in a variety of shapes and sizes – we'd suggest using the plain side of a larger one.

Infinity curve
An infinity curve is a curved background with no corners – it flows from the ceiling to the floor in one clean swoop. Typically found in big studios, they can also be recreated in miniature form with a piece of A3 paper or card. Tape the top of the card to the wall, and apply slight pressure so it curves to the floor – don't bend it, though, or you'll get creases. If you struggle to fill the frame with a sheet of A3, you can buy A2 card at craft shops.

Work surface
Plain kitchen counters often make great backdrops, because they're level, secure and not too overpowering. Wooden worktops emphasize the rustic feel, while modern worktops work well with a minimalist theme. Use the area where the work surface meets the wall, and make sure you avoid ugly distractions like wall plugs, corners of paintings and wires – that is anything that upsets the balance of the background.

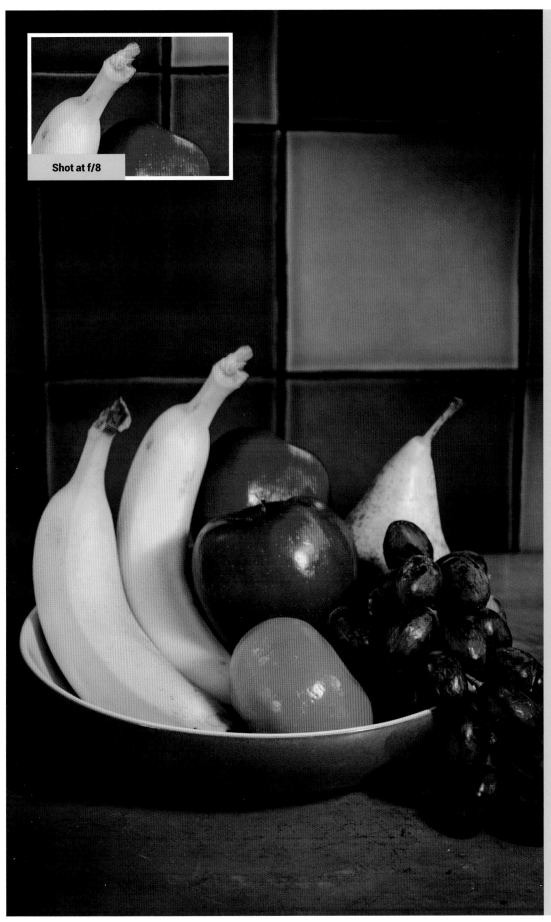

Shot at f/8

1 Simple composition

We've gone in tight to ensure there's no dead space around the subject. The chopping board and background fill the rest of the frame around the fruit, and there are no distractions around it. This keeps the image minimal.

2 Considered arrangement

We wanted a range of colours and sizes when it came to choosing fruit. It's important to take your time with arranging the objects so that they can all be seen. Use the viewfinder or Live View to make sure it looks right.

3 Depth of field

The main image was shot using an aperture of f/5.6 to ensure the background is blurred and the fruit pieces are clearly the main subject. An aperture such as f/8 wouldn't work as well, since there would be no difference in sharpness between subject and backdrop (see inset).

LIGHTING

Understanding how to use light creatively is one of the most important elements of photography, and it can really give your shots the wow factor. With still-life photography, you can enhance photographs by moving away from flat and even lighting and introducing directional light. To do this, you only need a simple light source, such as a desk lamp, to achieve great results. So long as the lamp head can be repositioned, it will be perfect for lighting a still-life setup such as a bowl of fruit.

CONTROL YOUR LIGHT

The main advantage of introducing artificial light is that it's more controllable than natural light. You can use artificial light to emphasize the shape and form of the subject with areas of shadow and highlight. And you can also control the quality of artificial light – that is whether it is hard or soft.

Hard light is direct light from the source that has a tendency to bleach out subject detail and create strong shadows. Soft light, on the other hand, is usually diffused by a material such as tissue or tracing/greaseproof paper, and the result is that more detail is captured, and shadows have softer, more graduated edges.

Both options can work in different situations, but for still life, using a diffuser will generally provide the best results. In our example, we've used a sheet of white card as a reflector to bounce light back into the shadows.

- The foreground and background in still-life photos are almost as important as the subject itself, so choose these wisely. We used kitchen tiles and a large wooden chopping board, but if you don't have anything like this, you could use a hessian shopping bag or a sheet of card.

- Use a sheet of white paper or card as a reflector. Reflecting light back on to a subject lightens shadows but keeps the contrast you need to accentuate the subject's shape and form.

- A tripod is a necessity when shooting indoors because light levels are low, meaning shutter speeds will be too slow for handholding. To avoid moving the camera during exposures, use a cable release or the self-timer.

- Use an anglepoise desk lamp to illuminate the subject. Using a lamp that can be repositioned gives you the high level of control you need to get the best results.

MAKE A REFLECTOR

The most interesting lighting comes from the side or from a 45-degree angle, but these options always create dark shadows on one side of the subject. To help lighten the shadows without totally eliminating them, use a sheet of white paper or card as a reflector. Card is better because it's more rigid and can be much more easily propped up. To get the best results, position the reflector opposite the light source so that it's perfectly placed to reflect light back on to the still life. If you own a reflector, use this, but stick to using the white side rather than the silver.

THE DIRECTION OF LIGHT

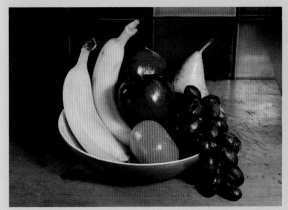

45-degree angled lighting
With the light source set at a 45-degree angle to the subject, you get a good balance between shadows and highlights. This is "safe" lighting that's less dramatic than sidelighting.

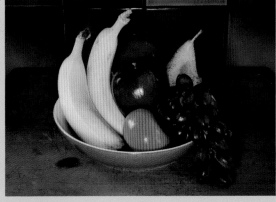

Front lighting
With the light source directly in front of the subject, shadows are minimal, but the arrangement lacks shape and form because the lighting appears so flat. Only use front lighting if shooting a two-dimensional subject.

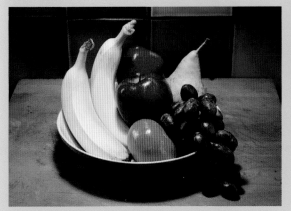

Top lighting
Lighting a subject from above works best with an object that has a strong and simple shape. For a more complex still-life subject, like a bowl of fruit, this lighting doesn't work quite so well.

Sidelighting
With the light positioned to the side of the subject, you get the best shadows and highlights for accentuating the shape and form of the subject. You really need a reflector with this position – see opposite and above.

FRAME UP AND TWEAK THE COMPOSITION
Before the final arrangement of the still life, you need to frame up the shot and choose your basic composition. Once this has been decided, attach the camera to a tripod. From this point on, only the subject(s) should be moved. There are two reasons for using a tripod. First, the camera settings and the light levels you're shooting in will result in a slow shutter speed. Second, once the shot is framed up, you won't have to move the camera until the shot has been taken. Even if the light levels allow for handholding it is still best to use a tripod.

Setting up your DSLR

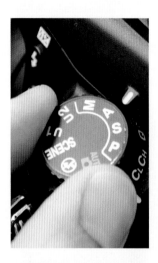

1 Select the mode
Rotate the dial to A or Av. If you're using a CSC (compact system camera), this function may only be accessible via the menu. It's best to shoot in this mode, because you select the aperture setting while the camera takes care of shutter speed. For your classic still-life image, select f/5.6 for a shallow depth of field, or f/11 for a larger depth of field.

2 Select white balance
White balance is very important, because you'll be using an artificial light source to illuminate the subject creatively. Most cameras have white-balance presets for different sources, but if lighting is mixed, the pre-sets won't work effectively. Unless you're shooting in darkness with a single light source, it's best to use auto white balance.

3 Set the ISO
Image quality is everything for still-life photography, so you should select the lowest setting possible – ISO 100. This low setting combined with low light levels indoors means shutter speed will most likely be too slow for handholding. To ensure sharp, blur-free shots, attach your camera to a tripod and use a cable release or the camera's self-timer.

4 Choose the metering mode
With still life, there's a good chance you'll be shooting a subject and background made up of a number of colours and tones. To ensure the most reliable exposure, the best metering mode to use is matrix/evaluative. This takes into account all tones then calculates an average exposure for the entire scene. It's not always perfect, and you may need to use exposure compensation – see opposite.

WHICH WHITE BALANCE?
Using the white-balance presets could result in images with colour casts if you don't choose the right one. To avoid problems and ensure correct colours, auto white balance is the best option.

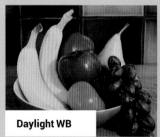
Daylight WB

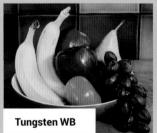
Tungsten WB

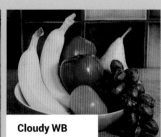
Cloudy WB

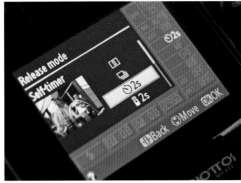

Above Use your camera's Live View feature to zoom in and check that your manual focusing is as accurate as possible.

Left If you don't have a cable release, use your camera's self-timer mode to minimize the risk of camera shake.

FOCUS MANUALLY USING LIVE VIEW

With the camera attached to a tripod, there's a reasonable chance that focus points won't be sitting over the part of the shot you want in focus. Even if they are, the best way to focus for still life is manually. This is so you can lock the focus exactly where you want it. Focusing manually using Live View is the best way to focus on a static subject, because it allows you to zoom into the image on the LCD for pinpoint focusing accuracy.

To focus manually with Live View, switch the camera or lens to manual focus, and activate Live View. Use the image, zoom button on the back of the camera to zoom into the subject on the LCD. Don't worry – the camera lens won't zoom, it's just the image on screen. If the part of the subject isn't visible, use the D-pad or arrow keys on the back of the camera to shift the image on the LCD into the correct position. Now simply turn the manual focus ring on the lens until the image on the LCD looks sharp. Once focused, turn off Live View, because you only need it for composing and focusing, and then take a shot.

USING EXPOSURE COMPENSATION

You've taken a shot or two with the camera set to aperture priority, and the image on the LCD looks either too light or too dark. The reason for this is that the tones in the scene you're shooting have tricked the camera's exposure meter into either underexposing (making the photo darker than it should be) or overexposing (making it lighter than it should be). It's not

a major problem and is something you'll come across frequently the more you use your camera.

The easiest way to remedy this over- or underexposure is with the exposure-compensation feature. This allows you to manually override the shutter speed the camera sets when shooting in aperture priority. When shooting in shutter priority, it's the other way round.

If the exposure doesn't look right, find the button on the camera with the -/+ icon or something very similar. Hold this down, and then rotate the finger dial on the back of the camera to select the exposure compensation. If the shot looks too dark, dial in overexposure (+). If too light, dial in underexposure (-). Once exposure compensation is dialled in take another shot.

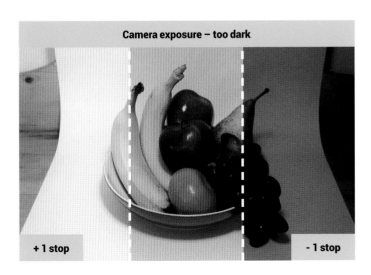

CONTROLLING DEPTH OF FIELD

Even if it's raining, still life is a subject you can always rely on to satisfy your photographic appetite. You don't need any expensive lighting because window light, even on dull days, is more than sufficient to illuminate small scenes, and reflectors can be used for extra control. The most important aspect of this type of photography is using depth of field to isolate subjects from their background. Pick the right aperture, and you're on to a winning shot. Pick the wrong one, and your photos could end up looking flat.

SUBJECTS THAT WORK

The home is an Aladdin's cave of still-life subjects, from kitchen utensils to tools and stationery. For these two example images, we've shot a potato masher and a set of kitchen knives – perfect candidates for abstract still-life shots. A shallow depth of field has helped the shot of the knives work, because the isolation created by one of the knives being in focus has created a strong focal point. On the other hand, the slightly larger depth of field used for the shot of the masher and the unconventional composition work well for this subject but perhaps wouldn't for the knives. For all still life, it's important to experiment with

depth of field, composition and viewpoint to find what works best for each subject. Take your time over this, and you'll be rewarded with great results.

Simple objects often provide the strongest shapes that are both easy to work with and very eye-catching. The photo above is obviously a set of knives, which can be clearly seen despite the tight crop.

- A tripod is essential for shooting still life indoors. Shutter speed can become very slow, so you won't always be able to handhold your DSLR.

- Spraying your subject with a mist of water can produce contrast and texture. It doesn't work for all subjects, though, so use it wisely.

- A silver reflector will allow you to throw light back on to the darker side of your subject to reduce shadows.

- A large window opposite the reflector has allowed enough light to enter the room and illuminate the still life.

EXPERIMENT WITH COMPOSITION

Only rarely will you find a successful composition and viewpoint immediately, so it's important to experiment with subject position and move around it to find the best angle. The great thing about still life is that your subject isn't going anywhere, so you have plenty of time to slow down, explore the scene fully and adjust the light for the best effect. In the examples on the right, finding the right composition was difficult and took some experimentation to find the strongest results. Even when using the rule of thirds as the basis for each composition, success wasn't guaranteed.

Use the rule of thirds to produce tighter compositions. Symmetrical compositions like the one on the right can be difficult to shoot successfully.

Setting up your DSLR

1 Choose your setup

The background you choose is as important as the subject. Whether you aim for contrast or cohesion between the two, they should complement one another in some way. The floor tile here contrasts perfectly with the shiny stainless-steel forks. Once your subject and background are chosen, experiment with the composition and viewpoint for best results.

2 Add interest

This shot works compositionally, but there's something missing. Adding more forks would only complicate matters, but there are one or two ways of improving it. To increase visual interest, we added a mist of water to the whole setup. A reflector was held to the left of the forks to control lighting, while a black card was held opposite to reduce reflections.

3 Select the mode

The best mode for this subject is aperture priority, because it allows you to fix the aperture setting while the camera takes care of shutter speed. We wanted a shallow depth of field, so we went as wide as we could with our kit lens, which is f/5.6. The ISO was set to 100, the lowest setting on most DSLRs.

4 Use exposure compensation

The tile used as the background is a tone darker than mid-grey, which results in 1 stop of overexposure and a light image. To compensate for this, it was necessary to dial in one stop of underexposure (-1). The result is a nice dark tile represented exactly the same way the naked eye sees it. For more about exposure compensation see page 146.

IS YOUR DIOPTRE SET CORRECTLY?

For those of you scratching your head wondering what on earth we're talking about, a dioptric correction control is a standard feature found on most DSLR viewfinders. It's simply a dial or switch that allows you to adjust the viewfinder to suit the eyesight of the camera user. Dioptric correction is most commonly used by people who wear glasses but prefer not to wear them when using their DSLR.

In some situations, manual focus is the most effective focus method. Having a correctly set dioptre is essential for accurate manual focusing, so you need to make sure it's on the correct setting. It's quite easy to knock the dial during normal use, and if this happens you could end up with soft images – let's leave that technique in the 1970s where it belongs.

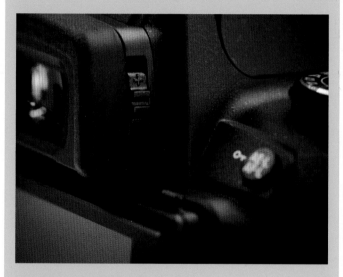

The dioptre on this DSLR is set to neutral. As you can see, the switch is in the central position.

To check your dioptre setting or set up for use with your eyesight:

1 Place your DSLR on a tripod.

2 Autofocus on a detailed object, so you can check sharpness.

3 Look through the viewfinder while changing the dioptre setting. Stop when the image in the viewfinder is sharpest – that's your correct setting.

USING REFLECTORS

Shadows can be a problem when using window light to illuminate subjects, because light comes from a single direction. In some cases, the contrast this creates is essential for mood, but this isn't always what you're looking for. A reflector is the ideal tool for reducing or completely eliminating shadows. A purpose-made reflector is the best option, particularly a 5-in-1 version, which has five surfaces for different effects. Alternatively, white paper or tin foil can be a good substitute.

Without reflector **With reflector**

Above In this shot, you can clearly see the shadows to the right of the subject.

Above right Introducing a reflector to the shoot has softened the shadows and reduced contrast.

Overexposed +2

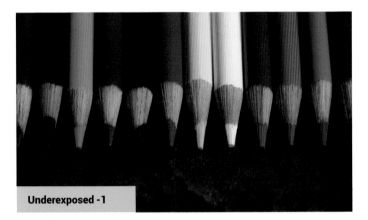

Overexposed +1

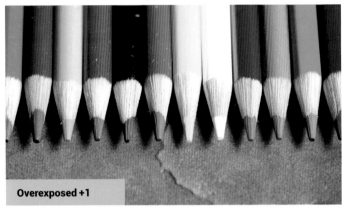

Underexposed -1

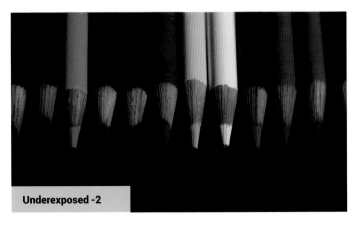

Underexposed -2

USING EXPOSURE COMPENSATION

Exposure compensation is a way of overriding the exposure set by the camera when shooting in aperture-priority and shutter-priority modes. Incorrect exposures occur because camera metering systems set exposure based on an assumption that everything in front of the camera is midtone grey. For example, when you shoot snow with normal settings, it is represented as a dull grey because the light meter underexposes. Dial in 2 stops of overexposure (+2), and the snow is now captured as white.

Conversely, if you were shooting a portrait against a dark background, the camera would overexpose the picture, rendering it too light. An exposure compensation between -1 and -2 should correct the exposure. It's a really simple concept and one that will greatly increase your control of exposure. As shown in the photo at the bottom of the page, some DSLRs have a button for quick access to exposure compensation. You'll have seen exposure compensation being used in the still-life setup on page 144, in step 4.

Getting it right

The shot of pencils (opposite) is exposed perfectly, but take a look at the examples to the left to see how over- and underexposure affect the look of images. Your image may be either too light (overexposed) or too dark (underexposed). While shooting in RAW does allow some exposure latitude, it's still best to get exposures as close to perfect as possible at the shooting stage. If you are using JPEG, it's even more important you get it right. Grasp this basic skills and you are already on the way to full manual control.

Overexposure
Overexposure is the result of too much light reaching the sensor, so the images are too light. If a photo is overexposed, a touch of underexposure will bring everything back into line. Begin at 1 stop, and assess results to see if you need to apply more exposure compensation or if you need to reduce it.

Underexposure
Underexposure results in images that are too dark because too little light has reached the sensor. The way to compensate is to apply overexposure to the degree you think the shot has been underexposed. It can take a bit of trial and error, so don't worry if you don't get it right first time.

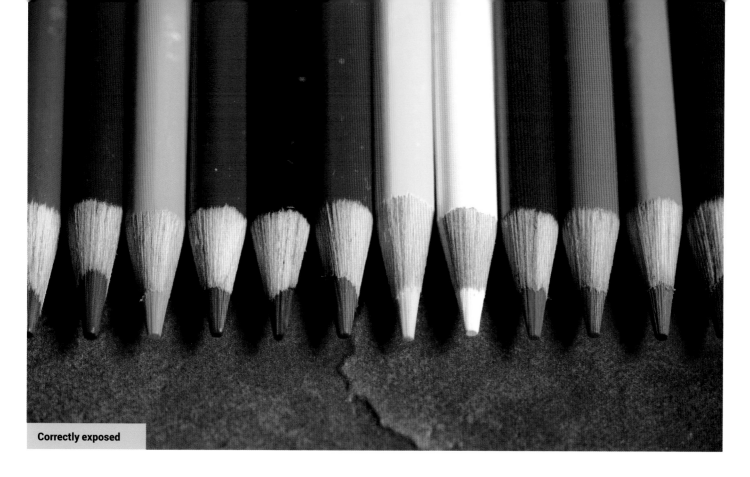

Correctly exposed

HOW TO ISOLATE YOUR SUBJECT

Shooting close to your subject and using a wide aperture results in a shallow depth of field. This isolates the subject from its background, making it a more prominent element of the composition. This technique can be used for most types of photography, from still life to portraiture.

CONTROL APERTURE

Aperture is the setting used to control the amount of light passing through the lens and to make adjustments to depth of field, which is the distance between the nearest and furthest in-focus objects. Small apertures such as f/22 let in less light but produce more through-the-image sharpness, while larger apertures such as f/4 let in more light and produce less sharpness. It can be a bit confusing to start with, but don't worry – you'll get your head round it in no time.

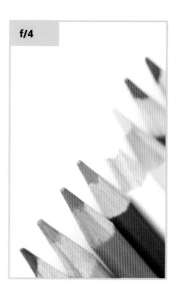

f/4

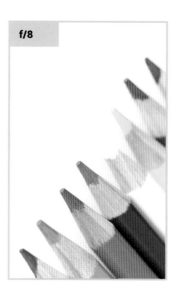

f/8

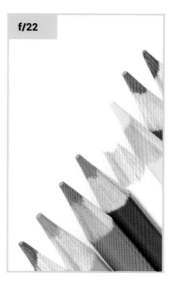

f/22

The impacts of these three images are all very different. Shooting at f/4 has created the shallowest depth of field, whereas at f/22 everything is sharp.

Graphic abstracts

Mechanical subjects often get overlooked by photographers. On the surface, greasy car parts and dirty gears don't seem like the ideal points of focus for a graphic image. Yet, on closer inspection, there's a unique beauty in the shapes, lines and unusual textures that can be found in industrial design. By breaking vehicles and machines down to these core components, you'll begin to see photo opportunities almost everywhere you look – and sometimes in the most unlikely of places. Even a simple cog can become the focus of a really interesting image.

The aim on the following pages is to create detail-rich photos with strong compositions. A bike gear or car wheel could be perfect subjects. You don't need any special equipment for these shots, just your DSLR or Compact System Camera (CSC) and a kit lens. Even a tripod isn't essential.

AVOID NOISE WITH LOWER ISO

Keep your ISO at the lowest usable level for the best image quality possible. On most cameras, this will be either ISO 100 or 200. As ISO level is increased, the camera sensor becomes more sensitive to the light that passes through the lens, but at the expense of more grain and coloured flecks.

DESIGN YOUR GRAPHIC ABSTRACT

For the most dynamic compositions, look out for areas of contrast and pattern in your subject. A repeating shape photographed from the right angle will create an attractive design, as its pattern continues infinitely and draws the viewer into the image.

Contrasts in tone, colour or texture can also add greater impact to your images. Our eyes are naturally drawn to obvious differences in a scene, which can be used to focus the viewer's attention on a particular object or area.

You don't need to use any specialist equipment to replicate the shots on the following pages – just a DSLR or CSC and kit lens. By using our suggested settings even a tripod shouldn't be necessary.

1 Excellent image quality
A low ISO kept this shot free of noise but resulted in a slow shutter speed. By enabling image stabilization and ensuring the shutter speed remained over 1/125sec, we avoided blur created by camera shake.

2 Well-chosen aperture
An aperture of f/8 is the "sweet spot" of lens producing maximum optical quality. It also produced a large enough depth of field to keep the entire subject in focus.

3 Strong composition
The subject fills the frame, but we have still used the rule of thirds to compose the shot. Two main joints sit on the "power points" of the frame, while the mechanical arm is positioned at a dynamic diagonal angle.

4 Accurate exposure
With an image that features a high proportion of either light or dark tones, the camera will struggle to achieve an accurate exposure. By using exposure compensation, we were able to correct the underexposure caused by the high proportion of black in the image.

GRAPHIC ABSTRACTS

PERFECT YOUR COMPOSITION

The composition you choose can
make or break your image. Following
the basic rules discussed on pages
30–31 will help to ensure that your
graphic abstracts are always
successful. Remember to divide your
subject into thirds, using the viewfinder
grid to help you. Ideally, you'll want
each image element to fill one or two
thirds of the frame. In this shot, the
spokes take up two-thirds, and the
wheel centre takes up one third. Try to
use lines to lead the viewer around the
image. In this shot, the spokes direct
the viewer's eye into the image and
help maintain interest. Aim to keep you
image as simple as possible. Carefully
compose your shot to eliminate clutter,
especially near the edges of the frame.

Above This clean, simple
composition uses the rule of
thirds for a balanced result.

Left The composition of
this shot is less appealing.

YOUR LENS'S SWEET SPOT

Ensuring the right parts of your image are sharp is
fundamental to good photography. An out-of-focus
scene, or one where depth of field is too large or small for
the subject, can ruin an otherwise perfectly taken shot.

In photography, sharpness comes in two types. The first
is through focusing and of course the overall quality of the
lens itself. The second is through depth of field, which is the
depth of sharpness that extends just in front and beyond the
point of focus. For landscape photography, it's common to
shoot with the aperture set to f/16 for a large depth of field,
while for portraiture, apertures around f/2.8 help to blur
backgrounds, thanks to a shallow depth of field.

When shooting graphic abstracts like the mechanical details
in these pages, it's important to use an aperture that keeps the
whole subject in focus and allows you to shoot handheld with a
shutter speed of at least 1/125sec. You might assume that an
aperture of f/16 or narrower would be the best option because
it produces a large depth of field, but this isn't actually true.

SELECT THE BEST APERTURE

Every lens has what's known as a sweet spot which is the
aperture at which the lens produces the sharpest image.
This is overall sharpness and not to be confused with depth
of field. For the vast majority of lenses, this will be f/8.
So, for graphic abstract images, shooting at the sweet spot
will produce a large enough depth of field to keep the subject
in focus and produce optimum image quality.

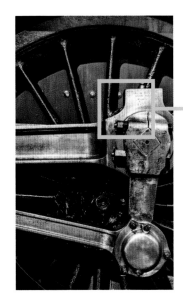
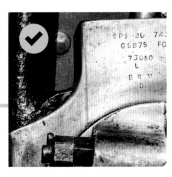

An aperture of f/8 produces
a sharper image.

Above and right Here you can see
how an aperture further away from
the sweet spot of a lens produces
a less sharp image overall.

An aperture of f/22 has
a sharpness fall-off.

TURN ON IMAGE STABILIZATION

For the best possible image quality, shoot with ISO between
100 and 400. With low light levels, this could result in shutter
speeds too slow to handhold the camera. If you have a
tripod, and there's space, you can use it. But if not, image
stabilization will help you to get the shot. Image stabilization
counteracts small movements of the camera and can allow
you to shoot at shutter speeds up to 3 stops slower than usual.
So, if you usually shoot at 1/125sec, with IS you could get
away with shooting at 1/15sec. If your camera is on a tripod,
make sure IS is turned off or it can result in a less sharp image.

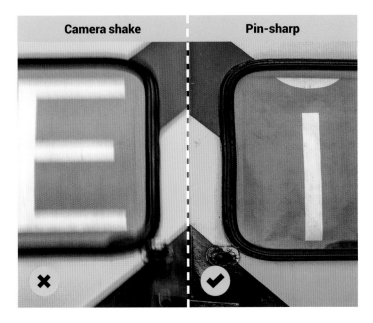

Camera shake | Pin-sharp

Left and right
Using image
stabilization (or
vibration reduction)
allows you to take
sharp handheld shots
at slower shutter
speeds than usual.

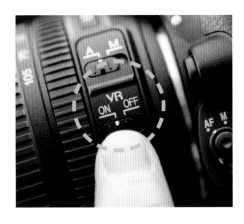

Setting up your DSLR

1 Set picture style

Start by finding your camera's image quality settings in the menu and choose JPEG Fine. Next, change Picture Control to Standard, giving punchy but natural-looking colours and contrast. Since you're working in natural light conditions, set the white balance to Daylight to ensure your images have a neutral colour balance. The icon for this is usually a sun shape. Switch on the viewfinder grid display to help you with composition. Finally, set your camera's mode dial to aperture-priority mode.

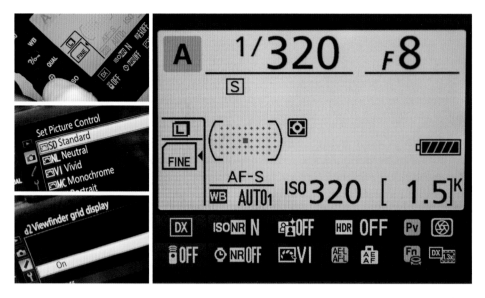

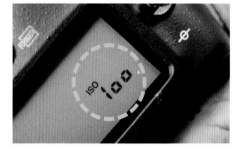

2 Select the mode

Once you're in aperture priority mode, choose an aperture of f/8. On most lenses, this is where image quality is best. A mid-range aperture also offers a relatively large depth of field so everything in your frame will appear perfectly in focus.

3 Set the ISO

To keep noise to a minimum, you should use the lowest ISO possible in the given light conditions. On bright days, set ISO to 100, checking your shutter speed is faster than about 1/125sec. If it's not, raise ISO to about 400 to avoid camera shake.

4 Choose the metering mode

For most images of this kind, there won't be a huge variation in the intensity of light, so matrix/evaluative metering mode, which assesses light levels right across the frame, is the best option. This should give you a well-balanced exposure.

GEAR UPGRADES FOR GRAPHIC ABSTRACTS

Hoya close-up filter

A close-up filter allows closer focusing for a more magnified subject. The filter screws on to the end of the lens. (Be sure to buy the right filter thread.) These are available in +1 to +10 dioptre settings, with a +10 filter providing a 1:1 ratio.

Joby Gorillapod GP2B

Joby's Gorillapod is a small, versatile tripod with articulated legs, allowing it to be wrapped around railings or lampposts. There are lots of different sizes of Gorillapod available, but for compacts and smaller DSLRs, the GP2B is ideal, since it holds up to 1kg in weight.

Manfrotto 24-LED light

This 24-LED panel with 5600K light temperature is ideal for lifting unwanted shadows on your subject. It's powered by two AAA batteries, and offers up to 2 hours of battery life. The light output can be dimmed using a power dial on the side of the panel.

TWEAK IMAGE BRIGHTNESS

Most modern cameras boast extremely accurate metering systems that will give you a precise exposure. However, your camera won't get it absolutely right every time, so you may need to override your camera and make a shot slightly brighter or darker. To do this, you can use exposure compensation. Simply find the button on the camera marked with a small +/- icon, and press and hold it while turning the finger dial or thumbwheel. Move it a few clicks to the right for a positive value and a brighter shot. Move it to the left for a negative value and a darker shot.

SET THE RIGHT FOCUS POINT

Focusing correctly is easy using autofocus, but if the wrong focus point is selected, or all points are turned on, it's just as easy to focus on the wrong part of the subject. The best AF mode to set is single-point, which is where just one point is active. By default, the central point is usually the one that's active, but this may not sit above or close to the desired point of focus in the frame. If this is the case it's best to select a different AF point. The way this is done varies between cameras, but for most it involves using the D-pad on the back of the camera.

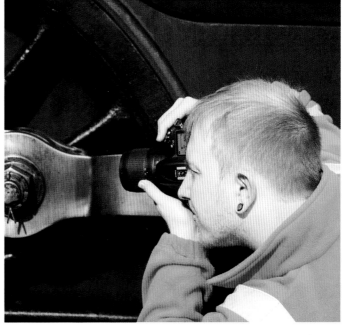

SHOOT CLOSE TO THE SUBJECT

Most kit lenses have a minimum focusing distance of just 25cm, which means you can get close to the subject to capture detail.

Right If your shot is too bright or too dark, you can tweak it using exposure compensation.

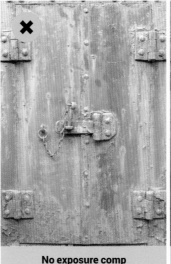

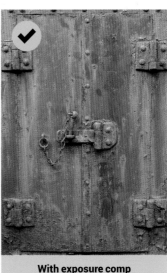

No exposure comp With exposure comp

Action

Action is a popular subject and could be something you've already tried using your camera's Sport scene mode. While this mode can provide reasonable results for any type of sports or wildlife photography, it won't help you to understand the settings it's using and why. It might not even be choosing the best ones for the job, because it's programmed using basic parameters rather than assessing the actual scene – not to mention the fact it removes any possibility for creative control.

USING SHUTTER SPEED

In previous pages, we've looked at aperture for controlling the depth of sharpness in photos. Now it's time for us to look at how fast movement can be frozen, or allowed to blur for creative effect. This control is known as shutter speed, which refers to the speed at which the camera's shutter, a light-tight curtain, opens and closes to allow light to reach the sensor and create a photo. In most situations, shutter speed is a fraction of a second. And while that is incredibly fast in terms of human perception, it can be considered quite slow when it comes to camera exposure.

The most commonly used shutter speeds range between 1 second and 1/1000sec. Shutter speeds beyond this range can be as slow as 30 seconds and, on some DSLRs, as fast as 1/8000sec, but for the majority of cameras, 1/4000sec is the fastest shutter speed. When photographing fast movement blur could occur at any shutter speed below about 1/200sec. However, this figure is arbitrary, and it really does depend on the speed of the subject.

When photographing action, the best mode to shoot in is shutter priority. This is a semi-automatic shooting mode that allows you to choose shutter speed while the camera selects appropriate aperture for a correct exposure. This mode is best for action, whether you're aiming to freeze movement or capture it as a blur, because it gives you full control of shutter speed. On most cameras, shutter priority is represented by S or Tv on the mode dial. If the camera doesn't have a mode dial, the setting is accessed through the camera menu system. You will still have to select ISO, and the exact setting you'll need depends on light conditions and the shutter speed you want to use. We'll take a closer look at this on page 157.

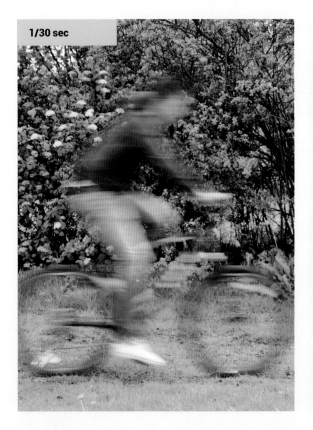

1/30 sec

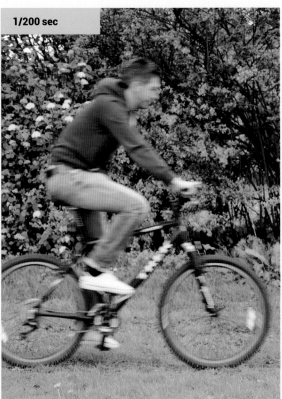

1/200 sec

Far left Shooting at slow shutter speeds, usually below 1/60sec, will capture any movement faster than walking as a blur.

Left Even shutter speeds as fast as 1/200sec won't be able to freeze movement every time. A safer option is 1/500sec to 1/1000sec.

Setting up your DSLR

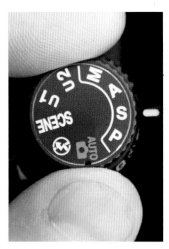

1 Select the mode
You'll find shutter-priority mode on your camera's mode dial, typically marked by an S or Tv. On some cameras you may need to access this through the main settings menu. With shutter priority selected, start with a shutter speed of 1/500sec. Your camera will automatically select the most suitable aperture.

2 Set the focus
The best focusing mode for shooting moving subjects is continuous. This is often accessed via the mode dial or main menu, but check the manual if you're not sure. Press the shutter halfway to activate – the camera's AF will detect and lock on to the moving subject, continually refocusing to ensure it stays sharp.

3 Check for an exposure warning
When set to shutter priority, lenses can't always open the aperture wide enough to allow a correct exposure, especially if you're working with fast shutter speeds. If this is the case, your camera will issue an exposure warning by flashing the aperture number on the LCD screen or top settings panel.

4 Set the ISO
To ensure your image is correctly exposed, you might need to increase ISO. This controls the sensor's sensitivity to light – the higher the ISO, the more sensitive it becomes. As a rule of thumb, start with ISO 100 for a sunny day and ISO 400 for a cloudy day. If this isn't enough (see step 3), simply increase the ISO until the exposure warning disappears.

UNDERSTANDING ISO

ISO is one of the three key creative controls, alongside shutter speed and aperture. Whether you're shooting your kid's sports day on a cloudy day or windsurfers off a sunny beach, adjusting ISO will help you achieve correctly exposed images.

By increasing ISO from 100 to 400, you make the sensor four times more sensitive to light. It makes faster shutter speeds possible and ensures you have pin-sharp and correctly exposed action shots. The only downside of increasing ISO is the effect it has on noise levels – the higher the ISO setting, the more obvious the noise (small coloured flecks) becomes. At ISO settings up to around 800, noise is barely visible on most digital cameras, though it becomes significantly more visible at higher settings like ISO 6400.

There are, of course, other ways to brighten your images, such as using flash, but this won't always look as natural. When you use a flashgun, the charge has to recycle after every shot too, so adjusting ISO is a more suitable technique for shooting continuously. Changing ISO settings takes a matter of seconds and will become instinctive once you've done it a few times, either via a direct-access button on the camera or through the main menu settings.

NOISE FOR EFFECT
Digital noise can add an old-fashioned film grain effect, so don't be afraid to increase ISO beyond 800.

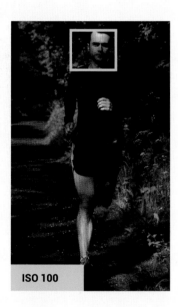

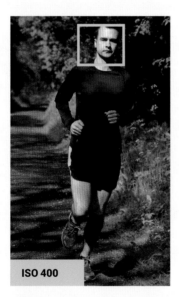

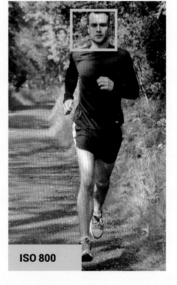

ISO 100

ISO 400

ISO 800

Start low
ISO 100 is the lowest setting on most cameras, and for bright sunny days this is perfect. However, the camera's sensor isn't at its most sensitive and will underexpose when shooting in darker locations with faster shutter speeds.

Push ISO
To achieve a correctly exposed image with a faster shutter speed, we increased ISO from 100 to 400. This is equivalent to 2 stops, and the image is brighter and there's less motion blur from the moving subject. But it's still not quite pin-sharp.

Push ISO further
To show you how ISO can be pushed even further, we increased to ISO 800. The image is now correctly exposed and the model is sharp. With a higher ISO, the level of noise has increased to the point where coloured specks are starting to show when zoomed in.

FOCUSING ON MOVEMENT

When shooting fast-moving objects, it's important that you understand your camera's autofocus settings for the best chance of a pin-sharp action image.

This is crucial because with the wrong settings, you'll end up with a whole lot of unusable images. Getting very fast-moving objects in focus can ask a lot of your camera's autofocus system, so don't be too frustrated if you have many out-of-focus photos mixed in with the good ones. The focusing techniques explained on these pages will give you the very best chance of getting a high hit-rate of pin-sharp action images. We'll start by looking at how your camera determines where in the frame to focus, how to change this on your camera, and which settings are best for action shots.

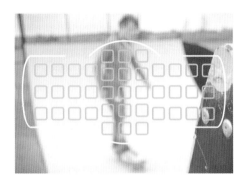

Using all autofocus points

With all autofocus points active, the camera will intelligently focus on an object in the frame. In our example above, the AF focused on the ramp in the foreground rather than the skateboarder, proving that this isn't a totally reliable method, although it might be the easiest mode to use.

Using a single autofocus point

Choosing one single point within the frame for your camera to focus on is our preferred method of focusing for action photography. We like to use the middle focus point because it's the fastest, the most accurate, and it's where your subject is for most of the time, although it might require more work than when all points are active.

Manual focus

Manual focusing gives you the most control over your shot, but it's the slowest method of focusing and is not suited to action photography. It's best to avoid manual focus for moving subjects. By the time we got our shot off here, the subject had nearly left the frame.

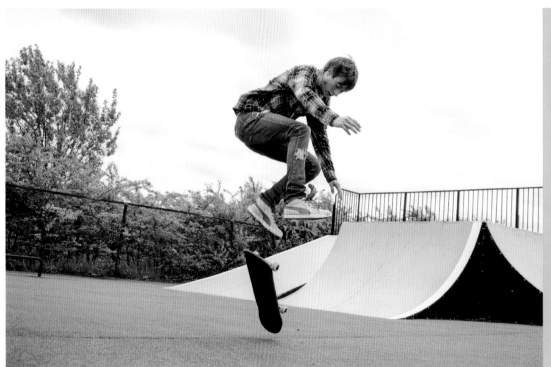

1 Single-point AF

In action photography, the subject is often in the middle of the frame, right in front of the central AF point.

2 Depth-of-field

Don't worry about how sharp your background is – the critical thing is to get your subject pin-sharp.

CONTINUOUS FOCUS-MODE

Until now, you may only have experimented with a one-shot focusing mode. This is the default, and it works by locking focus as you press your finger halfway down on the shutter button. The camera may give you a little beep to let you know it has focused, and until you let go of the shutter button the camera will stay focused on the same point.

Continuous focus (AF-C on Nikon, AI Servo on Canon) is similar to one-shot, but it will focus and refocus constantly for as long as you have your finger half-pressed on the shutter button. This means if your subject is moving around, it's really easy to keep it in focus wherever it goes. This is especially useful if your subject is moving directly toward you, because the distance between camera and subject is constantly changing, making this one of the most demanding focusing situations.

If you're shooting in high-speed burst mode, continuous focusing is really useful, because it will refocus a split second before every shot is taken. Simply leave your finger fully pressed down on the shutter button, and the camera will do the rest. This is how we took these photos of our model on his skateboard. We were able to get five action shots in quick succession without the subject drifting out of focus, even though he was moving towards the camera.

Automatic autofocus is a third focusing mode built into some modern digital cameras. In this mode, the camera intelligently switches between one-shot and continuous autofocus depending on how it judges the situation. We're not going to use this method for now, but you could experiment with it in the future.

 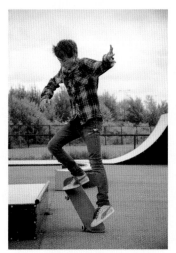 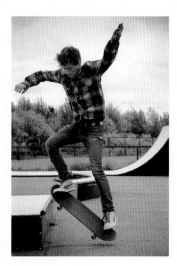

Our subject is quickly moving toward the camera, but continuous focusing ensures he's pin-sharp in every image — even in high-speed burst mode.

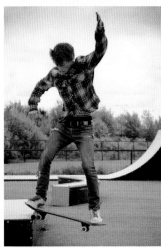 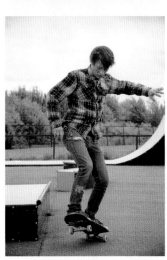

POWER-HUNGRY FOCUS
Make sure your batteries are fully charged, because continuous focusing is very demanding on power.

PERFECT YOUR COMPOSITION

Now you know how to best focus for action, let's talk about framing your shots successfully in both landscape and portrait format, as well as using burst mode.

Focus points play an important role in framing action images, because you have to consider composition before you set the active focus point. If you're planning a central composition, the central focus point should be set, but if you want to position the subject off-centre, you have to select the focus point that will sit above the subject when it enters the frame. The central focus point is the most sensitive on most DSLRs, and using this will provide a greater chance of in-focus shots. We therefore recommend shooting centrally until you gain more experience.

Composing action shots follows the same conventions as other subjects. We looked at the rule of thirds on page 31 but here's a quick reminder. Imagine the frame is split with an imaginary grid into nine equal rectangles. The points where these lines intersect are the best places on which to position the subject. Try to keep your subject slightly off-centre, and think about what's in the background, since this can play an important role in helping the subject to stand out. Don't forget to choose the right focal length when composing your shot. Empty space can look good, but usually it simply reduces the impact of the image, especially for fast-action subjects.

The area behind your subject can easily be overlooked when composing a shot, but it's actually really important. In the image to the left, the messy backdrop with no spectators doesn't do anything for the shot. But in the image above, the background really works to the picture's benefit.

Shooting action in landscape format

Shooting in landscape format often leaves more empty space in the image, so the environment can be included in the shot to add context. When working with these wider compositions, you have to be more careful about where the subject is positioned in the frame, simply because there's more potential for compositional error. With action shots where there's space around the subject, it's important to leave space for the subject to move into. Leaving no space stifles the sense of movement because it leaves no room for the viewer to imagine the subject moving. And don't forget to use the rule of thirds when you're composing your shot too.

No space to move into
It's best if your subject appears to be entering the frame rather than leaving it, so position it with lots of space to move in to. This isn't the case in the image on the left. The shot simply doesn't work.

SHOOTING MULTIPLE FRAMES IN BURST MODE

To get the very best action, shots you need to be able to anticipate how the subject will be moving when it's in the right part of the frame. For most people, this kind of knowledge comes from years of experience, so how can you fast-track your way to better action shots right now? The simple answer is to shoot with the camera set to continuous-burst mode. In this mode, the camera will continuously take photos while the shutter button is pressed down. This means you can take a series of shots from which you can select the best photo, rather than taking a single shot and potentially missing the action.

Different cameras can shoot at varying shooting speeds depending on their specifications. If you've never heard of it before, shooting speed is the number of frames per second (fps) cameras can shoot. The average shooting speed for DSLRs is around 6fps, but it could be as little as 3fps or as much as 14fps. Some compact system cameras can shoot as many as 60fps, which is too fast, because you end up with hundreds of images to search through for that one great shot. It's really best to set a lower shooting speed.

SAVE TIME LATER

Don't become trigger happy when shooting continuously. The more shots you take, the longer you have to spend time editing.

SETTING YOUR CAMERA FOR BURST MODE PHOTOGRAPHY

Setting your camera to continuous shooting is a simple task, but it varies from one camera to the next. If you're unsure of how it's done, take a look at your camera's instruction manual. Some Nikon DSLRs use a thin dial beneath the main dial mode, whereas Canons use a Drive button, that must be held in while turning the finger dial. There are usally fast and slow frame-burst speed options to choose from.

CL low speed

This setting provides a slower frames-per-second continuous shooting speed and is adequate for most fast-action situations. An advantage of this setting is that you won't be swamped with hundreds of very similar shots.

High speed

This setting provides the fastest shooting speed the DSLR is capable of shooting at. This is the best burst mode for extremely fast-moving subjects, where action unfolds so quickly that it's difficult to anticipate.

JPEG or RAW

When shooting in continuous burst mode, the camera uses a buffer to store images taken before they're saved to the memory card. Since JPEGs are smaller than RAWs, you can shoot continuously in longer bursts. When the buffer fills, the camera slows down and may even stop shooting while images are written to the card.

Shooting mode

You'll find your camera's continuous-shooting mode on the mode dial, a direct-access button or via the main menu. Check the user manual if it's not obvious.

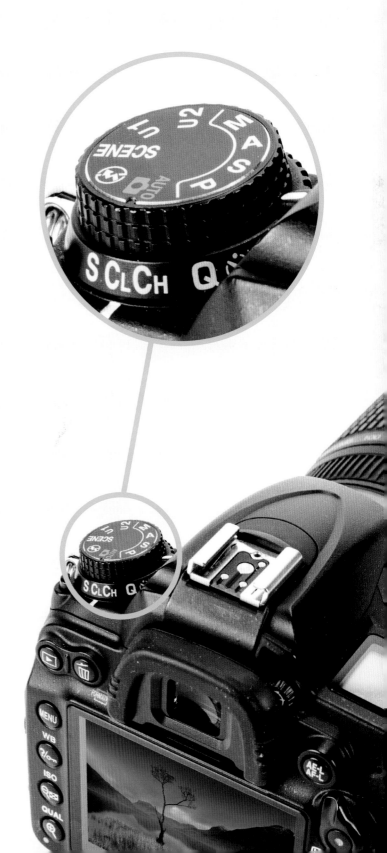

Creative flash

There are two basic options to freeze a subject when it's too dark to handhold your camera: use a tripod with a slow shutter speed, or use flash. The former is better for shooting static subjects, but if there are moving elements in your frame, this will result in unwanted motion blur. The latter will freeze any movement close to the camera but will result in a dark background, because when the flash is used in the auto modes, the default shutter speed of 1/60sec isn't long enough to capture much ambient light. But there is a third option that combines slow shutter speeds *and* flash, and it's a technique called slow-sync flash.

HAVE FUN WITH POP-UP FLASH

Using slow-sync flash will give you a sharp shot of your subject, even if it's moving, together with a healthy dose of ambient light, due to the length of the exposure. The result is either a blurred background or a movement trail of your subject, both of which can offer real impact. The chances are you've already seen slow-sync flash images around. It's a favourite technique of action and gig snappers, as it's a quick and easy way of capturing a sense of fun and energy. All you need to achieve this creative lighting effect is a camera with a flash. It's then simply a case of choosing the right settings.

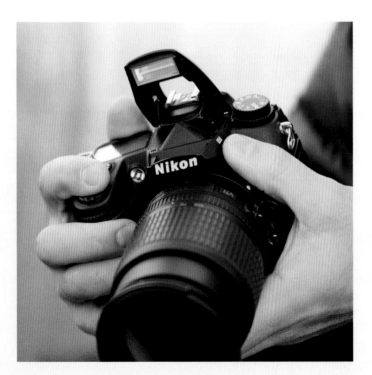

FRONT- AND REAR-CURTAIN SYNC

A typical burst of pop-up flash lasts for around 1/1000sec, so if you're shooting with a slow shutter speed, the flash is actually only on for a tiny fraction of the exposure. On most DSLRs, you can choose the point in the exposure when you want that flash burst to fire. The two options available are front-curtain sync and rear-curtain sync. The one you choose is significant because they give different effects. This might sound technical, but it's actually very simple.

Using flash in auto mode
When shooting in auto in low light, your camera will activate the pop-up flash and use a shutter speed of 1/60sec. This freezes everything to create a static image.

1/60sec exposure

Front-curtain sync
This is where the flash fires at the very start of the exposure. The flash freezes the subject, and the movement blur trails in front of the subject.

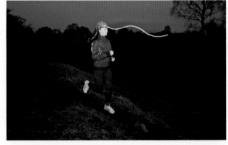

1/2sec exposure

Rear-curtain sync
With this option, the flash fires at the end of the exposure. Trails of motion appear behind the subject, perfect for capturing a sense of movement.

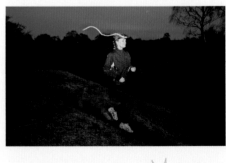

1/2sec exposure

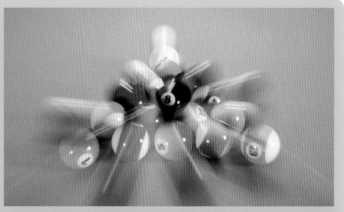

THREE GREAT SUBJECTS TO SHOOT WITH SLOW-SYNC FLASH

1 Sports and action
Use rear-curtain flash to freeze the athlete and create a streak of motion blur behind them to give a sense of speed and power. This is a very popular technique with sports photographers, who want their images to be as exciting as possible.

2 Colourful close-ups
Slow-sync flash isn't just a great technique for fast-action, high-octane subjects. It's also perfect for capturing a sense of movement on a smaller scale, such as this colourful shot of a pool table.

3 Live music
Capture a sense of the noise and energy of a small club or gig venue by using slow-sync flash. You're unlikely to need a photographer's pass, but be sure to check if the use of flash is permitted.

KNOW YOUR CURTAINS!
Some manufacturers refer to front- and rear-curtain flash as first- and second-curtain flash, so don't be surprised if you see this in your camera's menu. The curtain refers to the shutter that sits in front of the sensor and opens and closes to allow light through. The faster the shutter speed, the less time the curtain stays open.

GET READY FOR SLOW-SYNC

The good news about slow-sync flash is that this technique generally doesn't require any specialist kit other than your camera and the kit lens it came with, provided your camera has a built-in flash. An entry-level DSLR will do the job perfectly well. If you have a more expensive DSLR that doesn't have a pop-up flash, you'll need an external flashgun for this technique. Even if you have a basic compact camera, you may still be able to shoot a slow-sync image by using a preset such as Night Time Portrait. Check your camera's manual for the most appropriate preset on your model.

WHAT TO SHOOT AND WHEN

Now it's time to choose your subject. You can shoot anything you like, but ideally it will be moving and you can safely stand between 1m and 3m away from it (see the advice panel below). Obviously this rules out moving objects such as cars and trains, since it would be unsafe to get this close. A jogger or cyclist would be a good subject to start with. The best time of day for this is in the hour before dusk (golden hour), when the sun is low in the sky. This will enable you to use a slow shutter speed for motion blur, which would not be possible in bright overhead sunlight.

- When you're shooting handheld with a slow shutter speed, there's a risk of camera shake, so find a comfortable stance with your elbows tucked into your body or resting on your knees. If you're doing a panning shot, make sure you can turn your body comfortably to track the subject.

- Ensure your subject is moving across the frame rather than directly towards the camera, as this will create clearer motion trails.

- The constantly moving subject and low light make focusing difficult for this technique. Feel free to choose the method that works best for you, but we'd recommend getting your subject to stand in position, pre-focus on them using AF, then switch the lens to manual focus, allowing you to shoot all your images without having to focus every time.

Setting up your DSLR

1 Select the mode
Shoot in shutter-priority mode, so you have more precise control over shutter speed. Set the mode dial to S or Tv, and then turn the finger dial on your camera to your desired shutter speed. If you're shooting people, a 1/2sec exposure is a good starting point.

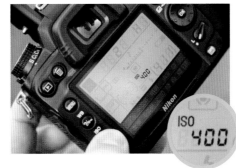

2 Set the ISO
Recommending an ISO setting is difficult, since it depends heavily on how much light is available. Start with ISO 400, but if the aperture warning is activated, you may have to increase the ISO to 800 and put up with a noisier image.

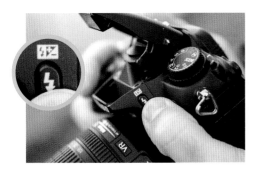

3 Activate the pop-up flash
In full auto mode, usually marked by a green logo on your camera's mode dial, the flash will automatically pop up in low light. However, in manual and semi-automatic modes, which includes shutter priority, you have to activate the flash yourself with the button on the side of the camera.

4 Switch to rear-curtain sync
If you want the motion blur to appear to trail the subject (recommended), you'll need to activate rear-curtain sync. Check your manual for instructions.

SUBJECT DISTANCE IS CRUCIAL
The light from your flashgun is actually only effective between about 1m and 3m from your subject. Any further away, and the flash simply isn't powerful enough to reach the subject. Any nearer, and the flash will "burn out", or overexpose them. The flashes going off in the crowd in sports stadiums are useless because they are way too far away to cast light on any of the players.

Too close **Too far**

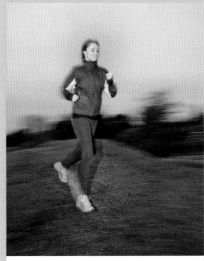

Correct

Consider your distance from the subject. Over 3m and the flash is too weak; less than 1m and it's too bright.

GET CREATIVE WITH SLOW-SYNC FLASH

Shooting slow-sync is the perfect opportunity to push your photographic ability a little further and experiment. During normal shooting, your foreground and background are either both sharp or both blurred. With slow-sync flash, this isn't necessarily the case, so try to think of some situations where you can creatively use this to your advantage. In the image to the right, the leaves near the camera appear sharp, since they're lit by the flash. But the photographer has twisted the camera during the exposure, so the leaves out of range of the flash are only lit by ambient light and appear to rotate around a central point. In this case, it doesn't really matter whether you use front- or rear-curtain sync, though having the camera mounted on a tripod or monopod will give the best results. You might also try zooming your lens during the exposure. This can look great at parties and wedding receptions, because the blurred lights in the background all appear to lead in to the centre of the frame, drawing the eye toward the subject.

USE FLASH-EXPOSURE COMPENSATION

We mentioned earlier that if your subject is too close to the camera (roughly less than 1m), then the light from the flash will be too harsh. If it's a distance away, then the flash may not be strong enough. However, if you do need to shoot outside of these boundaries, there's another weapon in your arsenal that could come in very useful. Flash-exposure compensation allows you to increase or decrease the power of the flash by several stops of light either way, without affecting the amount of ambient light the camera collects. In this way, flash exposure compensation is completely independent from normal exposure compensation since

Try twisting the camera during the exposure to get radial motion blur in the background, like on this detail of a tree. All of the leaves in the foreground are in range of the flash, so they appear perfectly frozen.

it doesn't affect shutter speed, ISO or aperture. When using slow-sync, flash-exposure compensation allows you to change how bright you want your subject without brightening or darkening the background. The method for increasing or decreasing flash power for a pop-up flash varies between cameras, so you will need to check your manual for instructions. If you're using an external flashgun, you can easily adjust flash-exposure compensation on the flashgun unit itself, and on many camera models it's also possible to do this through the camera's menu system.

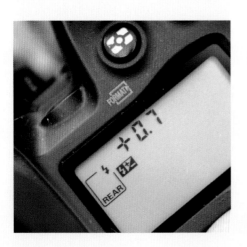

On a Nikon D7200, simply press and hold the button to release the flash while turning the back finger dial.

If your flash is too harsh, you can reduce its power without affecting the ambient light with negative flash-exposure compensation.

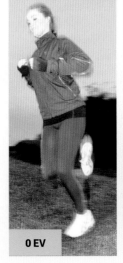
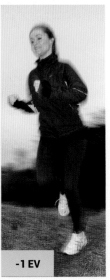

0 EV

-1 EV

1 Subject distance
In this image, the subject is the correct distance from the camera for the perfect shot. If she was any further away than 3m, the light from the flash would be too weak to achieve the desired effect. Any closer than 1m, and parts of the subject could appear burnt out.

2 Low evening light
In bright daylight, it isn't always possible to get a slow enough shutter speed for blurred movement. This image was shot just before dusk, when the ambient light was starting to fade. In these conditions, the desired shutter speed of 1/2sec was achieved.

3 Smooth and even pan
This image was shot handheld and the camera panned with the movement of the runner. A smooth pan meant the runner stayed at roughly the same position in the frame for the whole exposure. The moving camera produced pleasing background blur.

CREATIVE FLASH

Artistic light paintings

Light painting might seem like a modern idea, but it's been around in one form or another for well over a hundred years. In the 1930s, it picked up pace as an artistic technique, attracting some of the great artists and photographers of the time, including Pablo Picasso.

In the next few pages, you're going to be following in the footsteps of these early photographic pioneers by having a go at some basic light painting of your own. The technique is remarkably simple, with only a camera, a tripod and a torch needed to get a great image. With the right settings and some dogged determination, you'll be able to achieve seriously striking results and gain a much better understanding of long-exposure photography.

UNDERSTAND THE THEORY

When you shoot an image using a slow shutter speed, any object that moves within the frame will appear blurred, because it's in one position at the start of the exposure and another position at the end. Using this principle, if you shoot a long exposure in a very dark location, then move a light source across the frame as the camera's taking the image, a very distinct light trail will be recorded by the camera's sensor. With a little creativity and imagination, some incredibly eye-catching results can be achieved.

A torch that has a "candle mode" is perfect for this technique, as the bulb is fully exposed.

If you want to try light painting, start by shooting an everyday household object, such as a shoe or a picnic basket, and then use a torch to draw around its outline. The great thing about this experiment is that you don't have to worry about finding the perfect location as you do with landscape and travel photography – you can literally shoot this in the comfort of your own living room. And you don't need to be on a hilltop at sunrise waiting for the best light either – all you'll need is complete darkness. You don't even have to have a particularly attractive subject, since this technique is about shooting a normal object in a creative way. Because you'll be working in a very dark room, the trails will be the only thing the camera records, although a small amount of torchlight will spill out on the object itself, adding to the artistic effect. You'll need to work in manual mode for full control over shutter speed, aperture and ISO, setting an exposure of 30 seconds to allow plenty of time to paint your outline.

CHOOSE YOUR WEAPON

For this technique you'll need a small torch, ideally around the size of a marker pen and preferably with a single bulb. The ideal model for light painting is the Maglite Mini, which has a "candle mode" allowing the top to be removed for a completely exposed bulb.

However, any mini torch or single LED light will work. Make sure it's facing in the direction of the camera, but the beam shouldn't point straight into the lens or you may experience lens flare. Smartphone lights are not really suitable for this technique.

KEEP TORCH MOVEMENT SMOOTH

Moving the torch at a constant pace as you "paint" is key to achieving even and regular trails of light. If you finish painting before the end of the exposure, simply turn off the torch, or cover it with a sheet of card as you move it out of the frame so you don't create any unwanted light trails.

1 A small amount of light on the object

So that the viewer can make the subject out, you'll want some of the light from the torch to spill on to it. Exactly how much will depend on how close you hold the torch to the object during the exposure.

2 Correctly exposed trails

The ISO has been set so that the light trails are not too bright or too dark. This will need to be adjusted depending on the power of the torch. Speeding up or slowing down the movement of the torch also affects the intensity of the trails.

3 Perfectly in focus

The subject is completely sharp front to back, thanks to the relatively narrow aperture setting of f/16, which produces a large depth of field. Also, the subject is perfectly in focus owing to accurate pre-focusing before the lights were turned off.

4 Very dark background

The background should be pure black, so the subject stands out. If it's not (see inset), this may be because the room isn't dark enough. Alternatively, it could be being lit by the torch. If this is the case, move the subject further away from the background.

ACHIEVE PIN-SHARP RESULTS

There are three key factors that control the sharpness of your shots – camera shake, depth of field and focusing. If you get any of them wrong, not only will it ruin the aesthetics of the image, but the viewer might think you don't have complete command of your camera – that's a message you don't want to be sending out! So it's important to get these things right for the most professional-looking results.

As with most other long-exposure photography, it's crucial to use a sturdy tripod to keep the camera perfectly still for the duration of the exposure. It's also worth activating self-timer mode, so you're not touching the camera as the exposure starts. This also gives you a few seconds after pressing the shutter button to get yourself in position and ready to start painting too.

Achieve front-to-back sharpness

Depth of field is simply the distance between the nearest and farthest parts of the subject that appear in focus. It's controlled by the aperture setting you choose, among other things. Wider apertures (small f/numbers) produce a very shallow depth of field, whereas narrow apertures mean much more appears in focus. For this project, where you want the whole subject to be pin-sharp, a narrow aperture of around f/16 is needed. Once you've taken a shot, zoom in to check that both the front and back of your subject are sharp. If not, try f/18 or f/20, though be aware that image quality is reduced slightly at these narrower aperture settings.

Get focusing right

Even with the right aperture selected, your image won't be sharp without accurate focusing. Unfortunately, autofocus doesn't work in very dark conditions, so you'll need a slightly different focusing approach. Start by turning on the lights so it's bright enough to focus using AF, or simply illuminate the subject with a torch. Then half-press the shutter button to focus, before switching back to manual focus with the AF/MF switch on the lens barrel. Provided you now don't move the camera, subject or focus ring, your subject will remain sharp.

Your camera must be mounted securely on a tripod so that it stays perfectly still for the entire exposure.

KEEP YOUR BODY OUT OF THE WAY

While painting your outline, it's vital that the camera can "see" the torch at all times, so it's always best to stand to the side of the subject.

SELECT THE BEST APERTURE FOR MAXIMUM DEPTH OF FIELD

The aperture can be too wide or too narrow

If you choose an aperture that is too wide, you risk parts of the subject being out of focus. For example, the image below shot at f/4 clearly shows that the front and rear of the subject are not sharp. At the other end of the aperture range, you can also experience loss of sharpness, but this time it is because very narrow apertures produce images that suffer from an optical defect known as diffraction. The example image below shot at f/22 displays a slight lack of sharpness across the whole frame.

Correct aperture

It's also clear below that using a relatively narrow aperture of f/16 has produced a wide enough depth of field that both the front and back of the subject are perfectly sharp. This is the best aperture for this technique.

SELECT THE BEST FOCUS POINT

For maximum precision, use single-point AF (see your manual for how to change focus modes) so that only one focus point is active. By default, this is usually the central point, but if you look through the viewfinder while moving the D-pad, you can actually select any point you want. For best results, choose a point that sits directly over the middle of the subject. So if you're photographing an old boot, for example, the focus point should sit somewhere around the bottom of the laces. This will give you the best chance of getting the whole of the subject sharp.

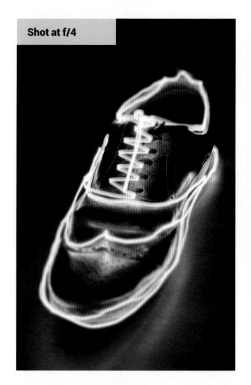

Shot at f/4

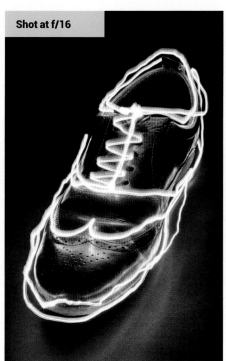

Shot at f/16

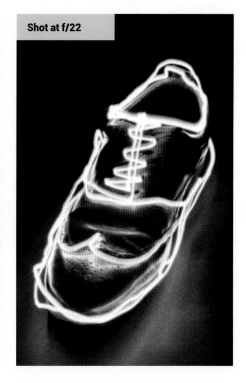

Shot at f/22

Setting up your DSLR

1 Choose the key settings

Start by putting the camera into manual mode so that you can take full control of the settings used in your exposure. Now turn the finger dial to change the shutter speed to 30 seconds. This will give you plenty of time to light-paint your subject. Now set an aperture of f/16. This ensures that when accurately focused there is front-to-back sharpness in your photo. Set image quality to fine JPEG. Choose your white balance setting (see opposite page) and set the ISO to 100.

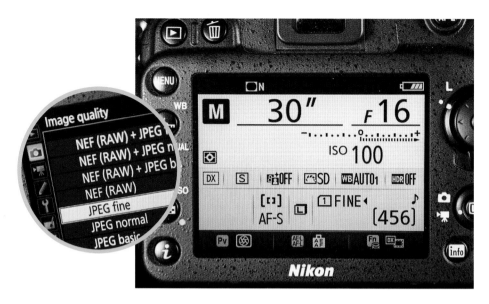

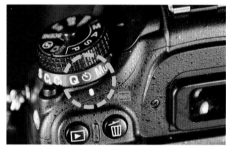

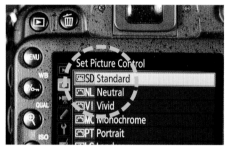

2 Choose a picture style

Picture control is accessed via your camera's menu, allowing you to make tweaks to the appearance of your shots. For this project, we recommend Standard, which will give you an image with balanced contrast, saturation, hue, brightness and sharpness.

3 Find your focus

With single-point AF selected, half-press the shutter to focus on your subject.Now switch from AF to manual focusing on the lens to focus at this distance. So long as the camera and subject aren't moved, focus will remain accurate between shots.

4 Set the self-timer

Switch the camera's shooting mode to self-timer, and set its delay to 5 seconds. This will allow the camera to steady itself after you have pressed the shutter, minimizing camera shake and allowing you the time to move into position with the torch.

GEAR UPGRADES FOR ARTISTIC LIGHT PAINTING

Maglite Mini Mag torch
With its useful candle mode, adjustable beam and impressively bright output, the compact Mini Mag is the perfect light-painting tool. This rugged device is also water- and drop-resistant.

Hahnel Captur wireless remote
This kit includes a transmitter, a receiver and a connecting cable, which is everything you need to fire your camera wirelessing. Working on a radio signal, it has a 100m range, and also doubles up as a wireless flashgun trigger.

Manfrotto 190XPRO3 & 496RC2 ball head
For sharp light painting photos you need your camera to remain stable during an exposure. This aluminium tripod comes complete with a ball head that can safely support up to 7kg of gear.

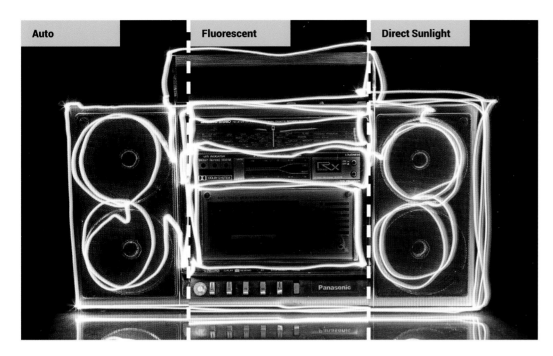

Auto | Fluorescent | Direct Sunlight

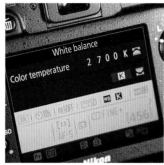

Above The custom white-balance setting allows you even more creative freedom.

CHOOSE A CREATIVE WHITE-BALANCE SETTING

Colours actually appear differently under different light sources. We don't normally notice this, because our brains adjust to these changes to ensure all the colours look natural, but cameras need help to do this. And they do it via their white-balance settings. Most cameras do a very good job of choosing the right white balance in auto mode, but you can also take control and manually select how warm or cool you want your images to appear for creative purposes.

Using a traditional bulb torch, the Incandescent white-balance setting will make the light appear as white, while the cooler Direct Sunlight setting will result in an orange light. Using a cooler LED torch with the Incandescent setting selected will result in blue, rather than white, streaks being captured.

Most cameras have a range of white-balance options that can be selected for varying light sources, but many also offer the option to input your own custom white balance. This is measured in Kelvin, and the lower the number you set, the cooler your image will appear.

SHOOT WITH THE RIGHT ISO LEVEL

The camera's ISO level controls the sensor's sensitivity to light. During a 30-second exposure, the sensor has lots of time to gather the light that is available. If you choose too high an ISO setting, the background of your shot, even in a dark room, may become visible. This will ruin the look of your image, because you want your illuminated subject to stand out in the darkness. In order to minimize this background illumination and only expose the areas you paint with light, select ISO 100.

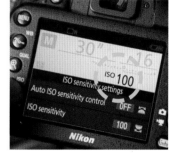

Below You want to ensure your background remains a solid black and is not partly exposed in the image.

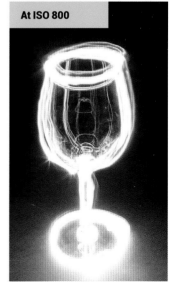

At ISO 100 | At ISO 800

Reflections

Reflections are one of nature's most impressive and most loved special effects. While we often associate them with the symmetrical scenes they can produce in landscape photography, smaller reflections can also be a brilliant creative tool for abstract-looking street shots. A strong reflection in a puddle following rain can appear like a portal into another world, turning a previously dull and flat scene into a far more dynamic one, filled with depth and intrigue. A well-composed subject that suddenly appears where it's not expected holds far greater interest than it would have in a non-reflected shot. On the following pages, you'll learn all of the settings and techniques needed for your own eye-catching reflection images.

FIND THE RIGHT REFLECTION

For the most interesting results, you need to frame a strong and recognizable subject in your reflection. Stand back, get down low, and circle around the puddle until you find the best viewpoint. You may attract a few confused looks from passers-by, but with the right shooting angle, all sorts of things could become the focal point of your photo. Without a clear subject for the viewer to focus on, the added depth of your reflection will quickly lose its intrigue.

It's worth bearing in mind that not all puddles reflect, and not all reflections have the same level of clarity. For the best results, there are certain conditions that must be met. First, for blur and distortion-free reflections the surface they appear in must be as flat — and still — as possible. Movement from flowing water produces blur that can completely eliminate any reflection at all, while even ripples caused by wind or rain can result in a warped subject. Take your time, and wait for the puddle to settle before capturing your image. Sometimes distortion can be desirable, resulting in interesting textures in the reflection, but for this project we'll be trying to keep as much clarity in our final image as possible.

Second, for the most vivid images, the puddle should be positioned in shadow, while the subject of the reflection should be well illuminated. This creates a contrast in brightness between the surface behind the puddle and the reflected scene, helping it to stand out. It also has the added benefit of making accurate focusing much easier for the camera. In strong direct light, the glare created on the

It may be a low-tech solution, but creating your own puddle from some bottled water can produce reflections on demand and at the location of your choosing.

surface of the water will produce reflections that are much fainter. In these conditions, it can be helpful to ask a friend to stand next to the puddle so that they cast a shadow over it. This will lead to a much more defined reflection in the image.

CREATE YOUR OWN REFLECTIONS TO SHOOT

If there are no puddles to be had on the day you set out to shoot one, then don't worry, other reflections will work equally well. Look for all-weather reflections in windows and polished metal, or alternatively, try producing your own reflections to shoot. Find a potential subject for your image and a nearby hard, flat surface. Then gently pour some water to form a puddle. So long as this surface is level, you'll have plenty of time to take your shots before the water evaporates or drains away.

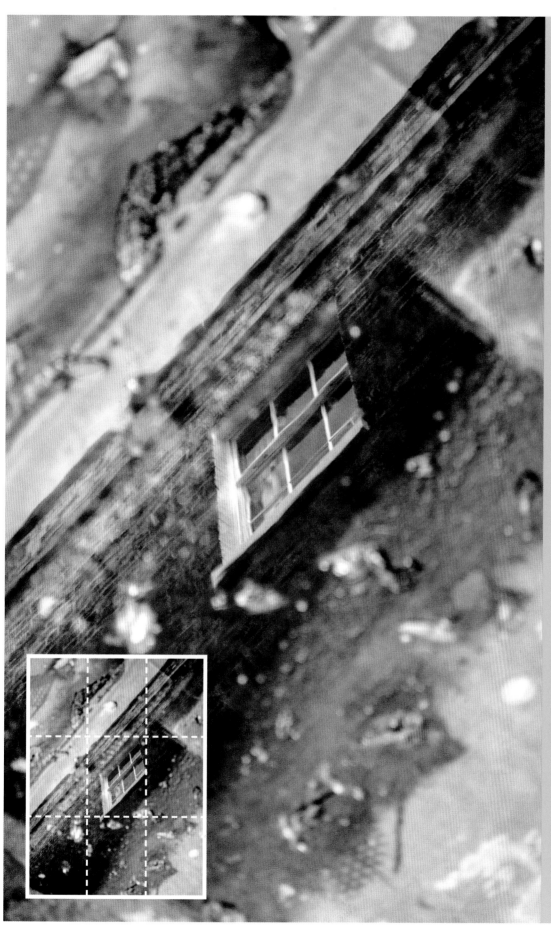

1 Fast shutter speed for crisp reflection

When shooting handheld, a fast shutter speed is needed to eliminate blur created by camera shake for a sharp shot. Using any available image stabilization system built into a lens will also help reduce the effects of shake.

2 Well-chosen depth of field

A wide aperture of f/5.6 has ensured that the pavement at either side of the reflection appears out of focus. A narrower aperture would have resulted in a larger depth of field, with an in-focus pavement creating a possible distraction.

3 Correct exposure for reflection

Finding the perfect exposure for a darker reflected scene can be a challenge. Use exposure compensation to lighten or darken your image and capture as much detail as possible.

4 Strong composition

Despite often being forced to shoot at a certain angle to capture a subject's reflection, a considered composition is still fundamental to a successful shot. With the reflected subject composed in the centre of the shot, the pavement forms a natural frame.

ACHIEVE PIN-SHARP SHOTS

Despite their abstract look, with the right camera settings, stunning reflection images are surprisingly simple to achieve. Here, we'll be shooting in aperture-priority mode and manually choosing an aperture of f/5.6 (see below), but there are still several other camera settings to be aware of to achieve the best results.

AVOID CAMERA SHAKE

When taking photos in a busy street, shooting handheld is usually the sensible option. Setting up a tripod may cause a nuisance to the public, and some models won't allow you to position the camera low enough for more acute reflection angles. But with shooting handheld comes the increased risk of instability during an exposure. In order to achieve sharp shots, it's important to use a fast enough shutter speed to avoid any camera shake (blur caused by small hand movements) appearing in the image. As a general rule, the shutter speed selected should be faster than the reciprocal of the effective focal length of the lens. In other words, the number on the bottom of the shutter-speed fraction should be the same or larger than the focal length. At 55mm, this will be roughly 1/60sec on a full-frame camera, while on an APS-C with a 1.5x crop factor producing an effective focal length of 82.5mm, it needs to be 1/100sec or faster. Choose a minimum of 1/125sec or quicker to ensure consistently sharp shots when using a kit lens.

USE VR TO MINIMIZE CAMERA SHAKE

Many lenses have a switch for a vibration-reduction, system. This reduces the shutter speed needed for shots free of camera shake.

CAPTURE THE BEST IMAGE QUALITY

To keep the minimum shutter speed that the camera selects over 1/125sec, you may have to be flexible in the ISO level that you choose. This setting controls how sensitive the camera's sensor is to light. Lower ISOs like 100 and 200 produce little image noise in a high-quality shot but at a fixed aperture require longer shutter speeds for a well-exposed image. While higher ISOs such as 800 or 1600 are much more sensitive to light and allow faster shutter speeds to be used, they will produce more noise that will damage image quality. Always use the lowest ISO level possible that will achieve the minimum shutter speed required.

CHOOSE THE RIGHT APERTURE FOR YOUR IMAGE

The aperture of the lens controls depth of field in images. This is the depth of sharpness in the scene. For this type of shot, it's always best to focus on the subject in the reflection to ensure it's sharp. Then, by using an aperture of f/5.6, we can produce a shallow depth of field. This will make sure areas at a distance from the subject, like the ground around the puddle, are out of focus.

In single-point focus mode, the camera's active focus point can be manually chosen from a range of areas in the frame using the D-pad.

Doing this helps to direct the viewer's attention to the subject by avoiding distractions. Conversely, using a narrow aperture of f/11 would produce a larger depth of field. This would bring the area around the reflection into focus, which on the one hand will introduce context, but could also result in a distraction around the point of focus. For this reason use an aperture of f/5.6 for a sharp reflection with an out-of-focus surrounding area. If you have a lens with a wider aperture, such as f/1.8, try shooting at this setting.

TAKE CARE WITH FOCUS

With two scenes in the image – the reflection and the world beyond – a camera will often struggle to find accurate focus. In order to ensure it gets it right, you need to make a few setting choices. First, set your focus mode to single-point and move it over an area of contrast in the reflected scene. Next, select single-shot focusing. This will force the camera to hold its focus distance after focus has been found but before the shutter has been fully pressed, allowing you to recompose the image as desired. This stops the camera hunting between the two scenes.

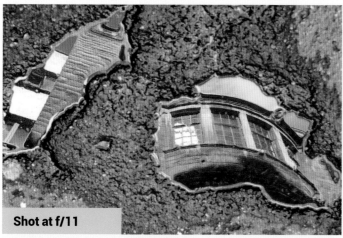

Shot at f/11

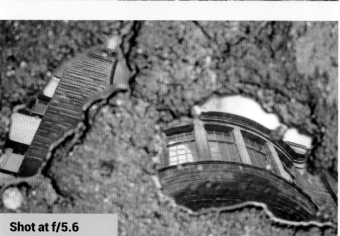

Shot at f/5.6

Most kit lenses have an aperture of f/5.6 or wider when at their longest focal length.

PERFECT YOUR COMPOSITION

Now you're armed with the settings and technique you'll need to achieve eye-catching results, you're almost ready to get out there and start shooting. But before you do, it's worth having a think about composition, since this can make a huge difference to the success of your shot. Most importantly, employ a less-is-more approach, and keep your shots as clean and simple as possible. This is especially important in the non-reflected areas of the frame, in order to help the reflection stand out. You can do this by eliminating clutter, including pieces of litter, chewing gum, and the edges of drain covers. You should also pay plenty of attention to the traditional compositional devices that tend to make your images more eye-catching.

USE THE RULE OF THIRDS

As you compose your shot, try to imagine the frame is split into nine equally sized rectangles. The idea is that your image will look more balanced, and therefore aesthetically more interesting, when your area of reflection takes up either one third or two thirds of the frame. The areas don't necessarily have to sit on your imaginary horizontal and vertical grid lines, since puddles are not geometric shapes, but the closer you can get to the one thirds/two thirds split, the better. You can also try to get the most important part of the image on one of the four points where the horizontals and verticals intersect, just like the church steeple opposite (top left). These four areas are sometimes called power points.

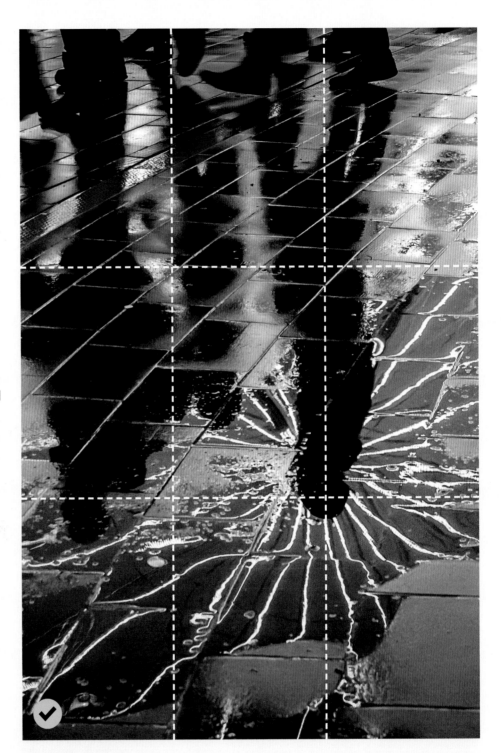

With the centre of the big wheel on the lower-right intersecting third and the puddle taking up one third of the frame area, this is a nicely balanced shot.

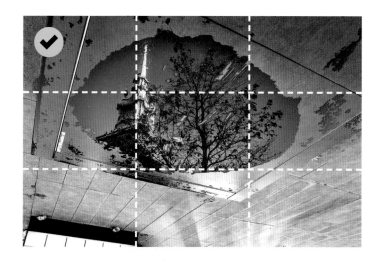

USE YOUR CAMERA'S TILT LCD
When shooting from low angles, a tilt-out or flip-out screen is really useful. These are available on some DSLRs and most Compact System Cameras (CSCs).

Top left Placing the church spire on an intersecting third, or power point, helps to make the image feel more balanced.

Above Split the frame into equal thirds, then try to ensure your reflection takes up either one third or two thirds of the frame.

Top right This clean, uncluttered surface helps keep the viewer's attention firmly on what's going on within the reflection.

Right Combining the bare tree in the reflection and an autumn leaf on the surface of the water makes for a really clever composition.

Setting up your DSLR

1 Select the mode

To get started, turn the mode dial on your camera to A or Av to select aperture priority, and set aperture to f/5.6 or f/11. Make sure the selected camera shutter speed is around 1/125sec. If it falls below this, increase the ISO. In bright conditions, you'll need a lower setting, while in lower light you'll need a higher one. A setting between 100 and 800 will be perfect. Finally, make sure that image quality is set to fine JPEG. This can usually be found in the main camera menu.

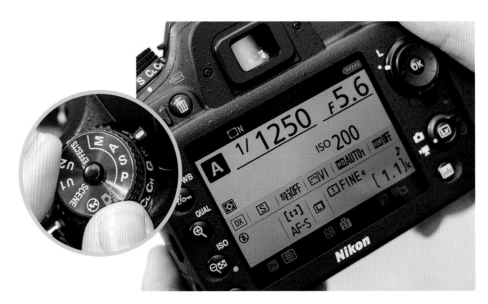

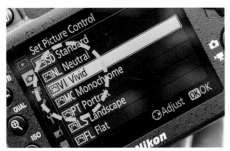

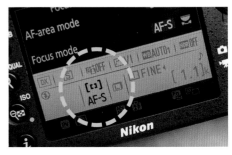

2 Select JPEG picture style

When shooting in JPEG mode, the camera processes images for you. To add a degree of control, you can select different picture styles. Since reflections in puddles are often muted, set the picture style to Vivid to help increase saturation.

3 Choose the metering mode

Different metering modes will produce different exposures. To get as close to the correct exposure as possible, use evaluative/matrix metering. This reads light from all areas of the frame and calculates an average exposure.

4 Use single-point AF

For this technique, you want to focus on a specific area of the reflection, so it's best to set the camera to single-point autofocus. Once selected, you can use the D-pad on the back of the camera to change the active focus point in the frame.

GEAR UPGRADES FOR REFLECTIONS

Storm Jacket SLR raincover

When you're out and about shooting puddles, there's a reasonable chance of rain. To keep your camera and lens dry, the Storm Jacket SLR small, medium and pro are great options.

Manfrotto Compact Light Black tripod

If you're shooting in dark conditions, you're going to need a tripod. The Compact Light Black is just 39cm long when closed down and weighs 921g. The maximum load it can take is 1.5kg.

Tamrom 35mm f/1.8 Di VC USD

This standard wide-angle prime with in-built image stabilization is compatible with full-frame and APS-C bodies. Its fast maximum aperture produces a very shallow depth of field. It's available in Canon or Nikon fit.

SELECT THE RIGHT FOCAL LENGTH

Shooting reflections is an easy, fun technique to try. The main challenge lies in finding a decent puddle, although that's really not difficult. With a suitable puddle located, remember to walk around it looking for the best viewpoint to shoot from.

With an image in mind, you now need to focus all attention on the reflection. The best way to do this is using the zoom ability of your kit lens. In fact, a kit lens is one of the best lenses to use for this technique, because most have a variable focal length ranging from 18–55mm.

The best setting to use is 55mm because you'll be narrowing the field of view, which in turn will reduce the clutter surrounding the reflection. You'll also need to stand further back from the puddle, so there's less chance of capturing your own reflection. Using a wider 18mm focal length can work exceptionally well when shooting symmetrical reflections in lakes, but with puddle reflections it's just too wide. Take a look at the two images below as an example. The shot taken at 55mm is the clear winner.

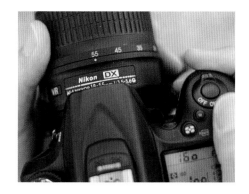

Most kit lenses have a focal range of 18–55mm. Setting the lens to 55mm will allow you to achieve a tighter composition.

USE EXPOSURE COMPENSATION

When shooting reflections, you're capturing reflected light. And when it's combined with a dark background, camera metering can be fooled into underexposure. It's safe to say this is more common than overexposure.

When you have any problems with exposure when shooting in aperture- or shutter-priority mode, exposure compensation can be used to override the camera. With this, you can lighten or darken the image by pressing the button with a -/+ symbol and turning the finger dial.

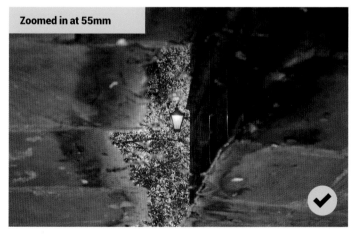

Zoomed in at 55mm

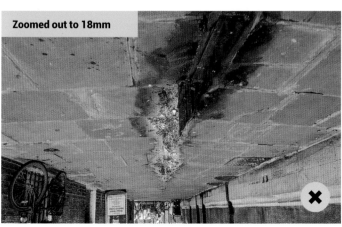

Zoomed out to 18mm

Camera exposure

With +1.0 exposure comp

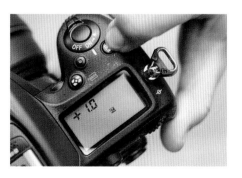

Above At the camera's exposure, the reflection is too dark. Exposure compensation of +1 lightened the shot.

Black and white

There will always be a timeless charm to black-and-white photography, because monochrome images serve to remind us of how photography used to be, when we were limited to only shooting with black-and-white film. Many of the techniques used in the past have now been superseded by technological advances, but the look and feel of a classic mono remain as popular as ever, and the same stunning results can be easily achieved in this digital age.

If anything, thanks to digital cameras and imaging software, we now have more creative control when producing our monochrome masterpieces. We can use greyscale settings on the camera to actually "see" our subject in mono as we compose and shoot, or compose and shoot in colour then convert to black and white later, when processing our images.

The trick to producing a successful and impactful monochrome shot is all in the subject matter. The absence of colour forces us to concentrate on shapes, textures, shadows, patterns and contrast, all of which are emphasized when shooting in black and white. Details like peeling paint, gritty stone walls and gravel on the floor are all great textures to shoot for black and white because intricate details really stand out once an image is stripped of colour. Harsh shadows produce interesting shapes in mono too, while bold highlights and shadows give crisp whites and blacks that enhance mood and drama.

The beauty of shooting in a mono palette is that you have an opportunity to capture a full range of greytones – ones we don't always get to see. It's important to have a correct exposure so you can capture as many of these exciting shades of grey as possible, and to really search for subjects that you think will benefit from being black-and-white. Here are a few ideas to get you started.

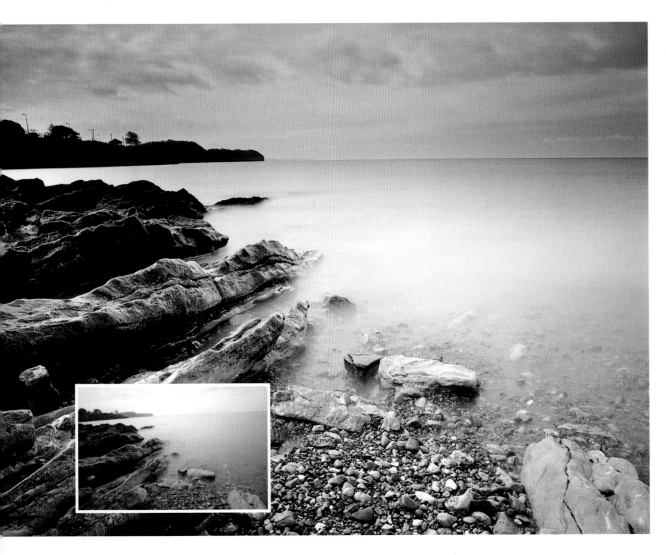

There's something very classic and traditional about black-and-white landscapes. They can feel more emotional and striking.

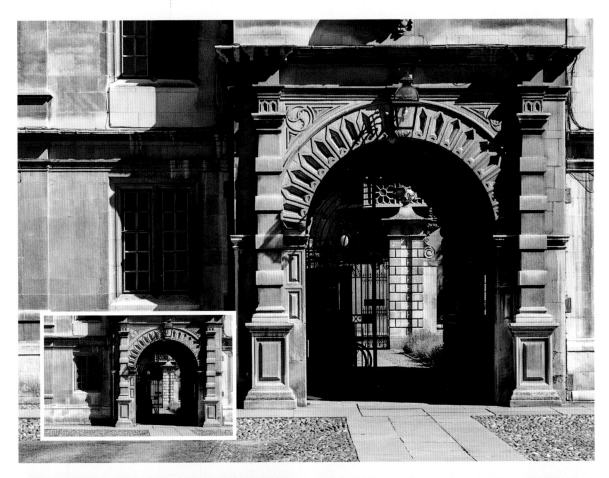

Bright sunlight and harsh shadows are a great combination for black and white, since they create lots of deep contrasts and interesting shapes.

Far left Ropes, bricks and peeling paint are all textured surfaces that work well as subjects for black and white. The mono tones make every detail stand out.

Left Black and white is very complimentary to the skintones in naturally lit portraits. And the lack of colour draws the attention to facial expressions.

SETTINGS FOR BLACK AND WHITE

Hopefully you'll be feeling really inspired by the black-and-white gallery on the previous pages and are now keen to create some great mono images of your own. The first thing you need to do is think about camera settings. Unlike when you're shooting a very specific subject, such as portraits or flowers, black-and-white photography can feature almost any subject. As such, it's a little more difficult to be quite so precise with the suggested camera settings you should use as your black-and-white images could range from a sweeping mountain landscape to a macro shot of a beautiful flower. But by now you should be building a better understanding of how your camera settings affect your images and how to change them on your camera, and you ought to be able to adapt your settings for the situation. For example, when shooting landscapes, you'll want to use a larger f/number for greater depth of field than for portraits and flower shots. And for sports images, you'll want a fast shutter speed to freeze the action.

Setting up your DSLR

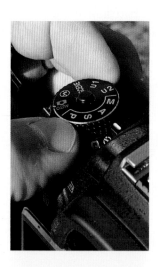

1 Select the mode
Turn the mode dial on your camera to A or Av. If your camera doesn't have a mode dial, change the mode in the menu. Set the aperture to f/8, since this is roughly where your lens performs best. If you feel you'd prefer less depth of field, try a wider aperture such as f/5.6, or even f/4 if your lens allows it.

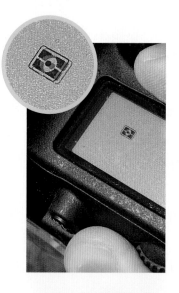

2 Choose the metering mode
The default metering mode on your camera is matrix, or evaluative, and in all but the most unusual lighting situations this is the best mode to shoot in. Check to see if your camera's already in its default mode, and if it isn't, then set it. Only change to a different mode if you feel there is good reason to do so.

3 Set the ISO
Later you'll see how you can use ISO for creative effect when shooting black and whites. However, start off by using ISO 400, which will give a relatively noise-free image. On most cameras, the ISO is changed by pressing the ISO button while turning the finger dial, though you may have to go into the menu system instead.

4 Select focal length
The focal length you choose will depend entirely on your subject and composition. Most cameras come with a kit lens that has a zoom range of around 18–55mm. The 50mm end is a good starting point, but if you find that your image isn't composed as you want, try exploring alternative focal lengths until your framing is just right.

SHOOTING BLACK-AND-WHITE JPEGS

So far, so good. You're in aperture-priority mode, and your ISO and aperture are set. Point the camera at your subject, and check that the shutter speed is faster than about 1/125sec. If it's not, push the ISO up a little or select a wider aperture. You should also now be in evaluative metering mode, which you can always change if you feel it's not exposing your image as you want, or you can use exposure compensation to force the camera to let in a little more or less light.

At the moment, your camera is still shooting in colour, so you need to switch it to black and white. RAW images can only be shot in colour and have to be converted to black and white in post-processing, so make sure you're shooting in JPEG. To start shooting in black and white, you'll need to go into the menu on your camera. This will bring up a range of presets to choose from, such as Standard, Neutral and Vivid. Find Monochrome in the list, and select it so it is highlighted. Clicking the OK button in the middle of the D-pad will select this mode, or for more advanced settings, press the right-hand button on the D-pad to bring up more options. Within these options, adding a little more contrast and sharpness can help improve the overall impact of your image, so you may want to experiment further. Pushing up contrast and sharpness work well for the image below.

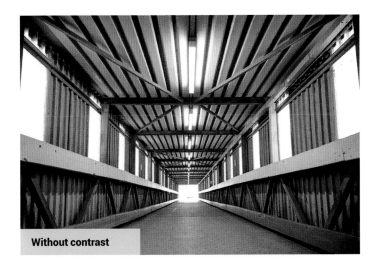

Without contrast

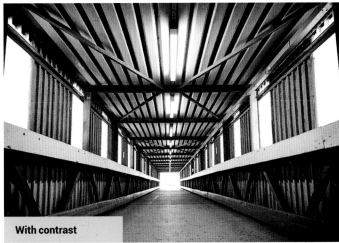

With contrast

TAKE YOUR BLACK-AND-WHITE IMAGES A STEP FURTHER

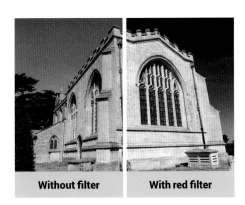

Without filter **With red filter**

1 Add a filter effect
Some cameras offer extra mono picture presets such as red, orange, yellow and green filter effects, which mimic coloured filters used with black-and-white film. The red filter, as used in this image, is great for deep blue skies.

2 Boost the tones
Toning changes all the blacks in your image to a colour of your choice. It will never restore realistic colours, since the image remains monochrome. The most popular toning option is sepia, but blue works well for this shot.

3 Apply selective colour
Some cameras have a selective-colour option. This emphasizes part of an image by keeping it in colour while everything else is made black and white. Up to three colours can be selected, and the range can be adjusted.

CREATIVE ISO CONTROL

As you already know, low ISO settings produce the "cleanest" images with the highest possible image quality. This is ideal for the majority of subjects and situations. With black and white, the noise from high ISOs can be used to creative effect and can actually enhance mono photos. This is because the luminance noise that creates a grain-like appearance in photos at high ISO settings produces a pleasing gritty texture that helps to add mood to mono shots. Back in the days of film, photographers would use high ISO film for this very effect. The downside then was that you were limited to the film in the camera, but with digital photography we have the advantage of being able to change ISO from one image to the next. We can even shoot a single subject at different ISO settings. With modern cameras, you really need to crank ISO up to 3200 or more to benefit from grain, because ISO performance has become so good in recent years. In brighter conditions, it can also be very difficult to obtain correct exposures if the camera sensor is too sensitive to light. One way around this is to use a neutral-density (ND) filter to reduce the amount of light entering through the lens.

HOW TO USE ND FILTERS TO MAINTAIN CREATIVE APERTURES

ND filters are grey filters available in varying light-blocking densities. The most popular densities are equivalent to 1, 2, 3, 4, 6 and 10 stops, although it should be said that NDs blocking 6 or more stops of light are too dark to use for anything other than landscape and architecture images.

You can also buy variable NDs that can be rotated to provide light-blocking settings between roughly 1 and 9 stops of light. If you have a circular polarizing filter, it can also be used as an ND filter because it can block up to 1.5 stops of light.

In practice, if your camera is in aperture-priority mode at f/16 and 1/4000sec, using a 4-stop ND will allow you to reduce the aperture setting to f/4 while the shutter remains at 1/4000sec. This means that you can shoot with ISO at a high level on bright days, without losing the ability of also selecting a shallow depth of field.

ND filters do nothing more than reduce the amount of light entering the lens, which allows you to use wider apertures or slower shutter speeds. They have no impact on colour.

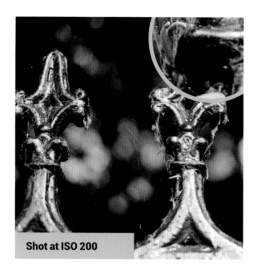

Shot at ISO 200

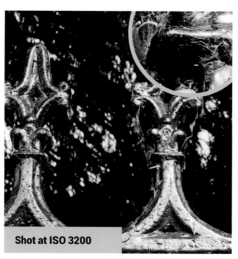

Shot at ISO 3200

CHANGE THE ISO BACK

If you've been shooting at high ISOs, ensure you change back to ISO 100 at the end of the shoot.

This type of photo is the perfect candidate for a high-ISO treatment, because the coarse surface of the subject works in harmony with the grain. You can also achieve great results with grainy indoor portraits, street scenes and even some types of landscape.

LIGHT AND COMPOSITION

You can turn an average black-and-white shot into a great photo you can be proud of, simply by using basic compositional techniques and a reflector.

Most successful images are captured by photographers who lay great stock in a firm foundation of viewpoint, composition and use of light. The main problem is that some people simply approach a subject and shoot from where they are, with little creative or technical consideration. This will never lead to the best results. The photographers with the best hit-rates are always those who scout their location trying to find the best position and height to shoot from, and those who spend a little time thinking about how to compose a shot. It doesn't really require much additional work – you just have to slow yourself down and explore the subject.

If the scene you're shooting allows, don't forget to use the rule of thirds to compose your shots. However, when capturing detail, the rule of thirds can often go out of the window, so viewpoint becomes increasingly important to pull the visual elements of photos together. With viewpoint

and composition under control, you have to think about technical ways to creatively approach the subject. Take a look at the three tips below to help you get the most out of simple subjects.

We've taken one of the most basic, and potentially difficult, subjects to shoot in an interesting way – the humble wall. The great thing about brick walls is that they're everywhere and come in different shapes, sizes and conditions and are made of different materials. This makes them an ideal subject for simple black-and-white photos focusing on pattern and texture. That's alongside things like bark, leaves, sand and gravel.

To help you get the most out of basic mono subjects and take shots with visual dynamics, the three techniques below show how to make photos of walls look more interesting. However, these tips can be used with any subject, and even in combinations, so make sure you give them a try next time you're out shooting. If you want to improve your black-and-white (and colour) photos right now, these tips will help you to do just that.

Choose your subject
This tip goes without saying, really, but it is really important to choose the most interesting subject possible. A plain old brick wall certainly shows texture and a man-made pattern, but it's not as successful as an image of a wall with some point of interest.

Change your viewpoint
Viewpoint is the key to all successful photos. The height and angle of the camera when photos are taken can make the difference between mediocre and great. By photographing a wall at an angle, you instantly create a much more interesting result.

Use a shallow depth of field
Depth of field, whether large to provide landscape photos with front-to-back sharpness or shallow to draw attention to detail, is a great way to add interest to shots. Have a go at shooting at f/4, but if you have a 50mm lens, give f/1.8 a try for a really shallow depth of field.

USING A REFLECTOR TO CONTROL YOUR LIGHTING

We've already looked at using reflectors in the Indoor Portraits section on pages 124–129, so you should have some idea of just how useful they can be. They really are invaluable accessories that are often inexpensive but can transform the way your photos are lit. In many cases, the quality of the light they reflect is so good that the result can look very similar to professional flash. Contrast is extremely important when it comes to shooting in mono – you want to achieve strong black-and-white tones, with a range of grey tones in between. When shooting natural patterns and textures, you can often be faced with mainly midtones or greys, so you have to throw some light on to the subject to increase the range of tones. The aim here is to create shadows and highlights, if possible, but you'll at least want to throw more light on to the subject to create shadows. A photographic reflector is always the best option, but if you don't have one, try using a sheet of white paper or silver foil.

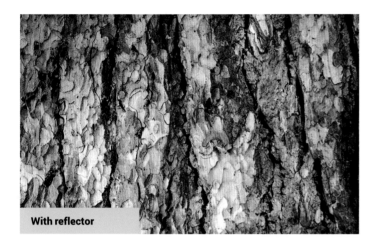

With reflector

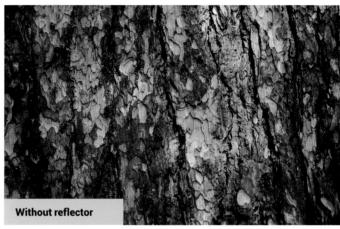

Without reflector

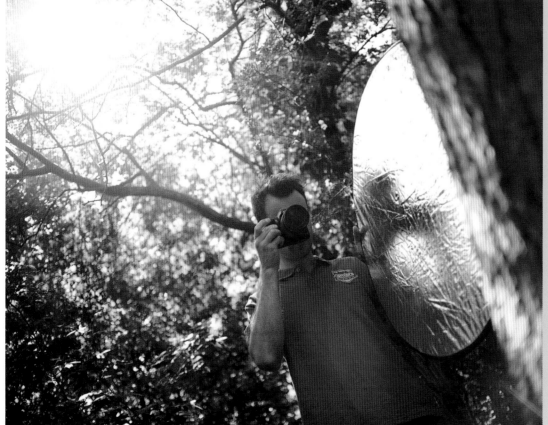

- When using a reflector, it always helps to have someone to hold it for you, so you have both of your hands free to hold the camera. If not, you'll have to shoot with one hand.

- A silver reflector is the best option for throwing light on to textures because it produces a hard and direct light. A white reflector will work, but the light will be softer and more even.

Silhouettes

If you want to convey a sense of drama, mystery and mood in your shots, silhouetting your subject is an effective way to do this, and it's really easy to achieve. Popular in many art forms, a silhouette is any image of a person or object in which they appear as a solid black shape with no discernible detail. In photography this is created by shooting into the light (also known as *contre jour*) and exposing correctly for the background while dramatically underexposing the subject. It's a relatively simple technique that can result in truly striking images.

SHOOT INTO THE LIGHT

The first step is to find a strong subject to act as the focal point of your image. Any subject can be silhouetted, but the more recognizable the shape, the better – people, trees and buildings are great subjects to start with. Remember that you can't rely on colour, texture or detail, so your shape needs a very well-defined outline.

Next you need to think about lighting. Winter is the perfect time to practise silhouettes, because the sun appears to be lower in the sky. Sunrise and sunset are at relatively sociable times, so position your subject against this light. Silhouettes rely on simplicity too, so don't clutter the frame. If you're silhouetting more than one subject, make sure they're separated enough not to merge into one shape.

Find an easily recognizable shape for your silhouette.

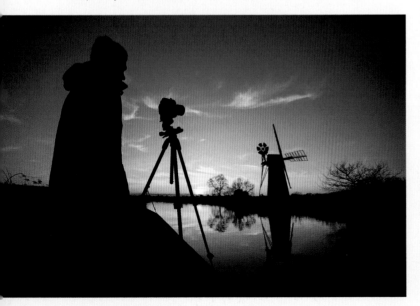

THREE GRAPHIC SUBJECTS FOR PERFECT SILHOUETTE IMAGES

1 Cyclists in action
There are plenty of mountain-biking events taking place, from cross-country and marathons to endurance. Do some research and find an event near you to try out your silhouette skills.

2 Seagulls at sunset
If you're near the coast, you'll find lots of gulls perched on roofs and posts, so why not silhouette their dinstinctive shape against an evening sky. This looks best with the head side on.

3 Ships at sea
The shape of a sail cutting across the sun-kissed sea is a classic scene. Regattas can provide a great opportunity to shoot ships and boats. If you live near the river or the sea, check out your local sailing club to find an event.

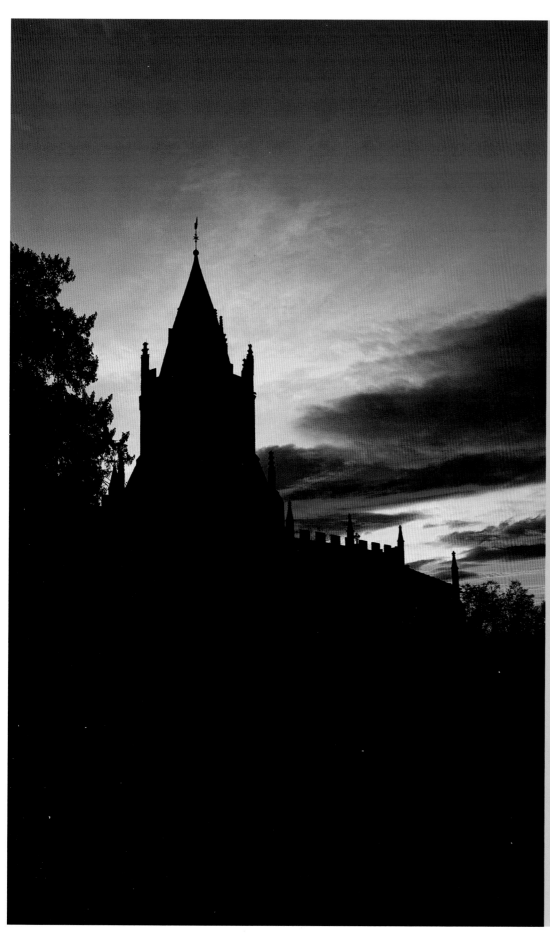

1 Recognizable subject

Any subject that is instantly recognizable by its outline will make a great silhouette, so this church is perfect. Objects with gaps rather than one solid shape can be more interesting. If you're short on ideas, a winter tree is a great place to start.

2 Colourful sky

Attempting to get an eye-catching silhouette against a flat, grey sky is bound to leave you underwhelmed. Check the weather forecast for a clear evening, and shoot around sunset for maximum colour and texture in the sky.

3 Uncluttered location

Your subject should be composed against the sky so that no other objects are in the way. Your image will have the most impact if you keep the composition minimal, so try to find a location like the brow of a hill, where there aren't lots of unwanted distractions in the background that would interfere with the shape.

4 Well composed

Frame your shot so that your subject has plenty of open space around it. Silhouette images can often look good when the subject is centrally composed for a very symmetrical image.

SILHOUETTES

EXPOSE FOR THE BRIGHTEST AREAS

A bold and crisp silhouette is achieved through correct exposure. The two images below illustrate why this is so important – one was metered for the bright sky resulting in a perfect silhouette, while the other was metered for the subject itself, which is why we can still see some detail. Take your first shot, check the image on your camera's LCD and if there's still detail in your subject, deliberately underexpose by 1–2 stops using exposure compensation.

PLAN YOUR SILHOUETTE

Hopefully you now have a better understanding of silhouettes and how they can give your photography more impact. You may even already have an idea of the subject you're going to shoot and the location you're going to use. So now you'll need to choose the most promising conditions to work in.

Choosing the right day for your shoot is key to silhouette success, since a flat, grey sky isn't going to give you a particularly striking image. Check the weather forecast for clear mornings and evenings. It's worth having your kit bag packed and ready to go, so when a shooting opportunity is coming up you can get out there at a moment's notice. Ideally, you'll want a sky with lots of colour and maybe a few scattered clouds, because a bit of texture will make your shot more interesting. Immediately after the sun dips below the horizon usually yields the most vivid colours.

While this technique is weather and time dependent, it doesn't rely on lots of specialist gear. Any DSLR or compact system camera (CSC) with kit lens will do the job perfectly well.

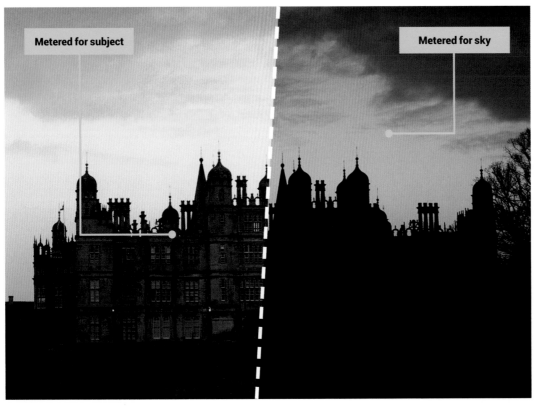

Metered for subject

Metered for sky

If at first you don't succeed

Try to arrive at your location 30 minutes before sunrise or sunset so you can find the best angle, but don't be too dismayed if you have to go out several times because you couldn't quite get what you wanted. Remember, every time you go out shooting, you're constantly learning and improving, even if you don't get immediate results.

A DSLR or CSC with a kit lens is ideal for capturing a good silhouette image.

- Shooting at sunrise and sunset brings its own set of problems, since there isn't much daylight and is therefore more risk of blurred shots. Find a comfortable stance with your elbows either tucked into your body or resting on your knees to reduce camera shake.

- If you find there is clutter behind your subject that is stopping you isolating it from the background, try getting closer to the subject, zooming out a little, and squatting down to shoot from a lower angle.

- You may have a particular shot in your head that you're determined to achieve, but beware of your images being too monotonous. Try silhouetting a range of subjects around you, or zoom in for close-up details. You may be surprised by shots you didn't imagine you'd get.

CHOOSE THE BEST CAMERA SETTINGS

Once you understand the theory, it's time to put your new skills into practice and shoot a silhouette of your own.

Silhouettes are one of the easiest photographic genres to master in terms of camera settings. If you understand metering and how the different modes work, you're already halfway there. When shooting into the light, it's much easier to obtain a silhouette than it is to correctly expose for the subject. In most situations, a silhouette isn't what you aim for, but this certainly works in this case.

Metering and exposure are only half the story. The recipe for a truly great silhouette comes down to the subject you photograph. You can't just take a snapshot of a featureless treeline against the sky and expect an award-winning result. The subject, as with all types of photography, is absolutely key to the final result.

Maximum sharpness

Silhouettes are very flat images with little or no depth. So, selecting where to focus is easy – the most distant part of the foreground. This will ensure the outline is sharp. Use single-point AF, and make sure the point covers an area of contrast – that is, part foreground and part background. Use a mid-range aperture of f/11, which will give you excellent optical quality.

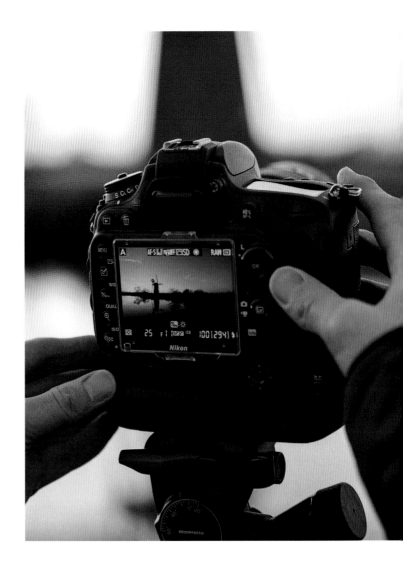

Setting up your DSLR

1 Select the mode
Select aperture priority so you have full control over aperture while the camera takes care of shutter speed. Turn the mode dial to A or Av, and set aperture to f/11. This is the sweet spot for most lenses, with the best image quality.

2 Set the ISO
To make sure you get the best colour reproduction from a dramatic sunset, set white balance to Daylight. The ISO setting depends on how bright the sky is, so aim for between 400 and 800.

3 Choose the metering mode
Set the metering mode to evaluative/matrix. This calculates exposure based on an average of the entire scene. If you can see some detail in the subject, use exposure compensation to underexpose by roughly 1 stop.

SHOOT A STARBURST SILHOUETTE

When you've perfected your technique for shooting silhouettes, you can begin to explore more creative approaches.

There are a number of ways the sun can be included in silhouette shots, but the one that really stands out above the rest is turning it into a starburst. This is a surprisingly simple technique that can, quite literally, add a sparkle to your work.

To create a successful starburst, position the sun so that it is just creeping out behind a solid section of the foreground – like the rock in the example above. Don't include the whole sun, since this will throw too much light into the lens and weaken the starburst effect.

Keep all the settings the same as you would for a standard silhouette, except for aperture. This should be changed to f/22. A starburst will now be recorded around the sun. Stopping down to this setting could result in a slow shutter speed, so you might need to use a tripod to keep the camera steady during the exposure.

USE METERING MODES FOR EFFECT

Shooting silhouettes relies heavily, although not entirely, on the way the camera is set to meter light and expose for the scene. To give the best results, you need to set the most appropriate metering mode for the job. The main three metering modes you'll find on a modern camera a re evaluative/matrix, centre-weighted and spot/partial.

Evaluative meters across the entire frame, taking into account light and dark areas to produce an averaged exposure. Centre-weighted metering places greater emphasis on light from the central portion of the frame. Spot-metering only considers light from a tiny spot that represents roughly 1.5 per cent of the frame. Spot-metering is ideal for taking a reading from a very specific part of the subject, and also for backlit subjects. However, for silhouettes the last thing you want is a perfectly exposed subject, so this isn't the best mode. See pages 44–45 for more information on metering modes. For shooting silhouettes, the best metering mode is evaluative. This mode will read light from the bright sky in the background and underexpose the darker foreground.

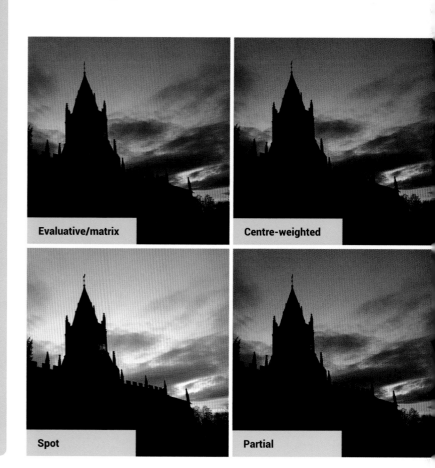

Evaluative/matrix

Centre-weighted

Spot

Partial

PART 3
BASIC EDITING SKILLS

Organize your shots

It almost goes without saying that saving and backing up your images to a computer is a necessary part of your workflow. Not only will it serve to keep your shots safe, but a well-organized file storage system makes it quick and easy for you to locate a particular image. It may not be the most exciting task, but storing your images in a methodical fashion is a huge time saver.

The simplest way to file your images is by using a logical naming system. But this is only a small part of the greater workflow that spans from the point of capture to processing, archiving and beyond. We're going to show you how a few small changes to the way you save, name and back up your images can benefit your photography.

IMPROVE YOUR WORKFLOW

The best habit to get into is to download images after every shoot, and file them in folders according to the date they were taken and what was photographed. Once this task has been completed, format the memory card so that it's empty and ready for the next shoot. The longer you allow a card to fill up with images, the greater the risk of losing all of them because the card is more likely to become corrupted. The same goes for hard drives and long-term storage. Don't put all your eggs in one basket.

Every photographer should have an external hard drive to make a second backup of the shots held on their computer. If you use an external drive as your main storage, consider getting a second one for added security. Most hard drives used for storing data are mechanical devices with moving parts, so over time they will naturally wear, and there's always the risk of them failing. Solid-state drives (SSDs), have no moving parts and are less likely to fail if dropped.

Starting file names with year then month before a description makes locating images easier.

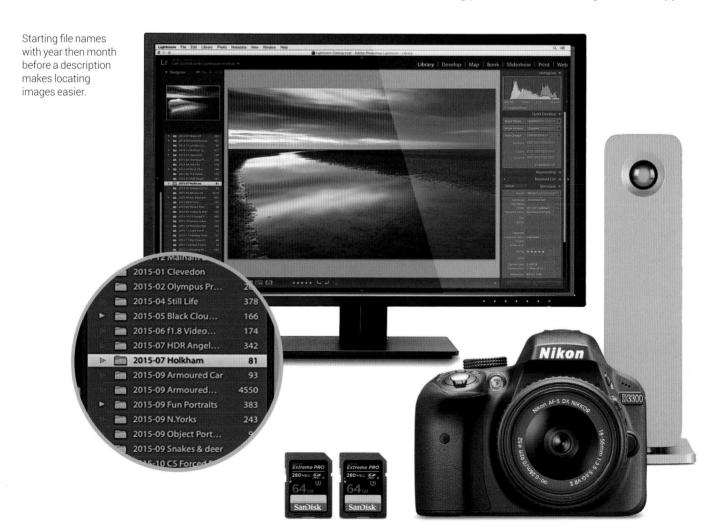

1 Create a folder for the year

The first thing you need to do is create a folder where you can save all of your images. This could be called anything, but something like Photography would be perfect. Alternatively you could use an external hard drive to save your images. Next create a folder called the name of the year to come. The idea here is that this folder will be home to all of your shots taken during that year.

2 Give folders a date and description

Folder naming on computers first looks at numbers, and then the alphabet. The best way to name individual folders is to put the year first, the month, and then a simple description. This means that all folders covering a single year will sit together in Lightroom, Bridge or the Elements Organizer. Putting the month first will jumble folders from different years. Having the description first will cause the same problem.

3 Enjoy the benefits of simplicity

As the year goes on, you'll obviously accumulate more and more folders of images. Using this simple filing system means you won't have too many folder levels to navigate. And even though all subjects are located in the same folder, they will be quickly identifiable by the short description. On some operating systems, you can even colour code your folders for extra clarity. For example, red could be portraits, and green, landcapes.

4 View your images with ease

Where this system really comes into its own is when you're searching for a set of images. We were looking for the shots above, which were taken in a particular place and summer. With that in mind, all we had to do was look at dated folders and search with keywords. We were able to find the image we needed using Adobe Bridge in less than 30 seconds.

ADOBE ELEMENTS OR LIGHTROOM

Lightroom and Elements Organizer require images to be loaded into the programs.

Elements Open Elements, and when the splash screen appears, click on the Organizer. When the Organizer window opens, click on Import in the top left corner, and select from Files and Folders from the two options.

A window will navigate to the relevant image folders.

Lightroom Open Lightroom and go to File>Import Photos and Video. When the Import window opens, make sure Add is selected at the top, and use the file tree on the left to locate the relevant folder. When the folder is selected, thumbnails will appear in the central area of the window. Select which shots to import and click the Import button.

Vignette effect

Sometimes images lacking a sense of depth can feel flat and lifeless. Dark edges around an image may be the result of the optical deficiencies of lenses, but the appearance of vignettes can be a highly desirable effect. While modern image-editing software has the ability to remove almost any kind of lens defects and perspective distortion, there are times when we choose to apply them manually.

Vignettes can do two things. They focus attention on the central part of images by making the edges darker, and this darkening effect also creates the illusion of depth. It's almost like you're looking through an object between the camera and the subject.

Adding a vignette is a simple process that can work well with many images. Below and opposite are three different techniques that can be applied in Photoshop, Elements, Adobe Camera Raw and Lightroom.

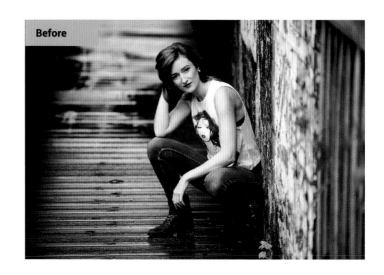

Before

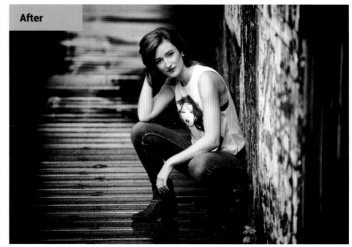

After

This image has plenty of atmosphere, but with one light side and one dark side there's an imbalance. A vignette focuses attention on the model.

ELEMENTS

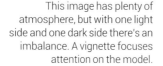

1 Create a reverse radial gradient
This technique can be applied in both Elements and Photoshop. Open your image in Elements, and click on the Create New Fill or Adjustment Layer icon at the top of the Layers panel. It's the half-black/half-white circle. Select Gradient from the list of options, and when the window opens set Style to Radial, Angle to 30º and check Reverse. Now adjust the Scale to change the vignette size. Click OK when finished.

2 Control the overall effect
The vignette will be dark with very little, if any, transparency in the darker areas. To fix this, go to the blending modes dropdown menu at the top of the Layers panel that's set to Normal by default. Select Overlay from the list of options. To further control the effect of the vignette, reduce Opacity of the vignette layer using the Opacity slider that can be found next to the blending modes menu.

PHOTOSHOP

1 Apply Lens Correction

Open your image in Photoshop and hold down Ctrl+Shift+N (Ctrl+Shift+N on a Mac) to create an empty new layer. Now press Shift+F5 to open the Fill dialogue and set Contents to 50 per cent Gray. Next go to Filter>Lens Correction and click on the Custom tab. Drag the Vignette Amount slider to -100, then use the Midpoint slider to control the size of the vignette. Click OK at the top right of the dialogue window when you're done.

2 Change blending modes

At this point, you'll be confronted by a grey image with a dark vignette around the edge. So, now need to add transparency to the Layer. Go to the dropdown menu near the top of the Layers panel that's set to Normal by default, and select Overlay from the list of options. Leave the Layer as it is for a full-strength vignette, or reduce Opacity using the slider at the top right of the Layers panel.

CAMERA RAW/LIGHTROOM

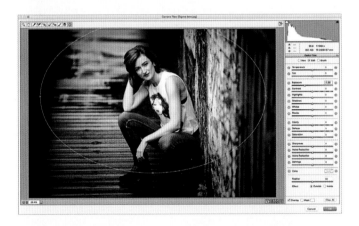

1 Use the Radial Filter

Open your RAW file in Adobe Camera Raw or Lightroom. In ACR the Radial Filter can be activated by pressing J on the keyboard, and in Lightroom by holding down Shift+M. To apply the filter left-click your mouse and drag so the guide becomes visible. To move the filter, click and drag the dot in the centre of the guide. The filter size can be changed by left-clicking and dragging the boxes on the edge of the guide.

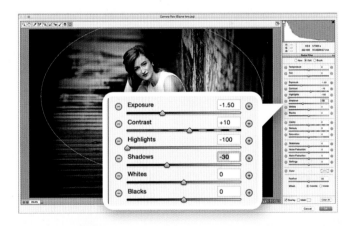

2 Adjust the vignette strength

With the Radial Filter in position, it's time to start making adjustments. If the previously used settings are in place, you'll need to click on the Clear All button. Make sure Feather is set to 50, and the Effect to Outside. Now all you have to do is reduce Exposure to darken the area outside the guide. Reducing Highlights and Shadows and increasing Contrast will help to darken the vignette. Click OK.

Improve image brightness

Even after achieving a well-exposed and correctly focused shot in-camera, there are very few images that don't benefit from some kind of boost during post-processing. Adjustment layers allow you to modify colour and tone without permanently affecting a file's pixels (known as non-destructive editing), and you can then turn these adjustments on and off at the touch of a button. One of the most powerful adjustment layers available in Photoshop is Levels. This is a visual tool that enables the moving and stretching of the brightness levels in an image, allowing solid blacks, solid whites and midtones to be specified. This can quickly revitalize tired images with muddy colours and flat lighting, increasing contrast for deeper shadows and brighter highlights. While similar results can be achieved using a Curves Layer, Levels is a much simpler tool to master, allowing highly effective changes to be made in just a matter of moments.

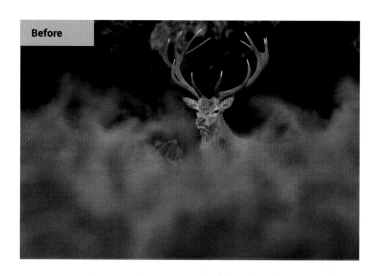

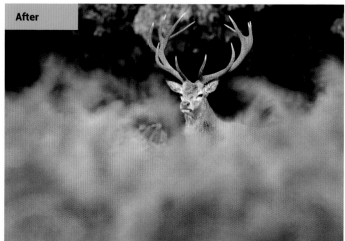

Our original image is rather muddy and flat straight out of the camera, but a few simple Levels adjustments give it the injection of contrast it needs to stand out.

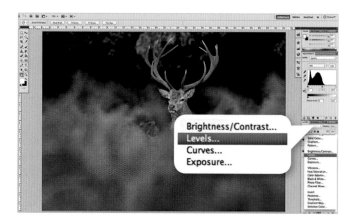

1 Add a levels adjustment layer
Open your image in Photoshop using Files/Open on the Create New Fill or Adjustment Layer icon, the half-black/half-white circle found at the bottom of the Layers palette, and select Levels from the menu. A new Levels control window will now appear – this contains a histogram that shows your image's complete tonal range, with shadows to the left, midtones in the middle, and highlights to the right.

2 Set the histogram colour channel
A well-exposed image will often show pixels spread across the histogram's entire range. If they don't quite extend to its edges your image may appear flat. You can, however, make some changes to quickly change this. The first step is to make sure that your channel menu is set to RGB, since you want your changes to affect all colour channels. Hold Alt during the next steps to display the areas of the image your changes are affecting.

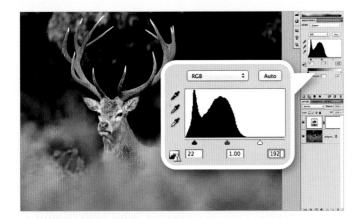

3 Drag in the black and white sliders

To give greater depth to the shadows, drag the black slider to the right to meet the edge of the histogram, and drag the white slider to the left to add brightness to the highlights. This will immediately increase overall contrast. Dragging the sliders beyond the histogram's edges (known as clipping) will create an even more dramatic image, but will cause a loss of detail in the highlights and shadows.

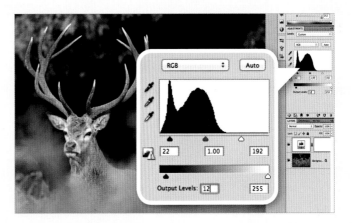

4 Choose new output levels

Too much contrast isn't always a good thing, so now we're going to use the Output Levels bar to limit the tonal range and remove solid blacks and solid whites. Dragging the black slider to the right limits the darkness of the shadows, while dragging the white slider to the left will limit the brightness of the highlights. Move the slider on the Output Levels to 12 for a slightly hazy effect.

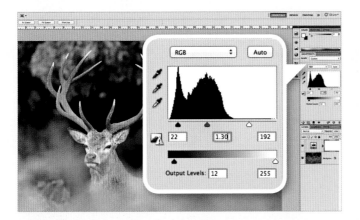

5 Adjust midtones

With contrast adjusted, you can now make controlled changes to your image's midtones. The grey slider below the histogram controls this aspect of your photo – moving the slider to the left will lighten midtones by stretching out the highlights and compressing the shadows, while moving it to the right has the opposite effect. The default central position will provide an even balance between the two.

6 Change blending mode to Luminosity

Increasing contrast often results in an increase in colour saturation, and while this may be a desired effect in many cases, it's possible to reduce this by selecting a new blending mode. Click on your Levels layer in the Layers palette, and select Luminosity from the drop-down blending-mode menu. This will preserve the image's original hue and saturation, while maintaining the luminance of the blended layer.

Index

PICTURE CREDITS

All photographs courtesy of Bauer Media except:
Getty Images: p40, p41 (top & centre right), p42
Shutterstock.com: p41 (centre), p165 (top right & middle right), p192 (top & middle right), p197 (top)

PUBLISHING CREDITS

Executive Editor Anna Marx
Project Editor Victoria Marshallsay
Design Jim Smith (www.jimsmithdesign.co.uk) and James Pople
Picture Research Steve Behan
Production Sarah Kramer

With special thanks to Tim Berry, Features Editor of *Practical Photography*.